The Great Limbaugh Con

To Tom Cantlon —
Keep defending
common sense in your
articles —
— Chuck Kelly

THE
Great
Limbaugh
Con

And other right-wing assaults on common sense

Charles M. Kelly

Fithian Press

SANTA BARBARA • 1994

To my wife, Marsha.
My very best supporter, occasional critic,
and number-one editor.

Copyright ©1994 by Charles M. Kelly
All rights reserved
Printed in the United States of America

Design and typography by Jim Cook

Published by Fithian Press
A division of Daniel & Daniel, Publishers, Inc.
Post Office Box 1525
Santa Barbara, California 93102

LIBRARY OF CONGRESS CATALOGING-IN-PUBLICATION DATA
Kelly, Charles M.
The Great Limbaugh Con: and other right-wing assaults
on common sense / Charles M. Kelly.
p. cm.
Includes index.
ISBN 1-56474-102-8
1. Conservatism—United States. 2. Limbaugh, Rush H. I. Title.
JC573.2.U6K45 1994
320.5′3′0973—dc20 94-7826
CIP

Contents

Part Two:
The Philosophical and the Devious

Part Three:
For the Serious Limbaugh Debater:
A Case Study for the Decade of the '80s

PREFACE

Some of my best friends are conservatives. Most of my favorite relatives are conservatives. Virtually all of them, both friends and relatives, are educated. By most people's standards, several are wealthy. So this was not an easy book to write.

It's a book about how conservatives, the wealthy, and the educated have created many of the economic and social problems of the United States. This is not to say that liberals, the poor, and uneducated haven't created problems. It's just that Rush Limbaugh has done a fantastic job of distorting the reality of what's happening in our society, and his arguments cry out for rebuttal.

Therefore, this book is intended to counteract many of the propaganda issues that Limbaugh has made popular. He admits that he has no obligation to be fair, balanced, or objective in his commentary. Although he also admits that he is a defender of conservatism and wealth, his words and actions betray a more historically malignant philosophy. He believes that the royalty of our society—those who make their livings by taking advantage of our least educated and hardest working citizens—should control our country and reap most of its benefits.

In many ways, I'm as critical of liberals as I am of conservatives,

especially on issues of education, law and order, and social discipline. However, the viciousness of Limbaugh's anti-liberal attacks has pushed me to the point of being anti-conservative, especially on economic issues. My reaction is, in itself, possibly a demonstration of the destructiveness of "attack politics." I've written some obviously nasty things in this book about conservatives, the wealthy, and the educated, probably to the point of being unfair.

Although conservatism, wealth, and education have contributed much to our country's success, they also have a dark side, and Limbaugh has forced it to the surface of our discussion. (I can claim some degree of objectivity about this, since I have a Ph.D. degree in industrial communication from Purdue, I certainly am not "poor," and I have very conservative views on most non-economic issues.)

My point: I can understand why wealthy, informed, responsible, and educated people can be conservatives, but I simply cannot understand how they can support an obvious demagogue like Limbaugh.

Do Limbaugh's deliberate distortions of facts help us understand and evaluate our options? Do we want a sophomoric kind of viciousness, even if done humorously, to be our standard for disagreeing with one another? Are ridicule, name-calling, card-stacking, and all the other techniques of the demagogue to be our tools for social change? Can his kind of daily harangue be good for rational problem solving, and for our society? If you support Limbaugh, that's what you're saying.

Our country is in trouble. Too many of us are trying to destroy those who oppose our selfish interests, rather than to solve ethically the problems of our society. To some people, politics seems to be more of a game to be won, than a serious attempt to make the United States a better place in which to live.

Actually, by exercising his right to be a demagogue, Limbaugh may yet prove the wisdom of our first amendment. His temporary popularity is encouraging many politicians to clarify their values and to expose them to national scrutiny. Many have come out of the woodwork to ally themselves with him. In doing so, they are saying more about their true values than their spin-doctors will ever be able to cover up. So far, they have probably benefited from associating with him.

But times are changing. The emptiness and destructiveness of attack politics are becoming more obvious with each passing day.

People are getting fed up. The entertainment value of viciousness is wearing thin. The public is beginning to look for leaders who actually want to solve society's problems, rather than those who have perfected the art of ridicule and divisiveness.

I hope this book can help voters to distinguish between the two.

INTRODUCTION:

The great Limbaugh con, and how to confront it

You may think that Rush Limbaugh is unique in American history. Or that his bigger-than-life popularity is the result of an enlightened American public. If you do, think again—on both counts.

According to *Fortune Magazine*, "So far as the response of his audience is concerned, [he] is just about the biggest thing that ever happened to radio." At one point, he had a stenographic staff of 145 to handle the tremendous volume of mail he was receiving.

Rush Limbaugh? Nope. Father Charles Edward Coughlin, the "radio priest" of the 1930s.

The similarities between Coughlin and Limbaugh are striking. In the '30s, Coughlin appealed to large numbers of the American public who wanted simple solutions for the complex economic problems of the depression. Radio listeners were eager to listen to anyone who would offer scapegoats to blame, as long as the scapegoats were "them" and not "us."

Coughlin's villains were government bureaucrats and "big shots," Jewish bankers and congressmen from New York City, the eastern elite and the New Deal Democrats, especially those with Jewish-sounding names. Although he charged others with being fascists, he eventually

defended the Nazis in their effort to "block the Jewish-Communist plan for subjugating Germany."

For Limbaugh, today's villains are the homeless, "Billary" Clinton, the NAACP and various black leaders, the news media, welfare mothers, Democrats, liberals, "Maarriooo," American Indians, various indigenous peoples of the world, and anyone else who exposes, or represents, genuine weaknesses in our political system.

While charging others with being "feminazis," "environmentalist wackos," or fascists, he appeals to the prejudices of all those who never quite bought the idea that we need to address the historic injustices and costly problems of our country.

Those who are mystified at the successes of Father Coughlin and Rush Limbaugh need to read any of the numerous books about demagoguery. A good place to begin is *Demagogues in the Depression* by David Bennett, or *The Fine Art of Propaganda* by the Institute for Propaganda Analysis.[1] Both are based on the life of Coughlin and his demagogic techniques, such as "band wagon," "name calling," "glittering generality," "transfer," "testimonial," "plain folks," and "card stacking."

As did Coughlin, Limbaugh uses all of them, but the most effective is undoubtedly the "band wagon." (Limbaugh even put it into words: "If you want to be mainstream, you oughta get onto the bandwagon now.") By screening callers, he gives the impression that there is a huge silent majority of right-thinking Americans out there who support the radical views he stands for. The rare "liberal" he lets get through the switchboard is either a sixteen-year-old student who wants high schools to hand out free condoms, or a person with a severe case of mike fright.

Anyone who has ever studied propaganda techniques knows that Limbaugh, like Coughlin, fits the classic description of a demagogue: he appeals to the ignorance and prejudices of a public that wants someone to blame for their problems. The danger here is that demagogues are never recognized as such by their supporters until they have done a great deal of damage.

Demagoguery, however, is not the real focus of this book. One hardly needs to demonstrate that Limbaugh is a demagogue, since it is

self-evident, and most of his supporters know it. (Any college fresh-man who has had a class in communications could write a book on his diatribes and prove it beyond doubt.)

In fact, Limbaugh's distortions and attacks against others are so obviously hypocritical that it becomes part of his defense against criti-cism. In effect, he's saying, "Hey, I'm just making a parody of my own demagoguery and having fun, where's your sense of humor?"

Limbaugh and America's Right Wing

Limbaugh is the most popular and visible spokesman for a corrupt and cynical political philosophy that needs to be challenged at every opportunity. Many false economic, social, and political "principles" are now accepted as true by the public simply because they have been repeated so often.

Therefore, this book is intended to give you some ammunition to confront the destructive influences, not only of the Limbaughs of the world, but also of the many well-financed conservative "think tanks" that are the sources of his ideas. Organizations such as the American Enterprise Institute, the Heritage Foundation, the Institute for Political Economy, the John Locke Foundation, the National Center for Public Policy Research, the Cato Institute, the Free Congress Foundation, Citizens for a Sound Economy, and a host of others too numerous to mention have been established by those in our society who believe that the wealthy and the politically powerful should control our nation and receive most of its material benefits.

When you read an opinion piece in a magazine or newspaper that suggests that

- the middle class will be better off when the rich get even more tax breaks than they already have, or
- only the middle class has enough money to support our govern-ment and to solve our society's problems, or
- we can solve our many national problems without money— because the private sector, if we let it alone, will do it for us, or
- government regulations on the unethical behaviors of business persons are bad for society, or

- protecting the environment is bad for the economy, or
- shipping jobs off to Mexico, Taiwan, Ireland, or wherever, will actually help employment in the U.S., or
- anything that obviously brings immediate benefits to the wealthy, the powerful, or the educated, but with only the promise of eventual "trickle down" to the middle class,

then look down at the end of the column for the author's name and position. You'll usually find that he or she is a member of one of these organizations, or an organization you never heard of, but that *sounds* as solidly American as the materialism of the '80s.

The following chapters, therefore, will deal with their most frequent assaults on common sense, which, when not vigorously confronted, become "truths."

Understanding the Limbaugh Con

Even a broken clock is right twice a day, and Limbaugh taps many of the legitimate concerns of us all. However, his "dittoheads" (fans and supporters) shouldn't allow his correct positions on a few social issues (relating to crime, education, foolish government regulation, welfare fraud, and so on), to distract them from his more basic agenda.

Admittedly, he's funny and entertaining, and much of what he does is relatively harmless. When he calls Clinton a liar, or characterizes him and his staff as a bunch of pack rats scurrying around a dark alley, fleeing from the light that Limbaugh is shining on them, it's little more than entertainment. Or when he plays a record of a group singing "The little first lady with megalomania, she's the terror of Pennsylvania Avenue,"there is not much to worry about.

However, we must take him seriously when he deals with basic economic and social issues, because many of the prejudiced and the economically naive in our society need little more than a Limbaugh to galvanize them into a potent political movement. If he is not effectively confronted, the economic falsehoods of our '80s decade of greed will continue gaining acceptance.

You see, the Limbaugh Con is, at its heart, a scam against workers. Under the pretext of fighting for their rights, he supports an eco-

nomic agenda that is designed to benefit the wealthy and the politically powerful—at the expense of low- and middle-income Americans. If he has his way, the growing disparity in income between the ultra rich and everybody else will only get worse—along with our national problems.

Three Levels of Discussion

The book is divided into three levels of difficulty. Part One deals with ten easily understood "sound bites" that Limbaugh has made popular, and that are some of his most important and most outrageous violations of common sense.

These are Limbaugh's favorite scams, and are fundamental to the propaganda efforts of those who want the United States to evolve to a form of plutocratic capitalism (control of our economy and government by the wealthy elite). It is important to understand how these so-called truths compare with the beliefs of those who want to preserve and protect our present system of democratic capitalism (control by an educated and informed public).

When you hear these issues brought up in casual conversation, on TV, or over the radio, you instinctively know they are in error. However, they are sometimes difficult to challenge if you've never thought them through, so a little thought and preparation can help.

Part Two goes beyond Limbaugh's sound bite propaganda, and explains how conservatives and liberals view important subjective issues. They both arrive at their philosophical conclusions because of the different "gut level" feelings they get from the same kinds of life experiences.

Our definitions of work, the ways we view the rights of workers, our understanding of the essentials of capitalism, and the ultimate purpose of our lives on earth—all these are very much the result of how we interpret our own personal experiences. Because of the subjectivity of the issues in Part Two, they will require more discussion and illustration.

Part Three makes the transition from the philosophical and judgmental to the concrete and the practical. You can appreciate the importance and true motivations of a Rush Limbaugh only if you

understand how he fits in with the major political movements of America's twentieth century.

He openly defends those who historically have always benefited when workers' wages are kept low and profits high, when jobs are exported out of our country, when the environment is raped, when a new tax system favors the rich—and so on. He has artfully covered up the fact, however, that *he also is from the same economic school that has fought every attempt to improve the lives of working class American families*—child labor laws, overtime laws, audited financial statements, safe working conditions, medical benefits, pension funding safeguards, etc.

Part Three, therefore, begins with a case study of Spartanburg, South Carolina, and its relationship to the rest of the country. Spartanburg is a microcosm of the United States, both in terms of its successes and its growing problems. In other words, it is an excellent place to begin a systematic analysis of what conservatives have been doing to this country during the current century.

Part Three then expands beyond Spartanburg to include the conservative South, as well as the rest of the world. The disastrous impact of conservative politics on middle- and low-income workers—and taxpayers—remains the same, whether studied on a local basis or world-wide basis.

Once you understand the cause-and-effect relationships between conservative political ideology, and its inevitable economic and social consequences—national or international—the nature and true objectives of the right-wing political movement, and Limbaugh's role in it, become obvious.

Oh, and if you are not all that concerned about working class Americans, watch out. What happened to them in the '80s is now happening to engineers, professionals of all descriptions, middle- and lower-level managers, and anyone else whose job can be eliminated for any reason whatsoever.

A study by the American Management Association showed that 54.6 percent of jobs cut by some 400 large corporations during the twelve months ending in June 1993 were in supervisory, middle-management and professional/technical positions.[2] So, if you feel comfort-

able in your job, and feel good about what the Limbaugh conservatives have done to workers in this country, wait awhile. They will eventually get around to you.

HOW TO CONFRONT THE LIMBAUGH CON

This book is primarily an aid for confronting the sound-bite clichés that Rush Limbaugh and his right-wing extremists have made popular. *It is a book about issues.* So, let's get some of the mechanics of confrontation out of the way in the very beginning.

Tactics

As though there were a shortage of right-wing propaganda mills, Republican presidential candidates Jack Kemp and Bill Bennett have created yet another one, called Empower America.

According to the *Wall Street Journal*, it has a budget of over $4 million, and a mailing list of over 100,000 donors, "worth millions in future contributions and able to sustain staff and big salaries for the organization's founders."[3]

Empower America's fax machines "spin out weekly reports for a network of 500 radio talk-show hosts across the country." Using microchip technology, they can even feed *taped quotes* to radio stations. They have plans for an 800 number so that conservatives can call in to get professional help on current issues that America's right wing wants to attack.

Think of it! Limbaugh and his conservative talk-show cohorts are now getting high-tech, state-of-the-art, pre-packaged propaganda pieces to relay to the public. They have, indeed, elevated the science of attack politics to an art form.

Unfortunately, to confront their distortions of reality, we must use some of their own tactics against them. Although we don't have the financial backing that conservative think tanks do, we have a tremendous advantage: history and logic are on our side, and we don't have to deliberately lie (while swearing we are telling the truth) in order to get our points across.

Most importantly, we must influence public opinion the same way they do—only honestly. You see, many writers of letters-to-the-editor and callers to local talk-radio shows are willing stooges of conservative strategists who ghost-write things for them to communicate.

Even the honest talk-show hosts and newspaper editors have no way of knowing the original source of much of the material they receive or hear. As a result, some of the lengthy opinion pieces in your newspaper (supposedly by a local businessman, a leader of a local civic organization, etc.), were probably ghost-written. And a caller to talk radio who sounds like a wild-eyed liberal from the lunatic fringe may, in fact, be a conservative trying to make liberals look bad.

As you read this book, you will recognize many of the prefabricated clichés that you've seen in your local paper or heard on the radio. They are being disseminated on a massive scale, and are creating the impression that our country is experiencing a national explosion of conservative wisdom.

If democratic capitalism is to have a chance of surviving such formidable propaganda onslaughts, we must all get involved and join the battle on the side of common sense.

But first, forget about calling Rush Limbaugh. All his calls are screened, so you won't get through unless he *has planned* to debate your particular issue.

As one caller said, "I've been on hold so long, I forgot what the screener said I could talk about."[4]

If you don't talk about the subject you told the screener you would, Limbaugh will chastise you and cut you off.

Remember, his show is a three-hour propaganda piece designed to support ultra-conservative goals and to con middle-income Americans into thinking he's on their side. There is no way he is going to let you get the upper hand.

If you start getting the better of him, he will attack you from ten different directions, ask you obscure questions that no one would have answers to without note cards, and, in general, try to make you look like an uninformed boob.

Talking to Rush is, as they say, like gettin' into a pissin' contest with a skunk: even if you win, you lose. If you *do* get the better of

him, his screeners, and his data bank, you can count on this: *the next callers he selects will talk about how he made you look stupid.* In other words, if he can't top you directly, he and his supporters will create the *impression* he did.

The Limbaugh program is a rigged debate in which Limbaugh, his researchers, and his staff ensure that only one person can win. They conduct sham verbal battles in which they ultimately control both the conservative *and* the liberal inputs.

So, to confront Limbaugh's con, write your newspaper editor and call your local talk-show host. Give them your *own* opinion, based on an honest understanding of the issues and your *own* observations of what is going on in society. Talk to your work associates, your neighbors and the person next to you on the train. The battle of ideas is going on everywhere.

Statistical Attack Politics

Some people say that Limbaugh is hard to argue against because much of what he says makes sense. He seems to have a battery of data to prove that conservative policies work, and that the '80s were good for America.

Always remember: whenever someone presents statistics that obviously contradict common sense, you *know* there has been a conscious, deliberate distortion. And if you take just a little time, you will find it and can argue against it. Usually the distortion is based on an isolated statistic that does not fairly represent the general picture.

For example, consider some of Limbaugh's most frequent claims:

- *Americans are better off because productivity has tripled since the beginning of the '80s.*

Okay. But *why* did productivity triple? If you fire 30 percent of your workforce, lower the salaries of the remaining 70 percent and force everyone to work much harder, productivity goes up dramatically. So do stress-related illnesses, spouse abuse, and all the other problems associated with a degenerating quality of worklife.

- *Workers are better off now because, in the '80s, the increase*

in high-skill jobs was greater than the increase in low-skill jobs.

Okay. But these are very selective statistics, and deliberately designed to deceive. In other words, the number of a *relatively few* high-skilled jobs in manufacturing increased at a faster rate than a *massive* number of jobs that require little or no skill.

This is bad news for workers. *Of course* lower-skill jobs didn't grow as fast. Huge numbers of them went out of the country, and the ones that were left paid even less than they did before, relative to inflation. And, naturally, when one highly skilled worker replaces ten low-skilled workers *via* automation (another way to increase productivity), that is terrible news for the displaced workers.

- *The total number of manufacturing jobs increased during the '80s.*

Okay. But the huge number of manufacturing jobs we lost paid $12 to $15 an hour. The new jobs that replaced, or even exceeded their number, pay only $6 to $8 an hour. And the incomes of executives and professionals in those same manufacturing operations actually *went up*.

- *More blacks became affluent in the '80s than ever before.*

Okay. But, like the skilled workers, there were relatively few affluent blacks in the '70s. And, as virtually everyone knows, a much larger number of blacks saw their quality of life get worse in the '80s, and for the bottom 20 percent or so, *intolerably* worse.

Actually, Limbaugh's statistics (above) substantiate what common sense tells us: during the '80s the rich got richer (including blacks and highly skilled workers), the poor got poorer, and the quality of life for most workers and many middle-income Americans got worse.

The shameful thing about such a cynical use of statistics is that conservatives have deliberately and totally distorted the data's implications and their cause-effect relationships.

So, again, remember: when Limbaugh makes a claim and supports it with data that defy common sense, look for the deliberate deception. It is always there.

The statistics, and the reasons for them, in the following chapters should help you spot that deception. You will find that most of them deal with the United States in its totality. Contrary to Limbaugh's statistics, they are not specifically selected *sub-sets of data* that are deliberately deceptive.

As a practical matter, you hardly need to rely on *any*one's statistics. If you have traveled at all, you have personally observed that affluent citizens and their communities have reached new peaks in luxury (world travel, elegant restaurants, expensive cars, golf courses, excellent schools and advanced educational degrees, tennis courts, private security patrols, the best of medical care, etc.).

At the same time, you have observed an accelerating degeneration in the quality of working-class lives and working-class communities (poor schools, loss of medical insurance and poor medical care, loss of pension benefits, loss of decent paying jobs, crime, poorer public services, *ad infinitum*).

These kinds of observations confirm, as if any confirmation were needed, the statistics that prove that America is becoming increasingly divided into haves and have-nots.

Past Time to Confront

Conservatives have had a tremendous advantage in recent years because they've had a free ride. Liberals thought that civil rights, solving growing national problems (and paying for them), a fair and progressive income tax, and so on were so obviously logical and morally imperative that they totally ignored decades of absurd conservative sound-bite propaganda. They didn't realize that repetition, without refutation, can be extremely persuasive.

Right wing conservatives—working behind the scenes, with massive financial support and few concerns about scruples—became the undisputed leaders in the science and practice of attack politics.

But we're belatedly learning about their tactics, and the public will eventually catch on to what they are doing. It will be hard to make up for our recent failures to appreciate the destructive nature of right-wing propaganda, but, with a little understanding, we can effectively, and *honestly*, confront it.

Part One

The Easy and the Obvious

Famous Limbaugh Sound Bites

We'll begin our exploration of the Limbaugh Con and right-wing demagoguery by analyzing some of their more obvious assaults on common sense.

It'll be easy.

1.

Symbolism over substance: if you live by the sword, you die by the sword

Ever wonder why so many people could fall for Jim and Tammy Bakker's endless appeals for money? Or how Jim Jones and David Koresh were able to lead their followers to their deaths?

Or why Rush Limbaugh can say the most absurd and destructive things over the radio, and millions of people say "right on"?

What all these demagogues have in common, and a major reason they are so effective, is that they "inoculate" themselves from criticism. It is the fundamental defense weapon of most con artists. By accusing others of what they themselves are doing, they beat others to the punch and pre-empt future attempts to expose them.

To illustrate, consider the religious demagogue first. His strategy is a classic, and one that most people can readily identify. The New Testament book of I John (4:1) has this to say about false prophets:

> Dear friends, do not believe every spirit, but test the spirits to see whether they are from God, because many false prophets have gone out into the world.

If you've been watching late-night television, you've noticed that one of the first things a false prophet will do is *quote I John (4:1) to*

his audience. In effect, the preacher has inoculated himself against being called a false prophet. He has short-circuited the listener's thinking by implanting a syllogistic fallacy into his system of logic:

- I have warned you to be on guard against false prophets.
- I wouldn't warn you against false prophets if I were one of them. Therefore,
- I am a true prophet of the Lord.

The audience is duly impressed, and another Jim Jones, or David Koresh, or Jim Bakker is on his way to success. Thereafter, everything he says makes sense to those who now consider themselves to be among the true believers. They are members of a sophisticated group, and properly on guard against the false prophets *out there*, who would try to discredit their leader. In the political world, Limbaugh is the consummate master of inoculation. He warns his listeners to be on guard against what he claims is a *liberal* strategy or tactic—and then, with brazen abandon, he goes on to do exactly what he warned against.

It is as though there is a rule somewhere that says: If I call you a demagogue first, then I can act like a demagogue and you can't call me one. So, by calling liberals "demagogues," he makes himself immune to the charges of demagoguery, just as David Koresh became immune to being called a false prophet.

Limbaugh's charge of "symbolism over substance" is a textbook example of inoculation, and is an important key to his success. Once his followers accept his oft-repeated premise that liberals are the ones who place symbolism over substance—essentially, a tactic of demagogues—Limbaugh, by inference, doesn't.

As a result, Limbaugh can safely degrade our president's efforts to reduce the deficit, to improve medical services, to establish a more just tax system, and so on, as only so much symbolism. It matters little that Clinton battled special interest groups and both liberals and conservatives in Congress to get cuts in the deficit.

When the cuts are not as significant as desired, Clinton gets the blame, and his efforts, according to Limbaugh, "had no substance." And dittoheads everywhere mindlessly chant the phrase, "symbolism

over substance," whatever the issue: health care reform, the Brady Bill, welfare reform, you name it.

At another time, Limbaugh feigned sympathy for the president when the press criticized him for his $200 haircut. After all, according to Limbaugh, someone in the president's position should be able to get a free, donated $200 haircut. Still, since Clinton tries to identify himself with the average American, and since he decided to place symbolism over substance in his administration, he deserved the derision he was getting. And, Limbaugh righteously intoned, "You live by the sword, you die by the sword"—a bit of conservative wisdom which seemed to be still more proof of the validity of Limbaugh's charge.

Limbaugh can take a single issue like this and spread it throughout a three-hour broadcast. During the entire time, he wallows in his own brand of symbolism, and his logic has substance only for those who confuse rabid partisan politics with thinking. He latches onto a subject like symbolism over substance, and endlessly repeats his charges, with no respect for accuracy, fairness, or completeness.

He giggles, rants and raves, shuffles his papers with melodramatic effect, and exudes adolescent humor. And out there is his audience, laughing uproariously along with the adult equivalent of a schoolyard bully. They enjoy his derisions of anyone who would disagree with his brand of super patriotism (although he never served in the armed forces), fundamental religion (he's been divorced twice), or capitalism based on greed (he always says "fairness" with a sneer).

To the demagogue and his fans, the substance of our country's problems is irrelevant. What counts is the further advancement of a class of American royalty that doesn't want to lose the unfair advantages they traditionally have always had. Limbaugh carefully screens his calls so the royalty can control the radio discussion. When you listen to his callers, you can hear at least six distinct types:

1. Those on the make, the predators of society who want the freedom to take immoral advantage of the system that continues to favor them. They want to become wealthy in a hurry, regardless of the effect on other individuals, on society, or on the environment. Hey, what counts is *me* and *now*.

2. White men and women who have benefited from hundreds of years of black slavery and oppressive discrimination against minorities of all kinds. They have always resented having lost some of their advantages, and they want to regain them for themselves and their children. They never *really* bought into civil rights.

3. Men who resent female intrusions on their traditional dominance in the home and in social situations, their significant advantages in business and industry, and their control of political organizations.

4. Wives whose husbands have it made, and who don't want their husbands to lose the financial advantages they have over the career women who compete with them.

5. Formerly disadvantaged blacks and whites who have become successful and now wish to take all the credit personally. They give no credit to the liberals of all colors who created the conditions that were necessary for them to be able to improve their lives.

 Now that *they* have it made, they want to be accepted into full membership with the powerful. They want to keep the privileges and unfair advantages the status quo gives to those who have established themselves in the power structure.

Then there is the sixth category of Limbaugh supporters, which, unfortunately, appears to be growing:

6. The majority of Limbaugh's listeners are those who are the usual victims of demagogues: people who have been conned into believing that he represents their best interests. Their *legitimate* frustrations with government and worsening social conditions have made them vulnerable to anyone with quick and, supposedly, painless solutions (lower taxes, end welfare, abandon all attempts that cost money to solve our problems).

 They choose to remain blind to the fact that Limbaugh's loyalty is to the wealthiest members of society, and that he has little concern for the futures of those who work hardest for a living.

Those in the sixth category of dittoheads should realize they are playing a dangerous game. In the process of venting their frustrations, they are aligning themselves with the Rush Limbaughs of the world, along with their standards of behavior and their political strategy. Limbaugh conservatives have galvanized their reliable supporters in the first five categories into a potent political movement. Anybody they can recruit from the sixth category is a bonus. Their intent is not to inform or to solve problems; it is to use any means available to distract and disorganize their opponents, and to gain power.

An axiom among public relations professionals is that it is easier to change the meanings of symbols than the reality the symbols represent. That's exactly what Limbaugh and America's right wing have done on issue after issue. To them, all that counts is their own material welfare. The substance of what is actually going on in our society is irrelevant.

To appeal to his fans in the six categories above, Limbaugh conducts mass inoculation exercises in order to help them justify their behaviors, to harden their consciences, and to make themselves immune to criticism. To do this, he has perverted the traditional meanings of the symbols, both positive and negative, that Americans have always recognized:

- The "free market" now symbolizes, not a fair market, but a market with no governmental protections from the most powerful, the wealthiest, and most ruthless members of society.
- "Greed," traditionally considered a vice in every major religion, is now to be considered a symbol of capitalist virtue, possibly an essential ingredient for its success.
- "Fairness," traditionally one of the tests for judging the morality of one's actions, and a goal of civilized societies, now becomes a vice of liberals.
- "Discrimination" has again gained respectability by those who have discovered a symbol to replace it: "reverse discrimination." It is a classic example of changing the symbols instead of dealing with the reality the symbols represent: the victims, who don't enjoy even half of the advantages that are

inherent in being white and male are now made the villains—
and the villains, the victims.

The symbols on the above list are only a few of many examples.
These and many more right-wing distortions of reality, through the use
of symbols, will be analyzed in the chapters to follow.

Lee Atwater's Final Warning

We should have learned more than we did from Lee Atwater. He
was chairman of the Republican National Committee before he died
on March 29, 1991, so he certainly was an expert on the political
communications of the Republican party at that time.

A deadly brain tumor changed Atwater from one of the most
accomplished political hatchet men in the U.S. to a person who saw
the need for our country to put truth and decency back into politics.
Besides apologizing to many of the Democratic opponents he had
unethically trashed, he announced in *Life*:

> The '80s were about acquiring—acquiring wealth, power,
> prestige. I know, I acquired more wealth, power and prestige
> than most. But you can acquire all you want and still feel empty.
> . . . It took a deadly illness to put me eye-to-eye with truth, but
> it is a truth that the country, caught up in ruthless ambitions
> and moral decay, can learn on my dime.[1]

An editorial in the *Charlotte Observer* pointed out that, following
his death, Atwater's former colleagues betrayed him in their eulogies.
Whereas he had condemned his own conduct, others "were quick to
commend Atwater for his public apologies [while] they ignored the
true intent of his actions. . . . His eulogists came not to praise Atwater,
but rather to rationalize and excuse their own conduct. They gave no
indication that they had heeded his message, no sign that they, too,
had learned that it is time to pull politics out of the gutter. . . . Atwater
deserved something better."[2]

If conservative reactions to Atwater's confession and repentance are
any indication, we can expect their communications to get even more

deceptive as they, like Limbaugh, hone their manipulative skills even more. They become further committed to victory at any price, and ethical communications are irrelevant. Symbolism without substance is everything, and they have demonstrated that it can be very effective.

The chapters to follow in Part One demonstrate how Limbaugh has been able to use symbolism and the strategies of attack politics, and yet inoculate himself against counterattack. He does masterfully what he accuses others of doing.

To the extent Limbaugh and his dittoheads of the future are successful, attack politics will become our dominant mode of communication. Sound-bite propaganda and divisiveness will replace rational decision making, and our fragile democracy will cease to function in the ways that we have always valued.

2.

Environmentalist wackos *versus* capitalist businessmen who hire American workers

Environmentalists have to be among Limbaugh's favorite targets. He loves to hate "environmentalist wackos" (liberals) who are trying to push the U.S. into "socialism slash communism." The issue is tailor-made for Rush. It has everything a demagogue could want—powerful emotional symbolism and nonexistent logic.

He repeats the following argument *ad nauseam* along these lines:

1. Environmentalists are liberals who care more about spotted owls than human beings, workers' jobs, or the economy.
2. Liberals want big government to control business's use of the environment, no matter what the cost.
3. Big government equals socialism/communism.
4. Communist countries are almost totally dominated by their governments, and they created some of the worst environmental disasters (air, water, land quality) in the world.
5. The U.S., through capitalism and free markets, created some of the best environmental conditions in the world. This is especially noteworthy since we are also the most productive country in history.

6. Therefore, private businesses, whose profits provide jobs, should be left alone, without government interference in the ways they use the environment.

I'm sure Limbaugh would like to take credit for this hypocritical line of reasoning. However, it has been around for awhile. Consider a 1990 opinion piece by Paul Craig Roberts, a Limbaugh-type conservative who held the William E. Simon Chair of Political Economy at the Center for Strategic & International Studies in Washington. Referring to the breakdown of the Communist bloc, Roberts presented the classic moth-eaten argument that equates liberals' defense of the environment with communism:

> The extraordinary extent of . . . pollution in the Soviet Union certainly cannot be attributed to private property. So, whatever its consequences, the failure of Soviet communism must make critics of the U.S. more realistic in their assessments of our own society.[1]

There you have it, in a roundabout way. Liberals criticize our nation's environmental practices. Therefore, liberals want a system of socialism/communism, or, at the very least, they are against private property.

The number and the viciousness of right-wing attempts to associate our desire to preserve our *environment*, of all things, with socialism/communism is indeed sad. It demonstrates how little concern right-wing conservatives have for ethical communication based on accurate information and honest reporting.

Limbaugh's diatribes and Roberts' conclusions are so hypocritical I'm embarrassed for them. Persons in their positions have to know that pollution in the Soviet Union and the Communist bloc was caused by *those who were responsible for production.* In communist countries, they were members of the government, and there was *no other power* to regulate, monitor, or control their behaviors.

As with other *producers* throughout the world, they kept costs of waste disposal as low as possible, and output as high as possible. The

careers of individual governmental officials depended on how much and how cheaply they produced—not how well they protected the environment for generations to come.

In the U.S., *private industry is responsible for production*. We all know that without the controls of our democratic government, our pollution levels would be much higher today, possibly as high as found in the Communist bloc. Even *with* our governmental regulations, many private businessmen—despite knowing better—continue to violate the environment.

This isn't an argument against capitalism, private property or a free market. It's just that that's not enough. Not all men are saints, and too many of them would sell the souls of their mothers to the devil, let alone pollute a river, to make an extra million.

Limbaugh, Roberts and others who have written and spoken such nonsense know full well that conservatives have fought every piece of environmental legislation that has been proposed since we began to sense that our planet was in trouble. From pesticide control to toxic waste disposal, conservatives have tried to prevent, or to water down, every attempt to make our world a safer place for our descendants.

Yet, with full knowledge of their roles in sabotaging our efforts to save the environment, conservatives still claim credit for the fact that the environment in the U.S. is one of the best in the world. They even suggest that the environment would be even better than it is, if it were not for liberals.

Ronald Reagan's political appointments are classic examples of environmental sabotage. He is a case study of how conservatives react to democratic efforts to protect and preserve the environment. Reagan disagreed with the concept that the government should be a responsible steward of the environment. So, naturally, he put people in charge of government agencies who also were contemptuous of environmentalism. Reagan's cynical appointments speak for themselves:

To oversee the Forest Service—John Crowell, vice-president and general counsel for Louisiana Pacific Corp., one of the largest purchasers of timber from national forest lands. Crowell

told a reporter in 1982 that he believed the Sierra Club and the Audubon Society were "infiltrated by people who have very strong ideas about socialism and even communism."

Director of the Bureau of Land Management—Robert Burford, a lifelong rancher who held grazing permits for 33,000 acres of federal lands in Colorado. He had been involved in several previous confrontations with the Bureau over unauthorized grazing and deteriorated rangeland.

Secretary of Interior—James Watt, who had a reputation for opposing federal intervention in natural-resource policy. He tried to open wilderness areas to mining and oil and gas leasing, advocated a halt to the purchase of national park land, among a whole host of other projects that were in direct contradiction to long range public interests.

Administrator of the Environmental Protection Agency— Anne Burford. She immediately set about diminishing *her own* (the EPA's) budget for law-enforcement activities, and departed from the traditional role as defender of the public's environmental health.[2]

As a result of these appointments and other governmental inactions, we're now in serious trouble. Because of our delays in blending the interests of the environment with the needs of business—and all that goes with those factors (jobs, cost of raw materials, and so on)— we are faced with intolerable solutions that no one wants to implement. When the government now tries to reach a satisfactory solution, say, in forest management, both the timber industry and the environmentalists refuse to cooperate.

And the demagoguery goes on. The daily news reports continue to describe environmental disasters—in rivers, the ocean, the atmosphere, and specific communities across the nation. Yet the Limbaughs of the world still advocate governmental *laissez-faire* neglect and label any effort to prevent problems—in order to avoid far more expensive problems in the future—as socialism/communism.

According to the Limbaugh conservatives, if we simply allow business to go its own way without restrictions, the economy will get bet-

ter, we'll save on taxes, inflation will remain low, and non-existent environmental problems will fade from public attention.

If you believe any of that, just take a hike on a trail in one of our many national parks that are in trouble, or paddle a canoe down one of your local rivers. See for yourself.

3.

Name just one country that ever taxed its way into prosperity

Taxation just about does Rush in. Nothing excites him as much. He shuffles his papers, sputters, shouts, and whines more about the rich having to pay taxes than just about any other subject.

One of his frequently repeated challenges is some version of: "Name just one country that ever taxed its way into prosperity," or ". . . one country that taxed its way out of a recession." Uh, Rush, if you're talking about tax rates for the wealthy, how about, ah, would you consider, the United States?

If a picture is worth a thousand words, the graph on the next page[1] is worth a book. Supposedly, the graph merely indicates the highest tax rates for America's richest citizens since 1913. But it also displays most of America's twentieth century. It not only charts our theories of taxation, it also clearly describes our economic successes and failures.

There seems to be a repeating cycle here. Notice all the periods in the chart in which low taxes are followed by high taxes, and then followed by low taxes.

- In pre-World War I the tax on the wealthy was low: 6 percent.
- When war became a dominant factor, the government raised

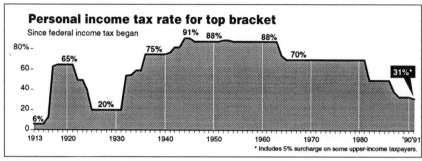

REPRINTED BY PERMISSION: KNIGHT-RIDDER TRIBUNE GRAPHICS

the top rate to 65 percent, in order to meet the new demands on the economy. As a result, many more jobs were created, employment was high, and there was increased demand for products of all kinds.

- In the post-war period, affluent conservatives were able to convince the public that the wealthy should now pay fewer taxes (20 percent)—in order to stimulate the economy, of course.

- This led to the boom and bust of the '20s, which was great for many of the wealthy and the powerful, but a disaster for the average working-class American.

That same cycle continues through the rest of the chart. You can't miss the most prosperous years for the American worker, as well as society as a whole—the late '30s to the '80s. *The top tax rate bracket for our richest citizens ranged from 70 to 91 percent for the entire forty-five-year period.*

During those forty-five years of taxing the rich, we came out of a serious depression, financed an unthinkable number of wars around the world, had more low- and middle-class people go to college than ever before, and sent astronauts to the moon and back. In *each* ten-year period, science discovered, and industry produced, more kinds of new products than in the entire history of the world that preceded the period.

More low- and middle-class people became wealthy, by world standards, than in any society, anywhere, ever. These also were the years

when working conditions improved for every segment of our population.

Despite opposition from wealthy conservatives, we got the eight-hour workday, unemployment insurance, sick pay, reasonable safety standards, and a whole host of advancements that we now consider normal for a civilized society.

You also can't miss the periods that led to extreme wealth along side extreme poverty, the '20s and the '80s, when the top income tax rates ranged from 20 to 31 percent. The rich got richer and the bottom half of the country got poorer—faster. These were also times of increasing unemployment, wanton land and property grabs, and excessive speculation for purely materialistic reasons.

In both periods, the number of millionaires *tripled*. The predominant force driving many of our wealthiest citizens was blatant greed. They abandoned genuine capitalistic risk-taking and chose the faster routes to riches—outright gambling with other people's money and legalized fraud. Wall Street became more of a casino than a center for capital development. Market manipulation for profit replaced legitimate stock trading.

Untaxed profits went into inordinate self-indulgence instead of investment. Huge amounts of money went into yachts, country clubs, resorts, luxury cars, vacation mansions, guarded communities, and world travel—instead of into the production of more wealth for more people: research, new plants, workers, and equipment.

These factors, along with the rich buying up everything of value (land, property, art, coins, precious metals, scarce resources, and so on), were the major sources of the income disparity that ruins the lives of workers.

Incidentally, inflation doesn't hurt the economy and the middle class nearly as much as conservatives claim. *After-tax income disparity between the wealthy and the middle class is what hurts.*

There is absolutely no virtue in a low inflation rate if increases in workers' after-tax income don't keep up with it, or if they lose their jobs, as happened in the early '30s and the '80s.

In both the '20s and the '80s, unfair trade and labor practices brought unprecedented prosperity for the affluent, and reduced the

quality of life for those low on the income scale. Workers in manufacturing jobs were especially hard hit. If they went on strike for higher wages, they were replaced and never rehired. Even the *possibility* of workers getting a decent wage encouraged some companies to abandon them and their communities, and to move where workers had even lower standards of living.

All of which was okay—until the workers, the ones who actually produced the goods and services that everyone was consuming, ran out of jobs and money. That is what happened in the '20s, and that is what started in the Reagan '80s and is continuing today.

THE LIMBAUGH SPIN

The Economic Policy Institute has reported that "Tax changes since 1980 increased the real income of the richest 1 percent by 73.9 percent, while the bottom fifth suffered a 4.4 percent decline."[2] So, how can Limbaugh say that more of the same will help the economy, especially for middle- and low-income Americans?

Easy. He distorts reality with abandon. On June 29, 1993, Limbaugh played excerpts from an address that President John F. Kennedy made in 1962. At that time, Kennedy said that reducing taxes would stimulate investment and help the economy. With great fanfare, Limbaugh stated that this was a tape that "liberals don't want you to hear. They will *cringe* when they know you are hearing this."

It was classic Limbaugh. What he *didn't* say was far more important than what he did say: the tax rate for America's richest citizens was a whopping *88 percent in 1962*—a far cry from the low rates, in the low 30 percent range, that existed in 1993. Lowering taxes from 88 percent to 70 percent in 1963 wasn't even remotely similar to lowering taxes from 70 percent to 31 percent in 1982.

The next day, on June 30, for one brief moment, Limbaugh told the truth. I suspect that someone informed him that too many people recognized his obvious distortion. He had to get it into the record that he had acknowledged what many people already knew.

So, on the 30th, he said the top tax rate in 1962 was 91 percent

(the Knight-Ridder news graph above says it was 88 percent, but the difference is insignificant for our discussion.) To save face, he then claimed that actual tax rates are less important than the *direction* of the proposed tax change.

Over the next several months, Limbaugh repeated his reference to the Kennedy speech, still saying that Kennedy would support lower taxes on the rich. He even called Kennedy a "dittohead" on the subject of taxing the rich. But, to my knowledge, except for that one occasion, he never again referred to the high tax rates at the time of the Kennedy address.

No matter what the facts are, Limbaugh will figure out a way to attack. He knows that the First Amendment protects demagogues in the United States and he doesn't have to be objective or fair. He also knows that his loyal listeners will overlook obvious assaults on common sense, and will support even his most absurd conclusions.

Cutting taxes on the wealthy, and taxing middle- and low-income citizens at a level that puts many of them around or under the poverty line, makes sense to Limbaugh and his right wing supporters. And truth has nothing to do with anything.

4.

Government regulations equal communism, or, at least, socialism

Hate big government? Sure you do. It's as American as apple pie. That's why you're a potential sucker for Limbaugh's distorted views of what government is all about. He drags big government and its regulations into almost every program. By doing so, Rush can push virtually all the emotional buttons of frustrated, stressed-out, red-blooded Americans.

With consummate melodrama, Rush offers this line of gobbledygook to those who are tired of serious analysis of our country's problems:

1. Liberals want to destroy capitalism and to get power for themselves through big government regulation of business.
2. Governmental regulation, in turn, equals socialism/communism—and that's the liberals' ultimate goal.
3. Only conservatives such as Limbaugh truly support the American ideals of open competition, free markets, and private enterprise.

Contrary to Limbaugh's harangues, liberals believe that democratic capitalism is the best political/economic system ever developed, and a

mental Control" of dictatorship, such as the Soviet Union's communism, or Nazi Germany's fascism. Although they are supposedly different systems, they're quite similar. Their leaders created anarchy by breaking down the controls of the previous government. Then they clamped down on all the basic freedoms, such as speech, dissent, and an effective press.

In both systems, fascist and communist, the governments not only manipulated their financial markets, they *were* the markets.

Markets existed for the benefit of the state and its rulers, and freedom was considered an evil.

So, anarchy never lasts, just as power vacuums never last. Without controls, whoever grabs the most power always prevails. Therefore, the only issues in any society, or market, are:

- Who's doing the controlling?
- How did they get their control, and how are they using it?
- For whose benefit are they controlling?

In a democracy, elected officials do the controlling for the purpose of maximizing genuine freedom for its citizens and businesses. The checks and balances of separated powers ensure that all issues and interests are represented. When done ethically, its solutions to problems are designed to benefit the total society.

Democratic government also tries to prevent special interest groups from subverting the system with their own controls. If officials don't do their jobs, then society—and its markets—become dominated by the most powerful and immoral forces within it.

Plutocratic Capitalism

Contrary to what Limbaugh and the far right want you to believe, the biggest threats to the middle class in the United States are *not* socialists or communists. They are *plutocratic capitalists*.

Plutocratic capitalism, as found in many Latin American countries, is a brand of "dictatorial capitalism." It is an alliance among powerful politicians, businessmen, land owners, and the wealthy, and sometimes includes the military and the local police.

43

Plutocratic capitalists can control society and the markets almost as much as they do in communist or fascist countries, especially when it comes to the wages and living conditions of middle- and low-income workers. While there are virtually no limits on the incomes and materialism of the powerful elite—*which always increase over time*—workers find that their ability to earn a decent living constantly gets worse.

In the United States, the only free market predators who stand a chance of being successful are the wealthy and the politically sophisticated. They have the necessary finances to dominate the propaganda networks, they know how play on the prejudices of the public, and they have no moral reluctance to do so.

Their goal is to achieve a rather benign plutocratic capitalism: control of the markets and government by the established wealthy and the politically powerful. They are exceptionally effective in appealing to our democratic sentimentalities, and in using the symbols that appeal to large masses of people.

ATTACKS ON AMERICAN CAPITALISM

Because of our traditions and our ideals, socialists and communists don't have a chance. Attacks on our system will therefore come from those who want to change, unofficially, to a plutocratic capitalism. The Limbaughs in our society have the necessary time, contacts, and sophistication to study our political system for the purpose of manipulating it. They know they can acquire more power and wealth by taking advantage of the system than they can by producing useful products or services.

A first step for those who wish to control a free society like ours is to attack the democratic process itself. The most common approach today is to portray the process of legitimate governmental control as "communism," by using a perverted dichotomy.

If well-financed special interest groups can convince enough people that freedom equals *no government control*, and, in turn, make government ineffective, they can then enter the power vacuum and gain control for themselves. Recently, they have been fairly successful at

THE LIMBAUGH DICHOTOMY

Freedom	Control
Capitalism	Communism
No Governmental Control of Business, Market Forces, or Social Issues	Any Governmental Control Of Business, Markets, and Social Issues

this. They are gaining wide acceptance of their claim that business and industrial associations can regulate their own members better than government bureaucrats can.

Of course, their reasoning *could* be right, but, sadly, it isn't. Organized special interest groups can prevent government intervention in one of two ways:

1. They can set standards, and monitor and police their own members—and actually punish violators, or
2. Lobby Congress to keep regulations to a minimum, so that their members can get away with whatever they want.

They *always* pick #2. Whenever they claim to have done #1, it is always a sham operation, actually designed to *prevent* serious monitoring of their members' behaviors.

How do you recognize these special interest groups and their spokespersons? Just listen to the words and phrases they endlessly repeat: "communism," "socialism," "politics of envy," "social engineering," "class warfare," "big government," and all the other emotionally charged symbols that frighten the public and distract people from the real issues. The last thing they want is for cool heads to prevail, and to discuss issues on their merits.

They also blame the news media whenever they are caught violat-

ing common standards of morality. Or they say they were forced into bad business practices *because* of government regulations.

Charles Keating, the mastermind of our biggest S&L fiasco, represents the worst of America's values, and is a perfect example of the spokesmen for today's special interest groups.

"Frontline" presented a TV documentary on "Other People's Money" in May, 1990.[1] It showed Charles Keating speaking to a sympathetic, appreciative audience of like-minded people:

> The problem with the regulators is that there's an arrogance without accountability. It's unparalleled in our system. By leaks, distortions, and outright lies, they will try to force us to capitulate to avoid being painted as a scoundrel or worse. But I will not, I simply cannot play the game.

After his speech, Keating received a *standing ovation* from the audience, which numbered in the hundreds. Later, Keating invoked the Fifth Amendment before the House banking committee, and declined to talk to "Frontline" reporters.

The Keatings of the world are the direct causes of the very things they criticize. The well-known inefficiencies of government don't *cause* the problems of the citizens of the U.S. The immorality of citizens causes, *and makes absolutely necessary*, the costs of government.

The Wall Street Journal: *Defender of Predators*

Some may argue that we should not have government programs or regulations, no matter what the problem, because dishonest people learn how to use them to their own advantage. Sad to say, that's partially true.

However, it is also true that those same dishonest people take even greater advantage of the *lack* of regulations. At least, with regulations, you have some basis to charge them with a crime.

What's the *Wall Street Journal's* reaction when its own class of predators take advantage of the government? It's unbelievable.

When the HUD scandals were in full bloom, and it became evident that Republican insiders were using the agency as a political cash cow,

the *Journal* was not offended by the dishonesty of some of its Republican stars. Instead, it vented its anger on the government's original intent to provide low-cost housing for low income citizens:

> The only sure way to put a stop to this sort of thing is to abolish federal subsidy programs. . . . Where better to start than HUD, with the worst record of any federal agency in furthering its putative goals.[2]

Can the *Journal* possibly understand the implications of its thoughtless statement? If we can't trust highly placed American businessmen and politicians to do the right thing in government, how can we possibly trust them in an unregulated market?

And the fact that Republican politicians financially raped a program and contributed to its failures—possibly even *causing* it to fail— does that prove that the program should never have been attempted?

THE BUSINESS OF GOVERNMENT

Government's job is to make sure that its citizens can become wealthy by *implementing* our capitalistic system, not by abusing it. This means that government must address the issues and problems no one wants to deal with, or that some people, for personal advantage, want ignored. The list of such problems is growing, and the longer we wait, the more expensive their solutions will be.

There is a bottom-line basis for judging which politicians wish to strengthen democratic capitalism, and which ones wish to protect their own class of predators: who benefits from their policies? *Everyone*, including low- and middle-income people? Or just the wealthy and the educated elite, at the expense of the low- and middle-income citizens?

Look at the statistics of the '80s. (If you haven't been reading a good local newspaper, or national news magazine, you'll find the statistics in other chapters throughout this book.) Then look at which politicians made them happen. You will have your answer.

5.

Straight-shooter Limbaugh *versus* the biased liberal news media

In terms of honesty, if you rank professionals in the news media lower than used car salesmen, lawyers, and Rush Limbaugh, you probably have a lot of company—and you're a victim of one of the slickest scams of modern conservatism.

Think about it. United States citizens probably get more information, in greater detail, on more subjects, from every point of view, than anyone else in the world. And it is because of our effective news media. That normally would be bad news for conservatives; however, they're doing a great job of damage control. Since they can't stop news reporters from describing what's happening in our country, they are doing the next best thing: they try to discredit journalists at every opportunity.

Naturally, Limbaugh leads the way. According to him:

- We really don't have a homeless problem or a health care crisis,
- The environment isn't really in trouble,
- The economy of the '80s actually was as good for low- and middle-income Americans as it was for the wealthy, and
- If you think otherwise, it's because the biased, liberal news media have lied to you. Only Limbaugh gives you the straight scoop.

These are just a few of the issues that conservatives are trying to distort. Whenever they are confronted with unfavorable news of *any* kind, they defuse it by blaming it on the "biased liberal news media." Conservatives have repeated the charge so often and so loudly that many people are now influenced more by conservative propaganda than by verifiable facts they read in the newspapers or see on television.

Bashing the media has become such an effective tactic that it is now the scoundrel's first line of defense. Whenever a business, religious, academic, or political leader is confronted with a scandal, or even bad news about his organization's poor results, his first reaction is to blame the media.

"Liberal" Is Not the Same as "Biased Liberal"

Limbaugh points out that most journalists are registered Democrats, which, he says, proves they are liberally biased. Inadvertently, he has betrayed the conservatives' Achilles heel.

Those who report the news—those who are where the action is, who see first hand what is going on in our country, who hear what people say *and* observe what they actually do—those people are predominantly liberals.

That is *not* the same thing as *biased* liberals. Of course, one can be a liberal and, as a result, bias a news report. That certainly can happen.

However, for the majority of professional journalists, the sequence is entirely different: the reporter sees what is happening in our country, reports news events objectively, and, in the process, becomes a liberal.

How could it be otherwise? The reporter sees and smells the polluted river, talks to a university scientist about it, and then hears the executive of the chemical company say that there is no problem. The reporter sees workers who have been injured on the job, talks to other workers about the lack of safety standards, and hears managers say they are running a safe operation. The reporter reads the new tax law that favors the wealthy and penalizes the middle class, and hears the conservative politician claim that the law will benefit the middle class.

The fact that most journalists are Democrats *has* to tell you something: most Democrats are trying to solve our country's problems.

49

Republicans and conservative Democrats (who should probably be labeled as Republicans) like things just the way they are, and are dedicated to gridlock.

(Of course, some journalists are conservatives. To understand how they can see what is going on in our society and still be conservatives, read Chapter 14. It explains how the modern conservative philosophy of survivalism enables them to deny any evidence that threatens their immediate self-interests.)

Journalistic Standards versus Advocacy Standards

Without a doubt, professional journalists have the highest ethical standards for objectivity and balance in reporting news events. Their standards demand that the news story be complete enough to be properly understood, important qualifications must be included, and facts must be verifiable. Otherwise, a journalist would be judged harshly by his boss, his peers and by his professional associations.

In contrast, advocates such as Limbaugh are committed to specific causes and feel they have the right, *even the obligation*, to be biased. Anyone who listens to Limbaugh's program realizes that he distorts news items with abandon. He thinks nothing of telling only half of the news and leaving out crucial qualifying information. If a dittohead calls into the program with an outlandish statement, verifiability isn't an issue; Limbaugh will treat it as fact.

The *Wall Street Journal* once had a story about Hillary Clinton's articles in law journals. It quoted some people who said that Hillary had written that children should be able to sue their parents if they made them take out the garbage. The story also quoted others who said that such criticisms against Hillary were absurd. Of course, Limbaugh quoted the criticisms, but not the statements that correctly interpreted Hillary's opinions.

After "Nightline" and other news programs broadcast the truth, and demonstrated the excellence of what Hillary had written, Limbaugh admitted that some were saying that the criticisms of Hillary were unwarranted. But, still, he intoned with ominous gravity, "no one can deny it. She has left a paper trail [which is true; she wrote some excellent articles], and I prefer to believe the paper trail."

50

Limbaugh gets all kinds of help from his callers in distorting the news. When a caller presents false information that conservatives love to hear, Limbaugh claims he doesn't know if it is true, but then talks and acts if it were true for the next ten minutes. One caller said that when Clinton was videotaped on the South Korean border, he tried to look into North Korea with binoculars, with the lens covers on. Supposedly, Clinton talked to others while he acted as if he could see through the binoculars. Limbaugh treated this as fact, and ridiculed the president for hypocrisy, and "symbolism over substance."

About an hour later Limbaugh said he was told that the story was essentially false. The president had been handed the binoculars, didn't notice the lens covers were on, tried to use them, noticed the lens covers and immediately removed them. Of course, Limbaugh's thirty-second retraction didn't come close to making up for the previous hour of his ridicule of Clinton.

The point of all this is: those in the news media have stringent professional ethical standards by which their communication performance is judged. Surely, some journalists don't meet those standards very well. However, professional advocates have no such standards. Indeed, advocates who have the Limbaugh mentality have *unethical* standards, and they seem to meet them every time.

The Wall Street Journal: *A Schizophrenic Example*

The *Wall Street Journal* has some of the best journalists in the country, both in quality and in terms of meeting high ethical standards. I have no idea what the liberal/conservative balance is among its reporters, but many *write* like they are liberals. If they are modern conservatives, at least their personal professional standards force them to be truthful.

Some of the best coverage of conservative excesses and misdeeds of the '80s is to be found in the *Journal*. Reporters have documented the incredible greed of executives at the tops of corporations, the debilitating maneuvers of egomaniacs who try to take over each others' companies, the disastrous effects of leveraged buyouts, the dishonesty and fraud in the investment industry, the efforts of doctors to fix prices on medical fees, the actual effects of proposed tax law on different income

levels, and on and on. I must confess: some of the best factual material used in this book to support liberal viewpoints came from *Journal* news stories.

The editorial pages, however, seem to come from outer space somewhere. No matter what the issue, if the wealthy will have to pay more taxes, or business might not make as much excessive profit, the *Journal* editors will be against it. Regulations of child labor, truth in packaging, worker safety, national programs for infant immunization, crime prevention via social action, environmental protection, improved securities laws, and so on—the *Journal* will fight them all, using the absurd logic of the demagogue.

If Jesus Christ were to come to earth again and tell us that he had a plan whereby the richest 10 percent of Americans would pay 20 percent more in taxes, and poverty and crime would be totally eliminated, the *Journal* reporters would accurately and fairly describe the plan. The editors, on the other hand, would hire a professor from the Harvard Business School to write an op-ed piece—and give ten reasons why Christ's plan would be bad for the middle-income taxpayer (the majority of voters).

The *Journal*'s schizophrenia just about sums up how professional journalists, compared to newspaper editors, react to issues. Most reporters, liberal or conservative, do a good job of adhering to high ethical standards of communication. Advocates of causes, liberal or conservative, do not. However, only *conservative* advocates try to discredit professional journalists and the news media. If you ever wondered why, now you know.

Full, accurate information, and an educated public, are bad for Limbaugh and his right-wing conservatives. And they will do everything they can to discredit the news media.

6.

Wealth trickles down

Limbaugh *tries* not to say the specific words, "wealth trickles down," but years of habit make him forget. Once he said, "This proves that wealth trickles dow. . . ." Then he stopped himself and said, "Well, 'trickle-down economics' are the wrong words, but the idea they represent is sound." Obviously, the statement that wealth trickles down has become unpopular in its raw form. The '80s thoroughly discredited it, and Limbaugh has learned to quit saying it.

He now camouflages the identical idea by claiming that:

- The source of jobs in the United States is the money that rich people invest, and
- By spending their money, the rich spread the wealth around, creating a demand for products and services, thus creating still more jobs. Therefore
- If we tax rich people too much, they not only will have less money to spend for products and services, they also will lose their incentive to invest what little money they have left.

In other words, wealth trickles down. Nonsense. *Wealth is sucked up.* It always has been and it always will be. It is a painfully simple and obvious truth, and I apologize to those who already understand it.

Wealth Isn't Money

The fundamental flaw in conservative thinking is that money is wealth. It isn't. Money is an abstraction. It just *represents* wealth. In itself, it is just a piece of paper, or an entry in a bank ledger. Some people have a whole bunch of that paper; some don't have any to speak of.

Real wealth, on the other hand, consists of products and services. It's homes, land, buildings, manufacturing equipment, electric drills, toasters, candy, and so on. It is the time you spend to travel, take vacations, get a hairdo, get a massage, play golf or tennis. The producers of wealth are *people who physically handle those products and provide those services.*

When workers produce wealth and give it to those who have produced nothing, in exchange for paper, the exchange is economically unsound. Only one person in the exchange produced a product or service; the other is a freeloader, a pure consumer of what other people created. In effect, by taking a product off the market, the freeloader has *reduced* the amount of wealth that is available to others who work.

It gets worse. Some of our most avaricious consumers have money, and are able to exchange it for wealth, because of their own predatory or immoral activities. They are worse than freeloaders; they have gained money by injuring the system that creates products and services. (Examples are unlimited. Just think of some the people you've seen exposed on "60 Minutes," "20-20," "Primetime," and other documentaries. These immoral predators can include social stalwarts such as doctors, lawyers, investment bankers, businessmen, academicians, politicians, and on and on.) In typical financial dealings, including the investment process, all we ever know is that, somehow, people with bargaining power have accumulated the paper we call money.

The Limbaughs of the world try to convince people that money is wealth because they are so good at accumulating money, without contributing useful products or services in exchange. In mutual support groups of like-minded rich conservatives, they even talk *themselves* into believing that just having money, *no matter how they came by it,* and spending it, *no matter how or for what,* contributes to the total wealth in society.

A typical Limbaugh strategy is to convince dittoheads that the fabu-

lously rich should keep more of their money instead of paying taxes. Supposedly, this would benefit the economy, and still more people would become wealthy, or, at least, wealthier. He may be right about tax breaks helping the economy, but he wants to give them to the wrong people. He wants to give them to a few of the biggest *accumulators of money* instead of to the far more numerous *producers of wealth*.

Why Workers Should Get More Tax Breaks

Middle- and low-income workers should get more tax breaks than they've been getting lately for one simple reason: *money in the hands of workers, not the super rich, is necessary to stimulate investments in new jobs—and to create genuine wealth.*

If you give a rich person a $100,000 tax refund, he might invest it in, say, U.S. treasury bills. Or he may buy the house you're living in and raise the rent. Both of these are socially desirable options in the view of conservatives. (By the way, guess who will pay most of the interest on the $100,000 worth of treasury bonds he bought with his tax refund: the middle-income taxpayer.)

On the other hand, he may just go to Las Vegas and gamble it away. Easy come, easy go. Unfortunately, this is exactly what too many people are doing today. Not just going to Las Vegas, of course, but they're simply using money to consume wealth that other people produced.

To rich people, $100,000 is discretionary—that is, they can spend it any way they damn well please. They can invest it, they can sock it away, or they can hoard wealth (especially land and buildings) and drive up the prices of everything from private homes to automobiles.

However, if you give a $1,000 tax refund to each of a hundred workers, you know *for sure* that investors will stand in line trying to figure out how to get it. Investors know that, in workers' hands, the money *has* to be spent, and usually for necessities. Not only will the money be spent, but it will create investment in producing goods that are needed by large numbers of people. Even if a few spend the money foolishly, at least it will be widely dispersed, and not dropped at a single casino in one lump sum.

If you still aren't convinced, consider this. In the early Reagan years, between 1983 and 1986, U.S. sales of Jaguars went up 55 per-

cent, Mercedes 35 percent, Porches 40 percent, and BMWs 63 percent. Sales of U.S.-made cars went up only 21 percent.[1] Which creates more jobs for Americans: one rich guy buying one Mercedes—or ten middle-income workers, for the same total amount of money, buying ten Chevys?

The differences get much more striking if you compare the purchase of a $7 million yacht, a $10 million summer home in Palm Beach, etc.—with things like clothes, household items, better quality food, water skis, camping equipment, school books, hand tools, and so on.

Perspectives

Of course, this discussion does not deny the necessary role of capital investment in the production of wealth. Nor does it deny the just rewards that nonworking individuals receive when they invest their earned income in productive enterprises.

It's just that right-wing conservatives have totally distorted the trickle-down *versus* sucked-up equation. You can go into your workshop and produce a chair (wealth) all by yourself and for your own use. But *if no one works, there is no creation of wealth—for anyone.* Zip. Nada. Period. And if investors cannot find workers to produce and consumers to buy, they simply cannot create wealth, unless they go to work themselves.

If this issue is still unclear to you, consider this. If a counterfeiter prints $10 million in twenty-dollar bills, and spends it, or even invests it, did he create any wealth? For himself, the answer is yes; he now has more *things* than he did before.

For society, the answer is: of course not. The money he spent did not represent his own contribution to society, and now there are fewer things available to those people who have actually produced things. And in the case of invested couterfeit money, it was the *workers* who produced the wealth, not the paper that represented nothing.

Make no mistake about it, *money,* in itself, does not produce wealth. People, *working,* produce wealth. Money can trickle down, but wealth is always *sucked up.* And sometimes the bastards sucking it up don't care if they suck it dry.

7.

Wealth is not a zero-sum game

At a Fortune 500 company, a group of assembly line employees discussed the huge salaries that pro basketball players were making. One of them complained that these high salaries caused ticket prices to go up, and it already was tough enough for someone like himself to take his kids to a game.

Another employee gave the response that would warm the heart of every conservative in the U.S., "Hey, more power to 'em. I would do the same." He added, "It's no skin off my nose. I never go to the games anyway."

You've probably been in discussions like this yourself. There is at least one of these guys in every crowd—an unwitting dupe of the conservative propaganda mill. He inflates his own ego by substituting a phony financial machismo for brains. He also demonstrates the dangers of an economically illiterate public that confuses conservative sound-bite clichés for thinking.

Modern conservative commentators have been able to convince the public that the huge incomes of the wealthiest Americans are irrelevant to those who make moderate-to-low incomes. They even suggest that the more money the wealthiest Americans make, the more wealth will trickle down to the lower classes.

If you've swallowed this line of conservative garbage, get ready to vomit. In some of the most important aspects of our lives, wealth is a zero-sum game. The more others have, the less you have.

This means that there is only so much wealth in the world, and, in many cases, the more others have, the less you have. This line of reasoning gives Limbaugh apoplexy. He practically shouts on his program that wealth is *not* a zero-sum game. In fact, he says that the more the rich have, the more the poor will have, and only envious liberals claim otherwise.

Sure, money is unlimited and it can multiply like crazy. Just look at the 1,000 percent-plus inflation rates that Peru, Brazil, or any number of other countries have had over the years. Devalued money *does* trickle down. But there are only so many *things* in the world. *Things.* Like the land you are on, the home you live in, or even the air you breathe.

HOMES AND LAND

Property and land are the classic examples of the zero-sum nature of wealth. As the real estate agent says, "They ain't makin' no more land." Except for brief periods at the ends of speculative binges, the prices of land, homes and other kinds of property only go up.

You already know that one of the fastest ways to get richer is to have enough money to hoard land and property. What conservatives would like you *not* to know is that, unless you're careful, the hoarding of land and property by others can cause your own *poverty* just as quickly. You see, as the United States runs out of space, the rates of increase—in both wealth *and poverty*—will speed up, and you just might end up on the wrong end of that deal.

There are more homes in the U.S. today than ever before, and we're building more every year. Yet the *rate of home ownership is declining* among young adults. In 1980, 52 percent of Americans aged twenty-five to thirty-four owned their homes. In 1988, the rate was only 45 percent.[1] In 1990 only 20 percent of white renters and 4 percent of black renters had both the income and savings needed to buy a typical starter home with a 10 percent down payment.[2]

In 1989, 3.5 million poor renters spent at least half their income on housing, leaving very little for luxuries such as a car, recreation, a little time for leisure, providing decent lives for their children, and so on. And, because of the inflation in housing prices, more people are having to settle for inexpensive mobile homes. In 1990, the fastest growing sector of the housing market was the mobile home. According to the U.S. Department of Commerce, their number has increased nearly 60 percent in just ten years.

As inflation drives property values up, people who own their own homes can maintain, to some extent, their financial status. Workers who never had enough money, or education, to participate in the housing grab at all fall further into debt as they see their rents skyrocket. Speculators buy *many* homes and become wealthy, if they aren't wealthy already.

In a city of any size at all, if you look in the classified section of the local newspaper, you'll see ads like this one:

FOR SALE

47 rental houses, singly or as a total package. Excellent rental histories, great tax advantages. Retiring. Call: 555-3578.

This advertiser has not only reaped tremendous tax advantages (because of Republicans and conservative Democrats), *he also has taken forty-seven homes off the market*, and contributed to the rapidly increasing cost of homes. And you wonder why your children can't afford to buy a place to live.

Similar things are happening all over the United States. As rich people look for investments, they take properties off the market and out of the reach of those with lower incomes. And in some cases, they take property and homes from renters who don't want to move, and from people who own their homes and don't want to sell.

The residents of Daufuskie Island, off the South Carolina coast, have lost their homes to rich developers who brought in condos and golf courses for the rich. The original residents used to have a decent life, making a few thousand dollars a year, having a garden, and fishing along their own shores. Now, those who still own property can't

afford to pay the new, outrageously high tax rates caused by skyrocketing real estate prices. They're left with only two choices: bankruptcy, or sell to the developers for whatever they are willing to pay.

Similar situations are happening in all areas of the U.S. As the rich move into a desirable area, or an industry moves into any kind of area, those with less money cannot afford the increased costs of living that the rich or the industry bring with them. For example, many people who actually *work* in towns like Aspen and Jackson Hole find that they can no longer afford to live there. They must move further away into the outlying, least desirable low-rent areas.

Newsweek called the phenomenon "Aspenization":

> A town [Crested Butte, Colorado] with such attractions is a natural target for what people in Colorado call Aspenization: the upscale living death that fossilizes trendy communities from Long Island's Hamptons to California's Lake Tahoe. Aspen was a splendid place, too, before it was discovered by the rich and famous—and the greedy and entrepreneurial. Now it's a case study in over-development. Its lavish second homes sit empty for most of the year while three quarters of the work force, who can't afford to live there, commute from forty miles down-valley—a two-hour trek at rush hour.[3]

The laborers who once worked on the pineapple plantations in Hawaii, and lived near them, find they have been displaced by, again, condos and golf courses for the wealthy. A news release by the Associated Press noted that ". . . a parade of land speculators and developers over the past two decades has pushed the cost of land out of reach for many, especially for the native people."[4]

Aspenization isn't occurring just in resort areas. It is happening all across America. A brother of mine was once considering retiring in North Carolina. When we were driving through what would be considered a run-of-the-mill mountain area, we stopped for gas. My brother asked the station owner how he felt about retirees who had relocated to the area.

The owner replied that it would be okay if they just came in and

lived there, and didn't try to take things over. It seems that a high-level executive from Florida had purchased twenty acres of land on the local river, and put a tall chain-link fence around the whole place. Now, the kids from the town can't get to what used to be their favorite swimming hole.

If you ever thought that other people's wealth can't hurt you, you'd better think again. If you are a middle-income American, some high income Americans may have already taken your children's future homes away from them. If your children will want to live in decent homes, they'll either have to inherit them, or rent them at whatever prices rich owners can gouge out of them.

AIR

Although land and property are probably the greatest creators and destroyers of financial well-being, the environment is increasingly becoming an important concern for middle- and low-income Americans. We're entering a very dangerous period. Our natural resources are running out, everything from pure water to breathable air.

What's worse, everyone knows it, but conservatives don't want anything, of substance, to be done about it. They make too much money from the process of using up the earth. Also, what good is money if you can't spend it for what you want?

Paul Ehrlich, Stanford University professor of population studies, described what's happening:

> Every American—because of the amount of resources he or she consumes—does 20 to 100 times more damage to the planet than any one person in the Third World. If the American is rich, he or she causes 1,000 times more destruction.[5]

The air we breathe is a good example of the zero sum nature of *things*, simply because we never think of it that way. If *air* is a zero-sum thing, think of how many other things in our lives are zero-sum.

Air the world over is polluted. Major cities throughout the U.S. fre-

quently give out "health alerts." A health alert means you should stay in an air-conditioned building if you are young or old, or in poor health. The air is simply too bad to breathe.

Let's consider the obvious issues first. If you don't have much money, you're pretty much stuck wherever you are. If you live in a big city industrial neighborhood, that's where you spend practically all of your time, breathing whatever air is there, along with the pollutants of the day.

If you have money, at least you can take vacations to where the fresh air is: ski resorts, Caribbean islands, your condo in the mountains or on the beach, and so on. Some people are able to do this for several months a year, or even for their entire lives—while they are polluting the air for everyone else.

Before you read the following news item, think about your Ford Taurus family sedan that will carry up to six people. It has a V-6, 3-liter, 140-horsepower engine and easily gets 28 miles to the gallon on the highway.

Now think of a 3,432 horsepower *diesel* engine. Now, go totally out of your mind and think of *three* 3,432 hp diesel engines, and the amounts of pollution they cause.

> Some folks always seem to be in a hurry, even in their leisure time. They're buying yachts with neck-snapping acceleration and 60 mph-plus speeds. . . . John Staluppi, a 41-year-old multi-millionaire car dealer . . . wants speed on the water.
>
> He recently paid over $8 million for a 132-foot waterborne missile he calls *Octopussy. Octopussy* peaks at 61mph, powered by a trio of 3,432hp diesel engines. . . . Staluppi's yacht can make Bermuda in 15 hours from New York. . . .
>
> Three years ago, 25-knot-plus yachts made up just 10 percent to 15 percent of the world market for 100-foot-plus yachts; today these yachts make up over 40 percent of that market.[6]

The more air these leading public citizens burn up, the less is left for everyone else. In other words, any rich cretin in the U.S. who

wants speed can buy it with absolutely no regard to what he does to the rest of the world.

We all know that the internal combustion engine is the most important cause of air pollution. At last count, that I know of, the burning of fossil fuels releases 5.6 billion tons of CO_2 into the atmosphere annually.

This is where rich-conservative-*versus*-low-income worker comes in. Leading spokespersons for the fabulously rich are all for creating pollution, simply because they can afford to avoid it. They can always move to where the air is best. In her *Forbes* article, Gretchen Morgenson typifies the typical conservative's attitude about pollution:

> Take cars, for example. Instead of mandating that manufacturers install expensive pollution-control equipment on all cars, the costs of which would be paid by every car buyer nationwide, why not tax those drivers, old and new, whose cars exceed federally set emission limits? That way, one could still drive one's favorite polluter-on-wheels.[7]

Also in *Forbes*, Susan Lee echoed the same argument against government regulations and in favor of the rights of rich conservatives to pollute the environment:

> Trouble is, enviromaniacs aren't hot to have the market forces injected into the clean air debate; their concern is not with costs. No one argues that we shouldn't have cleaner air, better education and strong scientific research. The question . . . is, Should resources for these purposes be channeled through the markets for these purposes or through the government? When we choose the government we penalize economic growth.[8]

Of course, Morgenson and Lee are basically correct. By taxing or raising the costs of polluting, low- and middle-income *workers* will pollute less. They have to, because they have no choice.

But rich conservatives will continue living like amoebas, moving through their environment consuming everything in their paths—that

God or workers have produced—and leaving their wastes behind them for workers to clean up, as long as it's still possible.

In fairness to Morgensen and Lee, we need to consider a possibility. Their views are amazingly similar, and came just six months apart. One suspects there's an editor somewhere at *Forbes* who is in charge of propaganda.

The editor periodically hands out an assignment: "Remind our readers that, if government regulates the air and environment, rich conservatives will be inconvenienced, just like everybody else. Only low- and middle-income workers should cut back on their driving, recycle their trash, and so on. Rich conservatives have better things to do, and the money to do them."

No matter how hard conservatives try to delay the days of increased environmental regulation, tougher regulations are going to come. The expense and inconvenience of these future regulations will affect workers the most: much higher taxes on gas, and tough, expensive restrictions on *necessary* car use. Because conservatives want to squander our fresh air now, workers will pay much more dearly later.

Air is zero-sum; the more some people use up, the less is available for others to breathe.

WHEN PUSH COMES TO SHOVE

The above examples demonstrate the dangers of an economically misinformed public. Just what do you think people do with the huge incomes they make? They always end up buying *things*. And when they do, the prices of those same things go out of sight for you, and you can't buy as many things as you could before. That is exactly what happened all through the '80s to the lower half of Americans whose incomes didn't keep up with inflation.

An innocuous one-inch column in a local Arkansas newspaper reported that three pro baseball players had purchased 2,000 acres of land in the area as an investment. Multiply that by thousands of times and you'll see what I mean.

Consider this: in 1990, Orange County had the highest median

housing price of any U.S. urban area. *One person* controlled a sixth of all the land in the county, and *$3-4 billion* of properties.[9]

The homes we live in and the air we breathe are just a few examples of the fact that wealth is a zero-sum game. There are as many other examples as there are objects that have a price attached to them.

Even a ticket to a basketball tournament has become a scarce commodity for the average American. News item:

> Atlantic Coast Conference basketball is as exclusive as some country clubs. "If you came in today . . . and said, 'I'd like to get tournament tickets,' it would take approximately $45,000 (donation to the university) to do it," says Ken Brown, director of ticket operations for UNC-Chapel Hill.[10]

Middle-income workers in South Carolina who used to be able to hunt for food, now find that they are being forced out of lands where they've hunted for years. Private hunting clubs of the rich are buying hunting rights, for sport, from timber companies and large-acreage owners. Independent hunters say they can't compete with the private clubs that pay top prices for the best lands.[11]

Naturally, it was *Forbes* that asked the question: "Is it time to treat organs as private property that people can buy and sell?" In the article, "Should I be allowed to buy your kidney," Ronald Bailey concluded:

> It is time . . . to consider seriously proposals that will invest private property rights in cadaver donors' families and, in the case of bone marrow and perhaps livers and kidneys, in the donors themselves.[12]

Another mindless defense of the unlimited power of money by *Forbes*. In other words, those with the most money should be ones who can extend their avaricious lives. If you're a worker who just lost a job in the recession, forget it. The rich guy outbid you. You're dead.

How much money other people make is of profound interest to you. Relatively speaking, it's as important as your own income. If middle-income workers don't adopt the same greedy philosophies of the

high-income predators of the '80s, and don't have enough money to protect themselves, they could lose their present standard of living. If they aren't able to become rich in some non-working fashion, and do whatever that requires, the predators will make them poor. ("Work" and "non-work" will be described in detail in Chapters 12 and 13.)

You can't stay the same. Today, you win if you play the predatory game of the '80s. You lose if you play the working game. At least, that's the way Limbaugh and some of our political and economic leaders want it.

Problem is, as more people choose to join the predator game, and our nation produces fewer goods and services (actual wealth), *everybody loses.*

8.

Tax coal miners at 100 percent; wealthy investors, sitting on their assets, 50 percent

If you've been listening to Limbaugh, you probably feel sorry for rich investors. According to him, taxing capital gains is a way socialist liberals try to redistribute the wealth. They use the tax system to take money from those who have worked hard for their investments, and give it to those whose incomes are low and who are envious of success.

In other words, Limbaugh feels that if a rich guy "works" at buying a building for a million, holds it for more than six months, and sells it for two million, his one million dollar profit is what you call "capital gains." And, since his profit is called capital gains, the guy should have to pay tax on only half of the million.

On the other hand, coal miners, workers in chicken processing plants, assembly line workers, ditch diggers, secretaries, and so on, make what is called "income" for their work. Therefore, workers should pay taxes on 100 percent of their incomes. That, in the view of Limbaugh, Republicans and even some conservative Democrats, is what tax justice, and capitalism, are all about.

Homes, Again

Since land and property are probably the biggest sources of wealth and poverty in the U.S., let's extend our discussion from the last chap-

ter, and apply it to the capital-gains issue. If you didn't like what you read before, you'll like this even less.

Kenneth Fisher described how the typical public-spirited reader of *Forbes* magazine could confiscate—at *no* cost—the homes of workers who lost their jobs in the '80s.

It seems that the Reynolds Metals rolling mill and a Textron bearings plant in Arkadelphia, Ark. shut down, taking out 900 jobs. Ken couldn't wait to spread the good news. According to him, anyone with a good credit rating could go to Arkadelphia, buy up nice homes for less than $35,000 each, and rent them for $350/month to students who attend one of the two local colleges. As helpful Ken wrote in 1990:

> At 100 percent leverage [you don't have to use *any* of your own money to buy these homes], . . . the carrying costs are about $290 monthly, which gives you $60 per month for repairs, property tax and insurance. Free money.
>
> . . . There are plenty of folks who want houses and can pay the rent. But students, or untenured faculty, or a host of other unbankable locals don't have the kind of income streams that qualify for a mortgage.
>
> . . . There are plenty of towns [like this] where corporate gamesmanship has created imbalances between rents and bankable buyers.[1]

Understand what Fisher is saying. If you're rich and have money, you can get more "free money," which is yours to keep. If you're "unbankable" (poor or middle class with a low credit rating), you can't.

Bear in mind that the unbankables include some of the junior professors who teach at the colleges, as well as other "locals" who have low-paying jobs. The workers who previously had good manufacturing jobs, but had their jobs taken away from them, became even more unbankable. Naturally, they lost whatever investment they had in their houses.

Get the picture? Let's say that a corporate raider takes over a company and decides to close down a plant, say, in Arkadelphia. He then:

- Gives a $10,000 tax-free gift to his sixteen-year-old-son, as he's been doing for the past ten years.
- His son, who's never worked a day in his life, now has over $100,000 and a better credit rating than 95 percent of the working adults in the U.S.
- Now, the corporate raider goes to Arkadelphia and buys, *with no money down*, ten homes in his son's name and with his son's credit rating. And—
- His brilliant son still has his original $100,000, plus ten $35,000 homes that used to belong to workers, and that will be fully paid off in fifteen or twenty years.

All this at no cost to the son or his prince of a dad. Because of the conservative version of tax justice, the dad doesn't have to pay any tax on the profits. Everything is taxed at junior's lower tax rate.

And here's where the capital gains comes in. If conservatives have their way, *again* (the rich have had tremendous capital-gains tax advantages in the past), Junior will get a *reduced capital-gains tax rate* when he sells his homes. In other words, although a coal miner will have to pay tax on *all* his income, Junior would pay tax on, say, only 30 to 50 percent of his profit. He and his dad simply took over workers' homes during their spare time, and at little or no cost to themselves. Since that kind of activity is "investment," or "capitalism" by their definition, they deserve a lower tax rate. (Conservatives say that anyone who criticizes this kind of tax injustice is envious and is conducting "class warfare.")

Of no concern to anyone, naturally, is the poor schlock who had worked fifteen years for the plant that fired him. He had $10,000–$20,000 invested in his home, that used to be worth $45,000–$55,000, before the local depression. He lost it through no fault of his own. And if he now has a job flipping hamburgers, he'll pay tax on 100 percent of his income.

The bank wouldn't give *him* a break because he needed one. Conservative bankers are only interested in helping people make money who don't need any help. Sound like the depression of the '30s all over again? For those who lost their homes in the '80s, it was.

If you think the Arkadelphia example is extreme, think again. According to economist Edward Wolff of New York University:

> More than anything else, family capital divides the haves from the have-nots. In 1983 as much as 85 percent of the wealth of boomers under forty could be traced to gifts and the capital gains the gifts engendered.[2]

Jane Bryant Quinn, looking at the same data, concluded that "nothing beats the profits earned from money invested in homes, stocks and businesses."[3] And the reason Quinn's conclusion is accurate is that conservatives have always made sure the rich had all the tax advantages possible. And capital gains is one of their most important advantages.

If you don't believe me, or Professor Wolff, or Jane Bryant Quinn—about low capital-gains taxes giving the wealthy tremendous advantages—consider the words of Federal Reserve Chairman Alan Greenspan. Senator Connie Mack asked him to give his opinion about how cutting the capital-gains tax would affect real estate values. Greenspan explained why conservatives want a reduced capital-gains tax:

> I think it's fairly evident that, to the extent that capital-gains tax is lowered, you will get potentially higher property values. . . . [4]

In other words, those who hoard property, and their descendants, get double-barreled benefits from capital-gains taxes: (1) they benefit tremendously from higher property values that result; and (2) they pay a much lower tax rate on their real estate profits than do people who actually work for a living.

For a specific example, consider Dr. Laszlo Tauber, the only practicing physician on *Forbes* magazine's 1991 list of the 400 richest people in the U.S. He had real estate valued at $500 million. He said, "I was looking for an office. That was when I got acquainted with the U.S. system of real estate finance."[5]

He continued, "Medicine is still my life. I spend 5 percent of my time on real estate and 95 percent on medicine." Tauber's work is

medicine, but he made his fortune by *not working*—a mere 5 percent of his time—and taking advantage of the system that wealthy conservatives have devised for themselves.

From the tax standpoint, the more profitable it becomes to buy property, the more the wealthy will continue to buy it. Prices will go up still more and the billions upon billions of real estate already owned by our richest Americans will continue to increase in value. And the cost of homes for workers will continue going out of sight.

Anytime anyone has excess cash, they try to decide what to buy next. In just about every case, it's something you'd like to have also: the vacant lot next to the house you own, or, if you're a renter, the house for sale in the next block. You might like a few acres in the country for a retreat, or a house to fix up to give to your son or daughter, . . . whatever.

You would buy it and put it to productive use. The person who has accumulated paper money (by whatever means) wants to buy it simply because he knows that someone else will want it later, at a much higher price. *And when he sells it, conservatives want to give him every tax break possible.*

THE CONSERVATIVE PROPAGANDA MACHINE

For a classic example of how far conservatives are willing to go to convince the public to support capital-gains taxes, just read the words of the U.S. Chamber of Commerce. In September of 1990, *Newsweek* blew the whistle on the Chamber's plans for a nation-wide ad.

In an effort to win a cut in the capital-gains tax, it likened the United States Congress to China and Cuba. According to our highly principled Chamber:

> In the 1980s, the whole world—except China, Cuba, and Congress—realized that communism and socialism don't work. . . . We need to make sure Congress knows that other successful countries treat capital and business more fairly than we do in the U.S.[6]

71

How's that for a blatant example of demagoguery? It seems to have become a staple in the arsenal of right wing attack scams.

In effect, the Chamber of Commerce calls a democratic attempt to tax capital gains *at the same rate as a worker's earnings*, "communism." They label the preferential treatment for their own kind, the businessmen and the wealthy, "capitalism." This preposterous distortion of reality is the Chamber's version of the Limbaugh dichotomy (mentioned in Chapter 4):

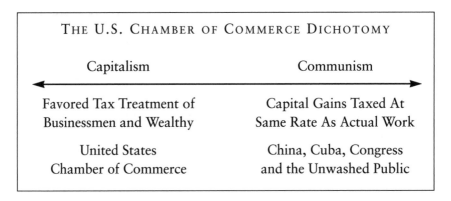

THE U.S. CHAMBER OF COMMERCE DICHOTOMY

Capitalism	Communism
Favored Tax Treatment of Businessmen and Wealthy	Capital Gains Taxed At Same Rate As Actual Work
United States Chamber of Commerce	China, Cuba, Congress and the Unwashed Public

I can understand that the U.S. Chamber of Commerce is charged with furthering the interests of its members, and fairness is not one of its concerns. But I still wish that any organization calling itself "the U.S. (anything)" would have higher ethical standards in presenting its case.

HISTORICAL PRECEDENT

Limbaugh, the Chamber, and other conservatives assure us that giving the wealthy capital-gains tax breaks always results in increased investment in business, thus creating more jobs.

History simply doesn't support their position. Joseph Minarik, chief economist of the House Budget Committee, studied the effects of changes in the capital-gains tax rates over the fifteen years since 1975. He found that tax rate changes had effects that were *opposite* of what conservatives claim.[7]

When rates were lowered in 1978, 1981, and 1984, investment in equipment, "the heart of productive business investment," *went down*, not up. When rates were raised in 1976 and 1987, investment *went up*, not down, and thus created more jobs.

Minarik did find, however, that commercial real estate values went up after capital-gains tax cuts, as Greenspan predicted. Of course, increases in real estate values benefit those who are already wealthy, which is the *real* reason for the conservatives' love affair with low capital-gains taxes. Increasing jobs for workers has absolutely nothing to do with it.

9.

So many middle-income taxpayers; so few wealthy

Leona Helmsley said, "Taxes are for the little people." Modern conservatives say the same thing, but they camouflage it. Every time they try to revise the tax laws in order to favor the rich, they do it in such a way that the middle class feels they are somehow better off.

In his war against the middle class, Limbaugh justifies his defense of the rich with the following illogic:

- There are so few rich people in the U.S., and, in total, they have relatively little money. There is no way they can help solve our deficit problems.
- Only the massive middle class has enough money to significantly reduce the deficit. Therefore,
- Middle income Americans must resist increased taxes on the rich because, if they don't, *the middle class* will be the next tax victims of liberals.

There may be other reasons Limbaugh doesn't want to be taxed, like greed, the desire of his like-minded friends to create permanent family dynasties of retired people, and the Freudian hope that, if he accumulates so unbelievably much in this life, he *has* to be able to take some of it with him when he dies.

But the previous arguments are what you'll hear from him.

Of course, if you're like most middle-income Americans, the bad news is: despite what Rush says, you can't avoid taxes. The United States is in trouble and it will take money to get us out. The good news: most of us won't have to pay so *much* tax if we arm ourselves with a little information and use our influence in national politics.

Our first line of defense is to understand who wants us to pay more taxes and why. There's a lot of nonsense out there that is damaging, not only to the middle-income worker, but to the economy as well.

The Wisdom of Malcolm

Limbaugh must have read the wisdom of the late Malcolm Forbes, who presented the classic case for not taxing the wealthy. In one of his 1989 editorials, he wrote:

> If the total wealth of the 400 richest people in America—over $268 billion—was confiscated by the feds today, it would run the government for three months.[1]

We're supposed to be shocked that their money would only last three months. This is another example of how extreme wealth creates a lack of perspective in a person. It reminds me of when Nelson Rockefeller said "You take an average guy making $100,000 a year. . . ." Or, when Rush Limbaugh constantly complains about how difficult it is for a "middle-class" person making only $120,000 a year to make ends meet.

By now, I imagine that St. Peter, or someone, has pointed out to Malcolm that for only four *hundred* people, out of 250 *million,* to support the government for the next three months isn't all that shabby.

If you took the total wealth of the poorest 38 *million* Americans (the bottom 15 percent), you'd be somewhere into *yesterday.* Add the next 88 million (35 percent of the lower middle class), and you could be, if you stretched it a bit, only into the first of next week.

St. Peter might also point out that the top 400 persons only had a mere $92 billion in 1982. During the next seven years of conservative tax breaks, their net worth almost *tripled.* According to Kevin Phillips,

75

a certified *Republican*, "Big capital gains caressed by low taxes are what tripled the net worth of those on [that same] Forbes list."[2] The Census Bureau says that the median net worth of American households *dropped* 4 percent between 1984 and 1988, roughly the same time period.

Statistics indicate that the wealthy aren't rare at all. During the 1980s, the number of billionaires (that is with a 'b') increased from thirteen to seventy-one, an increase of over 500 percent. Decamillionaires went from less than 40,000 to about 100,000, and millionaires tripled—to one-and-a-half *million*. By any standards, that's a lot of rich taxpayers. The top one percent of American households had 36 percent of all the private net worth in the United States in 1989, up from 31 percent in 1983.

The wealth of the top one percent, $6.14 trillion, was almost a fifth higher than the entire net worth of the bottom 90 percent of families.[3] Their wealth was more than the gross national product for that year. Think of it. Just one percent of our population owned the equivalent of *more than all the goods and services we produce in the United States for an entire year!*

Then add to those data the fact that, as of September 1990, 65,000 people reported making over a million dollars *per year*. How many made over a million and didn't report it, we'll never know. Puts everything in a whole new light, doesn't it?

Precedents for Special Tax Treatment

Limbaugh tries to make middle-incomers feel guilty about seeking lower tax rates for themselves, and higher rates for others.

They shouldn't. Wealthy conservatives (and at least a few wealthy liberals) have always done it, and without a qualm. It's part of the process.

By and large, everyone agrees that the rich have been putting it to the poor for at least the past ten years, and it's about time they made up for it. Everyone agrees, that is, except the Republicans who were at a tax summit meeting on September 13, 1990.

That meeting is particularly instructive because it clearly exposes

the Republican sense of tax justice, as well as how the political system works. According to the Associated Press:

> Republicans were outraged last week when an analysis of [the Republican] tax proposals was leaked and showed that, to reduce the federal deficit, Bush was proposing a 5.5 percent tax cut for the richest American families (those earning over $200,000 a year) and tax increases for everyone earning less than $50,000. Sen. Bob Dole, R-Kan., denounced the leaks. . . . [4]

This was a classic example of the way tax rates are determined: behind closed doors, with horse-trading, special-interest pleading, and compromises. Part of the process is a so-called gentlemen's agreement not to embarrass political colleagues by revealing who's actually recommending what.

> The Republican tax plan would have cost *$4.1 billion more* during the next year for taxpayers making *$50,000 or less*, while those making *$200,000 or more* would see their tax liability *reduced by $7.4 billion*. According to an analysis by the nonpartisan congressional Joint Committee on Taxation, all those making $50,000 or more would gain from the plan.[5]

Ever since there were taxes, people have been getting out of paying them. One of the best ways is to persuade a congressman to get a personalized bill through Congress for you.

For example, Xavier Roberts, the inventor of Cabbage Patch dolls got a *personal* $6 million tax break from the federal government. It seems that someone slipped the tax break into the 1986 Tax Reform Act by citing a "taxpayer who incorporated on Sept. 7, 1978, which is engaged in the business of manufacturing dolls and accessories."[6] That description doesn't fit a lot of other taxpayers.

Others who received similar benefits included New England Patriots owner William Sullivan, $6 million; New Orleans Saints owner Thomas Henson and partners, $1 million; and many others.

David Berenson, a tax expert with Ernst & Whinney: "These things

were pure pork barrel. They were ladled out to the congressmen who played the game according to the rules."[7]

Of course, these people were small fry compared to others of historic note. In 1951, Louis B. Mayer persuaded a friendly congressman to classify his $2.6 million retirement settlement from Metro-Goldwyn-Mayer as capital gains rather than ordinary income. That simple act saved Mayer $1.7 million.

The gold star for personalized tax breaks goes to the du Pont family. In 1962, Washington lawyer Clark Clifford, of BCCI fame, got a special bill passed that saved the family about $500 million in taxes on a court-ordered divestiture of $3 billion worth of GM stock.[8]

For those astute enough to catch it, there seems to be a precedent in all this: it's perfectly honorable, fair, and legal to get the tax laws changed to accomplish whatever you damn well please. So, don't let Limbaugh hang a guilt trip on you if you try to protect the interests of working-class Americans. Limbaugh and his wealthy conservative friends are way ahead of you in the battle for tax breaks, and guilt never enters their minds.

Oh, and don't worry about killing the incentive of the rich to invest their money and create jobs. They don't invest to create jobs, they do it to make money and they still will. As many of them say, "Money is just a game" and they'll invest because they enjoy the game. Others, the almost-rich, will still have incentive, as always, to *become* ridiculously rich.

10.

Class warfare: *liberals* are doing it?

There's been a marked increase lately in Limbaugh's rhetoric about, of all things, class warfare. And, would you believe it, it's those who support justice for middle- and low-income *workers* who are supposed to be waging it. If you haven't given the issue much thought, you haven't been listening to Rush or reading the leading business publications.

The Real Warriors

To find out about class warfare, and who's causing it, look at the editorials in some of Limbaugh's favorite publications, like the *Wall Street Journal* or *Forbes*. As with other issues, conservatives try to inoculate themselves from criticism by beating others to the punch. They've been remarkably successful in accusing others of doing what they've been doing for years.

Michael Novak set a new high standard for demagoguery in a *Forbes* magazine article. He tried to discredit a qualified political expert, who had impeccable qualifications for objectivity, by using the tired old clichés of the American right wing:

> Kevin Phillips, a self-described conservative, has delighted
> the "class warfare" left with a nasty attack on Reagan in a new

book, *The Politics of Rich and Poor*. The left loves conservatives who hate.

Phillips wants a knightly Democrat to saddle up and rescue the nation from Republicans, whose whole raison d'être, he says, is to concentrate wealth. . . .

Phillips claims to abhor plutocracy. He also claims to be a populist. However, he seems to know as little about populism as about our people's resistance to envy. . . .

Phillips imagines that the American people are burning with envy. Believing this, populists usually lose. Envy doesn't inspire.[1]

It's difficult to find an article that has more propaganda sound bites than this one. Two observations about it: first, it's worth noting that Phillips was chief political analyst for Richard Nixon's 1968 presidential campaign and later served as assistant to his attorney general. He is a respected *Republican, conservative* political analyst. His opinions are regularly sought by leading publications, and in 1988, *U.S. News and World Report* included him in their forty-member "Who's Who in Politics."

He now feels that the '80s Republicans have sold out. The Reagan and Bush conservatives have not only sold out the "cloth coat" conservative Republicans of the Nixon era, but they have also sold out America as well. This makes Novak's hysteria understandable—he sees a respected conservative telling the truth.

Second, the public's disgust with the rich and powerful is *outrage*, not envy. They're infuriated at what rich conservatives have done to our once great country and to the working person. The only "envy" involved is purely the invention of demagogues like Limbaugh and Novak. They are trying to diffuse the public's righteous anger, which in this case is a virtue, by labeling it envy, an unbecoming vice.

The Limbaugh and Novak style of vicious conservative analysis seems to be catching, especially when they react to others who want to improve the lives of low- and middle-income workers. For another example, consider Alix M. Freedman, a staff reporter for the *Wall Street Journal*.

Alix wrote a contemptuous review for the *Wall Street Journal* of

Barbara Ehrenreich's book, *Fear of Falling: The Inner Life of the Middle Class*, charging that it was a "windy, whiny book," because:

> Ms. Ehrenreich ends with a plea that liberal middle-class professionals incite the working-class majority to revolt against "the growing and inordinate power of wealth." Happily for the middle class, the only people the working class hates more than the poor are pointy-headed intellectuals. Indeed, *Fear of Falling* provides evidence aplenty that the plutocrats need have no fear of falling—and that Ms. Ehrenreich should mingle more with the masses.[2]

Alix tries to discredit any attempt to help the worker, by dredging up an unflattering stereotype—"pointy-headed intellectuals." She should realize she's made a self-damning Freudian slip. The kinds of people she holds in contempt, intellectual or not, are the ones who have traditionally discovered and tried to correct social injustices such as child labor, deceptive financial reporting, unsafe working conditions, environmental pollution, and on and on.

Every step of the way, on issue after issue, conservatives like Limbaugh, Novak, and Freedman oppose those who try to improve opportunities and conditions for anyone who is not a member of the power establishment.

The Wisdom of Shakespeare

In *Hamlet*, Queen Gertrude observed the devious behavior of another and voiced one of Shakespeare's most famous lines: "The lady doth protest too much, methinks." The corollary here is: "for innocent bystanders, conservatives doth protest a hell of a lot, methinks."

You can feel it in your gut. Limbaugh, Novak, Freedman, and conservatives everywhere know very well that class warfare in the U.S. is already going on. They're at the forefront and they've been winning for the entire decade of the '80s, at least. Now they're getting extremely self-conscious.

PANIC TIME

No wonder conservatives are getting antsy, even to the point of publicly embracing a demagogue like Limbaugh. The gross excesses of the '80s made people angry enough to elect anyone to the presidency of the United States other than George Bush. The last thing conservatives want now is for class warfare to be declared. Conservatives are dedicated to advancing the interests of the rich at the expense of middle-income workers. But they don't want their conspiracy to become *official.*

Therefore, it's done in private, although on a large scale. The average wait for memberships at existing country clubs is now five years, doubling since 1986. Michael Ebner, a historian of the upper class at Lake Forest College in Illinois, says that the new members of country clubs have much in common with the traditional members who

> . . . were the upper class created by wealth from the industrial revolution in the 1880s. They needed a refuge and the reassurance of those without antagonistic feelings toward riches.[3]

According to a thirty-six-year-old country club member, "In 1970, I thought country clubs symbolized the effete establishment and the Vietnam War machine. But today, the club is a safe harbor for my family." A thirty-two-year-old consultant paid $26,000 to join a new club after reading the names on its burgeoning rolls. "Many were from companies I wanted to do business with," she said matter-of-factly.

If you wonder how profitable a country club membership can be, consider the episode at the Ridgeway Country Club in Memphis. Everyone was surprised when four of its members were accused of insider trading on the stock market. It seems that, after a round of golf, a person who had inside information on a big investment deal told his buddies how they could make some easy money. Capitalizing on their inside information, the four made from $2,625 to $215,000 each, depending on how much they invested.

Especially notable are the reactions of the four guilty golfers in the episode:

"I guess everybody feels like they've been persecuted," muses one member of the group. And they and their wives wonder why, of all the stock tips ever passed on golf courses, over drinks, in boardrooms and at backyard barbecues, theirs led to disaster.[4]

Four weeks after the SEC filed charges, Mr. Van Weinberg, the one who tipped off the other golfers, was inducted into the Rotary Club of Memphis. The club's president, Richard Reynolds, describes the club as consisting of 590 of the "finest business and professional people in this town."

Reynolds went on to say that, while he was "shocked" to learn of the SEC charges, he believes the club extended the presumption of innocence to Mr. Weinberg, noting that he didn't plead guilty to any crime. Of course, Weinberg had received limited immunity from the SEC; that is, criminal charges wouldn't be brought against him for what he confessed to the agency.

This is an example of the most innocent kind of class warfare. Not only does "everybody do it," but they do it with no malice toward anyone. However, if workers were to organize to demand higher wages, these same people would become infuriated. It's simply a matter of prejudice, brought on by affluence and isolation. Winking at the laws is an assumed "right" of the educated wealthy. Workers should obey all laws, even those that are specifically designed to benefit the wealthy and the powerful.

It is a pervasive prejudice, and, in the long term, extremely detrimental to middle-income workers. Whenever a "steal" comes along in real estate, or the stock market, they always talk to the right people—other educated investors with the right breeding who can do something about it.

With inside information, they buy stock at reduced rates from workers and their pension funds, or sell their stock to workers and pension funds at inflated prices. With their "free," safe, and easy profits, they drive up prices of land, houses, and the kinds of things that we all compete with each other to acquire.

And when workers suffer from the inflation and community disrup-

tion that the rich have caused, the rich will fight against the social programs that are designed to assist those who have suffered most.

In influencing government decisions, the wealthy have a tremendous advantage: their side has been fighting a war and the other side hasn't. In addition, they're not stupid. They know that they are outnumbered, something on the order of twenty or thirty to one, depending upon how you define poverty and the middle class. So they keep the warfare under wraps.

Traditional, Violent Warfare

Therefore, it's not obvious, as it was in 1914. That's when John D. Rockefeller Jr. and the other coal barons used the Colorado militia to kill striking miners in the Ludlow Massacre. Men, women, and children were mowed down indiscriminately with machine guns and Springfield rifles.

Or when Andrew Carnegie brought in strike-breakers and Pinkertons to crush the strikes of steelworkers, driving thousands into poverty while accumulating millions for himself. Or when Henry Ford hired hoodlums from organized crime to crack open the heads of union sympathizers.

Modern (Tax) Warfare

Class warfare is more subtle today. When conservative politicians cut the funding for the Internal Revenue Service during the '80s, it hurt its ability to collect the taxes already owed.

You see, by 1990, deadbeats owed the government over $250 billion dollars, but the government couldn't get it, because the IRS was underfunded and didn't have the staff. Sheldon Cohen, once a commissioner of the IRS, asserted, "You could say without any qualm that for every dollar they don't spend [funding the IRS], that's $6 to $10 they don't collect."[5]

If you're a worker and you think that's good news, think again. It's easy to collect *your* taxes. Your income is reported on your pay slip, and there is no doubt about how much you make or how much you owe the IRS.

The deadbeats are the wealthy nonworkers with complicated tax

situations. They avoid taxes simply by creating confusion and playing the margins of the tax laws. Then they hire ex-IRS agents to defend their subterfuge in an audit.

Despite all that, President Bush's budget office once put pressure on the Internal Revenue Service to concentrate on auditing *lower-income* taxpayers rather than wealthier individuals and businesses.[6]

For another example of what has been going on in class warfare, look at the reactions of politicians to a 1990 study released by the nonpartisan Congressional Budget Office. The study clearly indicated that tax rates on the rich went down, while their incomes went up, and the tax rates on workers went up, while their incomes went down:

> It shows that from 1980 through 1990, the poorest 20 percent of Americans have seen their real income drop 3 percent and their net federal tax rate go up by 16 percent. Families in the poorest fifth have an average pretax income of $7,725.
>
> Meanwhile, the richest fifth—families with an average pretax income of $105,209—have had close to a 32 percent increase in their income, and a 5.5 percent cut in their net federal tax rate . . . [7]

In reacting to the study, House Democrat William Gray drew the obvious conclusion, "The statistics show that the rich are getting richer and the working- and middle-class Americans are being raped under the tax policy of the Republicans."

Propaganda Warfare

The classic response came from a senior official of the Republican White House at that time, who, naturally, asked not to be identified. He said:

> . . . the administration would welcome "class war" by the Democrats. "They tried it last year and it didn't work," said the official, referring to House Democrats' failure to block a cut in the tax rate on capital gains.[8]

The shadowy White House spokesman was probably right. Obvious appeals to class interests have always turned off the American public, even the workers. "Class warfare" suggests a despicable image of sniveling, whining failures who want to get free what others have worked for. That's why the true class warfarers use the term to apply to everyone else but themselves.

Evidently, the Republicans think the strategy works. Jack Kemp outdid himself in a public address, saying:

> Today we hear much in our politics about division—of rich against poor, black *versus* white—indeed almost of class warfare, disguised as one word—"fairness. . . ." We in America are being asked to choose between two opposing ideas, the politics of class warfare or Lincoln's all-embracing vision of boundless democratic opportunity."[9]

I'm in debt to Jack. I didn't realize Lincoln was against fairness. In fact, I always thought he had something to do with an *actual, real* war to improve fairness for blacks.

Be that as it may, conservatives obviously feel they have discovered the "speech for all occasions." They can squeeze it in anywhere and relate it to anything or anybody, as long as it'll keep people from thinking.

Whenever anyone asks for fairness, say, in the income tax system, or education, or a better break for workers, conservatives don't try to defend their abysmal record. They just charge their critics with "class warfare," and hope that the country doesn't self-destruct while they are still alive.

To counteract the charge of class warfare, don't be envious, just get *mad*. Tell others you are angry and why. And demonstrate your feelings in the voting booth.

Part Two

The Philosophical
and the Devious

Fundamental philosophical differences are at the heart of most liberal/ conservative disagreements.

Part Two, therefore, explores the philosophical assumptions, many of them hidden from public scrutiny, of the Rush Limbaughs of the world.

When compared to more ethical perspectives, the destructive nature of right-wing conservatism becomes apparent.

The way we view

- the effects of extreme wealth disparity on different levels of society,
- the concept of work,
- the individual as a "survivalist" or a "steward" of his society, economy, and environment, and
- the nature of capitalism as the best financial system for the well being of all citizens

affects the ways we choose to interpret reality, and the kinds of solutions we advocate to solve our country's problems.

Which, of course, affect all the other issues discussed in this book.

11.

Class warfare: the world perspective

When it was announced that Vice President Al Gore was going to lead an effort to "reinvent government," Rush Limbaugh had his excuse to fill up another program. With those two words alone, and no other information, Limbaugh went into orbit, making the following points:

- We already have the best system of government in the world and it doesn't need to be "reinvented" (said with a sneer).
- If we would just cut out the liberal spending and quit trying to soak the rich with taxes, we could easily solve most of our problems, and
- The need is not to reinvent government, but to get government out of our lives, and let the private sector solve our problems.

Old guard conservatives never learn. The super-patriot, super-conservative defenders of the power establishment always choose to remain blind to the injustices of the society they control. They fail to realize that when they unfairly defend and advance the materialistic welfare of their own class, they ensure the eventual destruction of the orderly society they are trying to preserve.

Class warfare eventually seems to afflict every society, and, as it progresses, everyone loses. In Northern Ireland, the conflict is between white Catholics and white Protestants (religion). In the Middle East, it's Jews and Arabs (religion). In South Africa, it's black and white (race). In Burundi, it's Hutu and Tutsi (tall black people and short black people). In Sri Lanka, it's Hindu Tamils and Buddhist Sinhalese (religion). In the former Yugoslavia, it seems to be everyone against everyone else, for whatever reason they can think of. And they're all killing each other like crazy.

The apparent reasons for these and similar warfare are differences in race, religion, nationality, tribe, political party, social status, tradition, or whatever. The sheer diversity of such reasons should, in itself, prove that the apparent reasons are not the real reason.

The real reason is that those who have the most power try to make sure they keep the power. Their goal is to ensure that they and their descendants will forever: live in the best locations (neighborhoods, beautiful surroundings, clean air, etc.), attend the best schools, enjoy the best medical care, eat the best food, get the most desirable jobs, and on and on. They manage their society so that their sons and daughters never have to become members of the working class (garbage handlers, assembly line operators, secretaries, etc.).

At the same time, they wish to ensure that they will always have a ready supply of uneducated workers with low expectations to provide them with products and services. The powerful can usually do a good job at this, at least for awhile. To keep workers complacent, they must provide opportunities for at least a few of them to achieve a better quality of life. However, economic systems that are *fundamentally* unjust to *significant numbers* of people eventually lead to revolution of some form, and it is always very unpleasant, and usually destructive.

Northern Ireland

A good case study for our purposes is "the troubles" in Northern Ireland. It has been well publicized and is far enough removed from us that we can discuss it fairly objectively. It also demonstrates the intimate relationship between discrimination, injustice, and class warfare.

Several years ago, a television documentary explored the causes of the violence there. In one scene, a Protestant cab driver gave the reporter a tour through a Catholic neighborhood. "Just look at how these people live. Look at the trash in the streets, the way they let their yards go. Look at those garbage cans turned over. This is the way they want to live. They don't want any better."

The scene had a strong effect on me because it reminded me of when I was fifteen years old, riding with a relative through a black section of Kansas City. My relative was "educating" me about the fundamental nature of blacks, how *they* wanted to live. I now find it incredible how anyone could attribute poor living standards to race or religious preference. The two just don't seem to go together. But, forty-five years ago, it seemed to make sense that blacks somehow wanted substandard living conditions. Such is the nature of prejudice.

The documentary on Northern Ireland continued with an interview with a social scientist who made two observations: (1) the problems in Northern Ireland have nothing to do with religion; and (2) the root cause of all prejudice is economic. It just so happens that the most significant, readily available source of economic discrimination in *that* particular country is *religious* difference.

In the United States, discrimination takes many forms: racial, sexual, religious, social status, educational, and so on. And Limbaugh-type conservatives are taking advantage of as many of them as they can. As many ways as they can divide their opposition, that's how many ways they will attempt to galvanize the power of the "haves" against the powerless "have-nots."

Cognitive Dissonance

Conservative demagogues are successful in turning the haves against the have-nots because prejudice feeds on economic injustice, and economic injustice feeds on prejudice. A psychological concept called "cognitive dissonance" explains how this happens.

Cognitive dissonance means that we can't have two conflicting values at the same time without incurring some form of mental and emotional distress. In other words, I am distressed because I can't take unfair advantage of you and think well of you at the same time. I

therefore have tremendous internal pressures to reconcile these incompatible values, and so achieve emotional harmony within myself.

So the con artist convinces himself that the sucker deserves to be taken, the wife beater imagines that his wife is cheating on him, and the chief executive officer fires 12,000 employees because, he rationalizes, they *deserve* to lose their jobs to Mexican laborers who are willing to work for subsistence wages.

It is a vicious cycle. First, we take unfair economic advantage of someone. To justify what we've done, we then must think that that someone is a bad person—or we lose the right to call ourselves Christians, or moral, or whatever is the basis for our values. Our resulting bad feelings toward that person, in turn, justify even worse treatment in the future . . . and the cycle feeds on itself. Cognitive dissonance helps to explain why hatred of the poor is increasing worldwide. They are a constant reminder of our moral and ethical failures, and we *must* hate them if we are going to continue our immoral behaviors toward them.

Some of those who call in to the talk-radio programs in Brazil express *support* for the death squads that are killing poor street children. Prior to being able to support the killing of children, however, the callers *had* to think of reasons to hate them, and to blame *them* for being an embarrassment to Brazilian society. Once they found a way to blame the children for their own sorry condition, they could support killing them.

Cognitive dissonance also explains the high level of vicious, sophomoric commentary one hears on the radio from the Limbaugh dittoheads. With mean-spirited glee, and feigned moral outrage, they take every opportunity to justify the advantages they have in this society, and, at the same time, degrade the victims of their political policies.

It is obvious to anyone other than a dittohead: the Limbaugh program is a planned strategy to keep the powerful in power, to turn greed into a virtue, to continue to ignore obvious injustices in our culture—and to allow modern conservatives to purge guilt out of their collective conscience.

And they are doing it successfully.

The Mystery of Moral Decay

When we see the moral injustices that occur in other countries, we wonder what conditions could have caused their decline into a barbaric state. Besides cognitive dissonance, what is it that encourages those in power to ignore the injustices and worsening imbalances in their own society? How can they excuse the obvious weaknesses in their own systems of government?

George Melloan, deputy editor of the *Wall Street Journal*'s editorial page, demonstrated how they do it when he wrote:

> Class-warfare rhetoric is uttered daily in the political arenas of the West, but so long as no significant class can genuinely say that it is denied a share of political influence or legal redress, such appeals will not inspire large-scale resorts to violence.[1]

Every student of history recognizes Melloan's rationalizations. On TV we've heard politicians in Northern Ireland refer to rebelling Catholics the same way: they've no right to complain, because they have access to the legal and court systems, (which Protestants control). Melloan knows full well that the class he represents is winning in the U.S. version of class warfare, and conditions are not yet bad enough for large-scale revolts.

Sure, the systems for the administration of justice are in place. But those who hold most of the power in those systems are, by and large, wealthy, formally educated, or in some way well connected. And they are *increasingly becoming biased against working class Americans and the poor.*

I'm sure that many wealthy conservatives will genuinely disagree with that last statement. They may find it hard to believe, because they give to charity, are basically honest, and wish those lower on the income scale the best of luck. But they also are quite insulated from any kind of serious contrary opinion about the rights of workers. They read the kinds of magazines and newspaper columns that reinforce their biases.

Many are probably unaware, or they choose to remain unaware, of the ways they wage their warfare: in legislative offices, country clubs,

civic organizations, business and professional organizations, etc. It only takes a few of them to get what they want for all members of their class. And it doesn't always take money, although that helps. Usually, friendship and membership in the network is all it takes.

Since they control the government, they consider their role in class warfare as simply "looking out for your own interests." Which is a solidly established American right. The rub, of course, is that the more benefits the rich get, the more it costs the worker.

The rich conduct expensive propaganda campaigns, get preferential treatment from legislators, and make tit-for-tat deals. But, most importantly, they deny, even to themselves, that they do it *to the massive extent that they do it*—as the '80s demonstrated so conclusively. And when anyone else tries to do just a little of the same, they scream "class warfare—un-American!"

Middle-income workers, on the other hand, are in serious competition with each other and with foreign workers for jobs at low wages that keep going down. They are too numerous and too dispersed to defend themselves surreptitiously. Most of them don't even *know* any influential people. They can't get anything done behind closed doors. Except for a few unions, they have no financial support.

What little influence the unions once had has severely deteriorated during the '80s. Well-financed, labor-bashing groups have provided a steady stream of anti-worker propaganda. Workers have no comparable access to unlimited funds. They have to influence the establishment openly, following regular governmental or business procedures.

If you think this view—that working-class Americans are unfairly discriminated against—is farfetched, read on. They have been deliberately put at a serious competitive disadvantage with outrageously abused workers throughout the world. The resulting decline in the standard of living in low- and middle-income American communities needs no documentation.

The rest of Part Two will explain why Limbaugh and right-wing conservatives have been so persuasive in conning American voters into bringing this condition about. You will know who is responsible for it, how they did it, and why it will get worse if we don't do something about it.

12.

What work is

The definition of "work" is an important part of the propaganda battle between liberals and conservatives. To align himself with some of the most potent symbols of American values, Limbaugh claims that "hard work" accounts for the success of the wealthy. To align liberals with negative symbols, he describes how they want to "punish success," because they are "envious" of those who, through work, have accumulated more than they have.

A *Wall Street Journal* story about the pay of CEOs of small firms demonstrates Limbaugh's powerful influence as a first-class demagogue. The *Journal* quoted Andrew Filipowski who was CEO of Platinum Technology Inc., a company that did $49 million in sales in 1992, and made $9.3 million. According to Filipowski, "I am absolutely baffled by those perverted, socialistic, moralistic issues that make [some people] so jealous and greedy they'd want somebody in the U.S. not to succeed." For his year of success, Filipowski took home $13.9 million, counting options gains.[1]

Filipowski *has* to be a dittohead. He has the clichés and strategies of conservatism down pat, including the inoculation technique (*others* are perverted, greedy, etc.), and he mimics Limbaugh perfectly.

Limbaugh has turned the traditional views of work completely

around. He has equated work with what rich people, like Filipowski, do. In effect, he is trying to justify the increasing disparity in incomes between the rich and middle-class workers. It's a great scam. The rich are adopting it lock, stock, and barrel, repeating it over and over—and too many middle-income people are being conned by it.

It's obvious that liberals and modern conservatives view work quite differently, especially in terms of how it is rewarded. Conservatives have capitalized on the subjective nature of work, and have gradually changed its traditional meaning to a modern excuse for pure greed.

THE TRADITIONAL VIEW OF WORK
(BEFORE CONSERVATIVES DEFINED IT)

I can claim some degree of expertise on the proper definition of work because I have been both a worker and a nonworker. From personal experience, I can assure you that nonwork is much more fun and pays a hell of a lot better.

You see, thanks to circumstances largely beyond my control, and sheer good luck, I haven't worked since the spring of 1951. That's when I tied auto tires into bundles for shipment from a Sears mail-order warehouse in Kansas City, Missouri. It was a dirty, hot, repetitious, tiring job. The pay wasn't enough for anything beyond basic living expenses—for one person.

When you're eighteen, with no money or practical experience, and no real expectations for improving your life, that kind of activity is truly work. You do it because you have to to survive. It isn't fun, you aren't preparing yourself for a better job, and you'd rather be doing something, almost *anything*, else.

Flight from Work

So it was in May of 1951 that a co-worker convinced me to join the U.S. Navy with him. He also was from a small town in Kansas, and we had known each other for three weeks. "We'll go through our naval careers together and look out for each other." The sentimentality

of the event almost brought tears to my eyes. Besides, the government was offering the G.I. Bill at the time.

After five minutes of careful thought, we went to the recruiting office and signed up. Then we took the physical. I passed, and he flunked—some sort of heart condition, as I recall. A week later, I was alone among fifteen swearing teen-agers, looking out the back end of a truck in San Diego, California.

My last view of civilian life was when the military police slammed the gates behind us as we entered the base. On the way to our destination, we saw the veterans, recruits of four or five weeks, giving us the one-finger salute, and singing, "you'll be sorrrry." I suddenly realized that my life was not my own for the next four years.

I guess I should call boot camp work, because I didn't enjoy most of it. However, it wasn't quite work, because I knew that I would eventually get a college education. I wasn't dead-ended in life. This four-year period would be a temporary stepping stone to a better life.

Flying Even Further from Work

Eventually, I went to aviation electronics school in Memphis, Tennessee, for about a year, and received flight training for airborne radar operators. Although this period was very demanding at times, I certainly couldn't call it work. It was challenging, and, except for the usual Navy penchant for making sure no one ever got the idea they were free human beings, it occasionally was downright fun.

My next assignment, to Anti-Submarine Squadron VS-23, wasn't work either, although I wouldn't want to do it again. I also began to appreciate how skewed our values are. I got paid much more to play around with electronic equipment and to fly—which was fun, like any exciting sport where danger is involved—than did people who truly worked. When we returned from a flight, I used to feel sorry for the seamen who were pushing the airplanes around, or, much worse, chipping paint. (There are *always* drudges chipping paint on an aircraft carrier.) In fact, of the two aspects of my own job, I much preferred to risk my life flying off of, and landing on, aircraft carriers than to work on electronic equipment.

Pay For Not Working

After the Navy, it was a bachelor's degree in three years from Central Missouri State, including summers, and a Ph.D. from Purdue University in another four years. Of course, the G.I. Bill wasn't enough, and I had to make money during these times. As an undergrad, I was a residence hall counselor. In grad school, I taught basic courses on a half-time assistantship, and was director of a residence hall.

This was all totally recreation, even though I was dirt poor during the entire time. Learning is fun, not work. And the jobs just filled out a busy and interesting schedule. I still had time to go to athletic events, plays, special convocations, and all the things large campuses offer.

At one point in grad school, I almost did what you would call work. Another student asked me to go with him to help a farmer harvest some hay. It seems the farmer had just cut hay, and a severe rain storm was predicted for the next day. He had to get it out of the field before the evening.

The farmer gave us gloves and hay hooks (a thick metal hook about twelve inches long with a circular handle, used to grab the far end of a hay bale). Our job was to lift the bales of hay off the ground and throw them onto the wagon as the farmer towed it. By noon of that day, both my hands were covered with blisters.

The farmer's wife fixed us a lunch that has never been surpassed in my lifetime. Fried chicken, mashed potatoes and gravy, fresh tomatoes and salad, ice tea—the works. It was all home grown and there was as much as we wanted.

When we finished haying at about five o'clock, the blisters had turned to bleeding sores and the gloves were ruined. For the next week I could hardly get out of bed. But it wasn't work. It was an enjoyable, fleeting *slice* of life, not the *rest* of my life.

To me, a young college student, spending a day on a beautiful, hot day in a hayfield—feeling my body going through motions I wasn't sure I could do—was recreation. In fact, I was so pleased with the experience, I "recreated" for the farmer on several other occasions.

Continued Avoidance of a Respectable Life

Then it was ten years of college teaching and consulting, which has to be one of the most recreational combinations in existence. Naturally, any professor worth his pay spends long hours at his craft. But if he considers it work, he's in the wrong business. And when he occasionally takes a break from classes to travel across the country for extra income, it's a boost to the ego as well as to the wallet.

After that, it was fifteen years as a full-time management consultant. This experience taught me that managers, executives and professionals rarely work, at least not like hourly paid employees do.

PERSPECTIVES ABOUT WORK

Any CEO, company president, or senior executive who brags that he "works" seventy hours a week is either lying or has a demented notion of work. I once had one of these guys come into my office trembling severely. "They" were about to force him out, and he didn't know what he was going to do with his remaining years.

The company had been his personal erector set. He moved people and plants around like the pieces of a child's Christmas present. He was respected in the community because of his position. People treated him with awe. Money wasn't the issue; he had more than enough to last him and his family for the rest of *all* their lives.

I suggested that he do some volunteer work, possibly improve his golf game. No dice. He only played golf because he was expected to; he never really enjoyed it that much. Volunteer work? No, he wouldn't be in charge. How about seminars that teach you how to deal with retirement? He had already been to two of the best ones in the country.

Had he actually been spending seventy hours per week at his job during his career? Yes. Was it work? No, it was not only recreation, it was his whole life.

Marketing professionals have told me that taking a client on an all-expenses-paid ski weekend was work, because sometimes they didn't like the client or the client's wife. Good gawd, how intolerable.

I've taught week-long seminars for industry in which I had virtually

no time off. People talked to me about business during breakfast, dinner, lunch, and over cocktails in the evening. Occasionally I felt trapped and wanted to be back in my own home.

Still, the creature comforts were always the best. The rooms, the meals, the way the trainees and the hotel staff treated me—I didn't want to do anything else, at least at that time in my life. Was it work? Of course not.

Well, then, what is work? Real work is cutting up meat in a slaughter house, while you are ruining the muscles and tendons in your hands, wrists, and arms. It's spending eight hours a day, five days a week in a dead-end job that you detest. It's harvesting hay for most of the summer, when you never want to see another bale of hay.

It's sucking poisonous fumes into your lungs when you clean out a vat that contained toxic chemicals. It's typing reports for some jerk who treats you like a brainless idiot. It's cleaning up a motel room where someone has vomited on the floor, and you're only making minimum wage.

For my money, a "worker" is anyone who handles a physical product or provides a genuine physical service, and who is in a job that has few formal educational requirements. The further removed you are from this, the less you are a worker, and the more you are a *nonworker*.

It's important to understand these distinctions, because your own particular category, worker or nonworker, makes a gigantic difference in how business persons, politicians, and the Limbaugh's of the world will evaluate your worth to society. It not only directly affects your wages, it affects the laws that control your ability to have a decent life.

RATIONALE FOR GREED

In my role as a management consultant, I've had many discussions with highly paid executives and professionals. Their rationale for their extremely high pay, relative to others, seem to fall into five categories. They're the same categories you see repeated in the financial press—refined, dressed up, and camouflaged, of course:

1. Most common reason given: "I work hard for my money." This is followed by a description of sixteen hour days in which the abused person travels, attends meetings, is away from his or her family, and ends the day exhausted.
2. "There are too many of *them*." Sure, you can pay high level executives huge incomes, but they are relatively few. There is no way you could pay thousands of workers a decent wage.
3. "Executives need incentives." How can you expect a high level executive to give his best effort, or act in the best interests of the organization, if you don't pay him an outrageous salary and benefits?
4. "Whoever said life was fair?" Life has never been fair, and there's no way to make it fair. All attempts to try only make conditions worse. You have to play the hand you're given. (And when some people make incredible amounts of money, it is inspirational to everyone else.)
5. "Workers are common, executives are rare." Workers are too common, and therefore less valuable to society. People who can manage and create jobs for others are much more rare, and more valuable—even to the workers themselves. Therefore, executives and professionals deserve the kinds of money they make.

Every worker reading these five excuses will immediately recognize their absurdities. For the benefit of affluent nonworkers, and other moral defectives who are incapable of seeing them, the patently obvious realities are:

First, the highly paid executive *enjoys* first-class pampering, and sixteen hours of it a day are barely enough. His subordinates, the company doctor, the corporate attorney, and an endless supply of stewardesses, hotel clerks, and general sycophants take care of his every need.

You can't mention an excellent restaurant in France, Spain, or wherever he's traveled, that he hasn't eaten at. And guess what (surprise!)—he'd rather die than to change places with the lower-level people who actually work in his own company.

Second, no one *expects* everyone to be paid the same. It's just that we shouldn't be creating a new class of royalty while large numbers of others don't make enough money to responsibly raise their own kids. Several surveys have found that American CEOs made six times as much as their counterparts in Japan, and four times those in Germany. (The same differentials apply for all the higher levels of executives.)

Third, if people making hundreds of thousands of dollars need still more incentives to do conscientious jobs, we've become totally corrupt. These are the same hypocrites who criticize the American worker, on a pitifully low fixed income, for not having a sound work ethic, and for not wanting to compete with workers in Mexico who make one tenth as much.

I guarantee you: work values are *strongest* among those Americans who truly work the most. But they are slowly losing them. "Uneducated" workers see what's happening on TV and read about it in the newspapers. They think about it and talk about it. The message they're getting is that work doesn't count. It's all image and salesmanship and what you can get away with. And the greedy jerks at the top are causing it all.

Fourth, as soon as we agree that life isn't fair, it becomes even less fair. That's the story of the '80s. Since life isn't fair, it's perfectly moral to get all you can, and don't worry about those who get left out. The practical expediencies of today become the moral standards for tomorrow.

Fifth, it's true that good workers are common in America. They're all over the place. But executives are common too. There seems to be a literal explosion of executives who are interested only in their own material welfare and little else. If you don't believe it, you need to talk to some lower-level personnel in almost any large American corporation. They've seen it personally.

And if you don't have access to anyone who actually works for a living, to give you an unbiased perspective, just read the newspapers. The destructive gyrations of egomaniacs at the upper levels of our corporations, financial investment groups, and government are splashed all over the front pages.

THE POWER OF INFORMED CITIZENS

So what do you do now? The most important action now is to separate yourself from the emotionalism of the Limbaugh demagogues. Do some research on your own and discover what's actually going on in our economy. Just reading a good daily newspaper should be enough, especially if you focus on the news items relating to politics, taxes, social problems, and proposed solutions.

Then, participate in the debate. Educate others about what work is, who the real workers are, and who truly creates wealth and jobs.

13.

Conservatives' hidden agenda: Screw the real workers

Remember this about demagogues: they *always* support the values and moral ideals of the people they wish to seduce. They can't be successful unless they come across as the victim's friend. Therefore, Limbaugh never says that low- or middle-income workers should pay higher taxes; he says that higher taxes on the rich will eventually hurt the middle-income worker. Instead of saying that powerful businesses should be able to pollute the environment, he says that we shouldn't allow government to strangle *small* businesses with environmental regulations.

The most important thing that Limbaugh lies about, however, is that he claims to value those who work hard for a living. Actually, everything he talks about ends up benefiting those who work *least* for a living—those whose activities are focused on milking democratic capitalism for everything it is worth.

The Limbaugh Double-Cross

A massive double-cross of the American worker is going on. Sons and daughters, grandsons and granddaughters, have been talked into sacrificing the class of people who gave them the kind of society in which they could become successful. Their ancestors put in long hours,

fought hard for better working conditions, and did an honest day's work for a sometimes miserly day's pay. Many of them gave up their own comforts and living standards, to send their kids to college. They fought in a few wars to preserve our social and economic system.

Now, because of the past fourteen years of conservative propaganda, our society has decided to betray the memory of those same people. It prefers short-term affluence over long-term economic health. Workers' livelihoods have become irrelevant in the political arena. They are as defenseless today as they were in the '20s and early '30s.

Limbaugh, well-financed conservative groups, business owners and executives have become politically powerful. Unions have lost most of their influence. Workers have only a few supporters in Congress, and the executive branch isn't all that friendly either. The '80s were hell for workers, and things don't seem to be getting better for the '90s.

The Conservative War on Workers

Recently, it seems that conservatives have been giving most of the credit for the success of the United States to nonworkers, at least if income is any indication. Nonworkers would include chief executive officers, high-level managers, investment bankers, college professors, lawyers, doctors, stockholders, management consultants, bond coupon clippers, and all those whose incomes are in the stratosphere.

On the other hand, workers' incomes didn't keep pace with inflation during the '80s. Manual laborers of all kinds saw their after-tax incomes actually go down relative to inflation: garbage handlers, manufacturing workers, farm hands, secretaries, machine operators, drivers, sales clerks, janitors, and hourly-paid employees of all kinds.

Those in between the two categories of worker or nonworker were able to keep up with inflation, exceed it a little, or lag behind a little: nurses, teachers, tradespersons, various categories of professionals, lower-level managers and supervisors, and those fortunate to have at least some support from those who control the distribution of income.

Income Disparity Between Workers and Nonworkers

So why do people who don't work make so *much more* money than people who do work? Because conservative nonworkers have

absolute control of our business and labor markets, and no other reason. It doesn't matter whether a person's income is sub-marginal or already outrageously high—*today, only the affluent and educated have the power to control their own incomes, because they control their own "free" markets.* Workers, because of the conservative political and financial successes of the '80s, have totally lost their ability to negotiate for higher income. They are trapped in a labor market that is rigged in every possible way against them. (This is described in detail in Part Three.)

Compare the "free labor markets" for two groups of health-care providers.

The *Wall Street Journal*, no less, reported that the rising number of physicians during the '80s coincided with *climbing* incomes for doctors. The data supported "the widely held belief that doctors, rather than consumers, control demand and compensate for any income shortfall by performing and billing for more services."[1]

Wait a minute! What was that? The supply of doctors goes up, and patients pay *more* because of it? Of course. If doctors have fewer patients, they simply charge each patient more in order to keep up their high standard of living. Naturally. Doctors are part of the power establishment. They have a great union, the American Medical Association, so they control their own market, which isn't "free" in any sense of the word.

Now consider nurses. In August 1993, a large Southern hospital announced that it was cutting nurses' pay in order to reflect "the end of the nursing shortage that marked the late 1980s."[2] In other words, nurses—those nurturing, caring, dedicated, anti-union, everything-for-the-patient, sacrificing souls—must take whatever others are grudgingly willing to let trickle down to them. For them, the wage market is truly a market, in the most cut-throat sense. They get what is left after the doctors, hospital executives, insurance companies, and all the hangers-on associated with them, have skimmed the cream off the top.

Look at two more situations. Example #1: In 1989, in a *failed* attempt to buy United Air Lines, a Wall Street firm made $8.25 million for its services over a two-month period. On average, that amounted

to $41,045 *per day*, per banker, for his or her efforts. It also assumes that the bankers worked seven days a week.[3]

Example #2: In June, 1992, the workers at Monroe Manufacturing Corp. earned the minimum wage of $4.25 an hour. The day before they were to vote in a union election, the president, Edward Hakim, told them: "Listen, if I can't compete in America with American workers, I'll take your jobs overseas where we can be competitive!"[4] He also told them that if they joined the union and went on strike, he would replace them with other workers. What he *didn't* tell them was that his company was immensely profitable, selling to "buy American" retailers such as Wal-Mart, Sears, and Kmart.

What's the difference in these two incidents? Well, the bankers were probably Harvard MBAs who wore white shirts, ties, and gray flannel suits. That alone makes them immune from criticism, even though they diverted over $8 million from productive use, caused the airline's stock to plummet, and triggered a minor stock market collapse. You see, there are absolutely no limits on how much affluent, educated people can legally steal.

Manufacturing workers, however, have totally lost their bargaining power. The way Mr. Hakim put it, "Look, it's better to be a Third World class of work force than no work force at all." How comforting. A philosophy that only a conservative could love.

If the above comparisons aren't enough, honestly answer this question: Who has been of more benefit to society in the past ten years, 500,000 savings and loan executives, with their investment bankers, lawyers, accountants, and marketers—or a single, solitary garbage collector who comes by your house twice a week?

A typical S&L president, especially of the *failed* S&Ls, made over a million dollars a year. The garbage collector, considerably less.

The only rationale for these kinds of injustice is that conservatives have been able to con us into making them *legal*, and, thus, morally acceptable. The huge income disparities we are seeing in our country are the result of our federal and local laws relating to working conditions, collective bargaining, income tax, investments, real estate, and every activity that affects who-gets-what of the material benefits our society has to offer.

To some extent, we've always had conditions that were biased against workers. But during the Republican '80s, it got much worse. (Of course, there were some conservative Democrats involved also.)

The "Uneducated" Worker

Of course, the ones who are worst off in our society are the workers without an advanced formal education, such as those at Monroe Manufacturing.

In the minds of conservatives, American workers have been lucky to have been associated with our nonworking, public-spirited rich citizens for the last few centuries. Coarse, uneducated, with simple wants and limited potential, they have benefited from the best social order that mankind has ever developed. Despite the poor quality of their work, they've had a high standard of living—compared to the drudges of historical note—dumped into their laps.

Judging from the kinds of legislation we've been getting lately, the free ride is over. The affluent and educated nonworkers of America are tired of carrying workers on their backs.

You see, manual labor is out and intellectual activity is in. The reason is simple: there are very poor people all over the world who will work their heads off just to have enough to eat. And the American worker's privileged status as the main provider of American goods and services has been officially declared dead.

Conservatives throughout the world agree that, in the international free market, those with intellectual skills will have, and be entitled to, an excellent standard of living. Those who physically handle a product or provide a necessary service will have, and deserve, only a subsistence standard of living, at best.

While this may seem a harsh reality to some, there are simple solutions. Whether they like it or not, workers must start sending their prekindergarten kids to prestigious developmental schools. At home, they should help their teenagers with their homework—learning French, calculus, English literature, and so on.

When the kids graduate, they should be forced to attend a first rate university—like Harvard, Princeton, or Yale. While there, they should be made to join a fraternity or sorority and suffer all the hard work,

pain, and suffering associated with these kinds of broadening experiences.

During these developmental years, American workers and their families should vacation in several different countries so they will be able to function effectively in the worldwide community of the future.

In other words, if American workers are to justify receiving more than a subsistence income, they must start making the same sacrifices that rich nonworkers have had to endure over the years.

THE REALITY OF WORK AND WORKERS

It's hard to tell which is worse in conservative politics: the sheer callousness in discounting the contributions of American workers since the beginning of our country—or the hypocritical pretense that masses of workers can magically educate themselves into higher-paying occupations. In my thirty years of consulting, I've dealt with all levels of American management. Some of them had Ph.D.s, some had MBAs, and some simply developed themselves by coming up through the ranks. I've also worked with laborers who were *forever* trapped in manual-skill jobs because of poor education or poor family background.

Judging from the behaviors I've observed, I believe that *at least* half of the credit for America's success is due to workers' quality of work and the sacrifices they've made. Most of them are good, smart people with high school degrees or less. If they are unskilled to begin with, they can become quite skilled at doing whatever is asked of them.

I would also say that the present problems of our economy are *totally* caused by the nonworkers who now are in control of our society—investors, managers, owners, stockholders, doctors, lawyers, consultants, college professors and administrators, and all those who support their short-term, riches-at-any-price practices.

Workers produced our food, made our clothing, gave us our cars, and built our cities. They also fought our wars, beyond their proportionate share, relative to the affluent and educated. (In Vietnam, only 7 percent of our enlisted troops had completed even a year of college.)

No matter how good the inventor's idea, or how hard the developer worked, nothing happened without the American worker. If the worker didn't mine the metal, build the factories or operate the machines, nothing happened. Yet their incomes, and the refinements in their working conditions, have never kept pace with the quality and amount of their contributions.

From the sweat shops of the '20s to the chicken processing plants of today, workers have sacrificed their physical health, and often their mental health, to provide the products that made us what we are—and often for very little money or gratitude.

Of course, owners, managers, college professors, doctors, etc. deserve more of the finer things in life than others who have not developed the necessary self-discipline or taken similar risks or made the same kinds of sacrifices. It is just that the differences in rewards should not be so incredibly huge—to the point where the affluent are a new kind of royalty.

On the other hand, poorer workers, even marginal middle-class workers, are entrapped in chattel-like conditions, having little hope for a gratifying future, either for themselves or their children. They're living in increasingly dangerous communities, sending their children to deteriorating public schools.

What is especially galling today, however, is that we are abandoning what little support we used to give to our workers. We've decided that we no longer need the people whose efforts got us our affluence. They are getting in the way of progress, and they are slowing the uninterrupted accumulation of wealth by those who are already either wealthy or educated, or both.

A TIME FOR CHANGE

It's time to change some attitudes. Workers' requests for more pay are considered inflationary. At the same time, wanton greed among nonworkers is not only not condemned, it is respected.

It's interesting how readily we will set limits on the worth of man-

ual labor. Yet, we won't even begin to consider setting limits on how much nonworkers can make.

I'm not suggesting that we *should* set limits on how much anyone can make. The point is that in the United States (although the problem is worldwide) prejudices against workers are getting worse, not better. These prejudices have many causes, but the major one in the United States is to be found in the persuasive communications of powerful conservative individuals, like Rush Limbaugh, and organizations that are brainwashing the public.

The kind of people who are smart enough not to work are also smart enough to convince those who do work that they, the rich nonworkers deserve so *incredibly much more*. Those who scheme and plot and devote their lives to materialism always take advantage of those who simply believe in a fair day's pay for a fair day's work.

In other words, if you are an American worker, Rush Limbaugh and the conservative political establishment have sold you out. You've outlived your usefulness. You'll now have to fend for yourself, and few business persons or politicians are willing to make any sacrifices to help you out of the bind you're in.

It will be well worth your time and effort to find out who your friends really are. If you are a worker and a Limbaugh supporter—wise up, you've fallen for one of the slickest cons going.

14.

Two philosophies: survivalism and stewardship

When newspapers reported that Ruth Bader Ginsburg was worth $6.1 million, Limbaugh repeated his frequent charge of hypocrisy against Democrats: "Aren't you amazed at how many in Clinton's circle are millionaires? And they've tried to convince everyone that they're just common folks like you."

He does this all the time. It is another version of his liberals-hate-wealthy-people themes, like: "If Jay Rockefeller wants to pay more money to the federal government, all he has to do is just do it. He doesn't have to raise *your* taxes."

In both of the above instances, Limbaugh is the hypocrite. Liberals don't have anything against wealth or the wealthy, as Limbaugh charges. Many liberals are very wealthy, and want to get wealthier. It's just that wealthy liberals realize they are better able than most people to pay more taxes without undue sacrifice. They also know that millionaire "volunteerism" won't work, because most millionaires aren't known for their charitable instincts.

Two Kinds of Political Philosophy

Of course, the real hypocrites are the ultra-rich who say that taxes on them are bad for the middle-income American. They eagerly propa-

gandize the myth that wealth trickles down. Their political philosophy is one of *financial survivalism*, and they will say anything if it benefits them materially. They actively try to convince voters that:

- It's every person for himself or herself. Life is, and always has been, survival of the fittest.
- All spoils go to the victor; losers should accept their lot without whining.
- Society should not try to control, or compensate for, "natural" predatory behaviors *in the world of taxes, finance, and business.*
- "Fairness" (one of Limbaugh's pet peeves) has nothing to do with anything. You can't worry about the sins of the past, whether yesterday or 300 years ago. You play the hand you were dealt, and you don't complain.

The hypocrisy of the financial survivalists is that they are either the direct beneficiaries of the abuses of their ancestors, or they are now abusing the system they are controlling.

They don't *have* to worry about fairness, because the rules are biased in their favor. They don't worry about losers, because they and their descendants are almost guaranteed to win. Since they are winners, they want to win a *lot*. Whereas they can't see the need to protect society from financial predators—which *they* are—they *do* want protection from physical predators (predominantly, low class crime). They are all for rules, law and order—for others.

On the other hand, the millionaires who want higher taxes for their own class believe in the *stewardship* responsibility of every citizen. They know that:

- Fairness is the foundation of every society. An unjust society will self-destruct from within. If any society is to survive for the long haul, it must provide genuine opportunities for everyone to succeed.
- A government must collect whatever taxes are necessary to solve the significant problems that private enterprise or gov-

ernment has caused in the past, and that are not adequately addressed by charities and similar organizations.

- As a minimum standard, every citizen who works forty hours a week should be financially able, after taxes, to do a responsible job of raising a family.
- Those who are best able to pay taxes are also the ones who have already benefited most from society. They have an increased obligation to financially support government for the benefit of their own descendants, if for no other reason.

Those who have the political philosophy of stewardship believe that *every* citizen has a moral obligation to help maintain both the physical environment and his human community. This obligation extends to the government, the financial world, the tax system, and all those elements that affect the quality of life for everyone.

The rich who believe in a stewardship form of political action know that millionaire "volunteerism" won't work, because too few of them would willingly agree to pay more taxes. Internal Revenue Service data showed that the very rich became stingier as the '80s progressed.

As the highest marginal tax rate plummeted from 70 percent to 28 percent in 1988, taxpayers earning $500,000 to $1 million cut their average charitable donations from $47,432 to $16,062, while those with incomes over $1 million slashed theirs to $72,784 from $207,089. A mere 5 percent of those with incomes over $1 million account for half of all contributions by this highest-income group.[1]

In other words, for most members of the super-rich, the richer they got, the stingier they got.

ECONOMIC "EXPERTS"

If the '80s proved anything, it's that you can't trust *anyone*, and you *especially* can't trust people just because they have an impressive sounding position in academia or in government.

The precise connection between reality and one's economic ideol-

ogy—whether survivalism or stewardship—remains a mystery. However, the diversity of economic philosophy indicates that it has more to do with potty training than it does with a formal education in economics or a university degree.

Actually, it's probably not how an expert was potty trained, as much as whether he or she was born into the nonworking class or into the working class. It also could be the result of being born a worker and then becoming a wealthy nonworker, or *planning* to become a wealthy nonworker. Or an individual may be a rich nonworker who is afraid of the workers, or a worker who is angry at the nonworkers.

As the expert grew up, his role models gave him a sense of stewardship—justice and ethical responsibility—or they taught him that life is survival of the fittest or the most fortunate, and justice (or fairness) has nothing to do with anything.

There are limitless kinds of worker/nonworker/justice circumstances, but, in one way or another, they account for all the economic philosophies you'll ever come across. These have more to do with an expert's personal view of the world than any objective reality.

The "Expertise" of Rush Limbaugh

Consider Rush Limbaugh III and his family's influence on his thinking. His grandfather, Rush Limbaugh, Sr., was a lawyer, a member of the Missouri House of Representatives and chairman of the Cape Girardeau County Republican Committee. His father, Rush Limbaugh, Jr., was also a lawyer, also chairman of the Cape Girardeau County Republican Committee, and was one of the popular right-wing conservative speakers in his area.

President Ronald Reagan named Limbaugh's Republican uncle, Stephen Limbaugh, to the U.S. District Court. His Republican cousin, Stephen Limbaugh, Jr., was appointed to the Missouri Supreme Court. His brother David is a wealthy Republican lawyer, and has represented Rush in contract negotiations.[2]

Think of it! An entire family of wealthy Republican lawyers.

How could anyone overcome that kind of environment? So, if you ever marveled at how li'l Rush Limbaugh III can spend three hours a day in endless, repetitious, mean-spirited, conservative babble, now

you understand. It is no accident, and it isn't all that difficult for him. It is a classic example of how defenseless children can be programmed from birth to spew out mindless conservative sound bites with no conscious thought whatsoever.

Friedman versus Galbraith

For genuine economic expertise, consider Milton Friedman and John Kenneth Galbraith. Their contrasting opinions are perfect examples of the subjective nature of economics. They are fully accredited experts, and look at the same economic and social data. Both are past presidents of the American Economics Association, Friedman in 1967, and Galbraith in 1972. Both have a lifetime of prestigious positions and a long list of books and articles in scholarly journals.

Friedman feels that the totally free market would solve most of our economic and social problems. Hence, workers would be better off if the market worked without any restrictions, and unions didn't exist. Galbraith, on the other hand, sees the need for government intervention to overcome some of the deficiencies of unfettered capitalism, and feels that workers need bargaining power.

These two brief explanations are oversimplifications of their positions, but they are adequate enough to point out something that hardly needs proving: being a legitimate, recognized expert doesn't mean that one is correct about *anything* relating to economics. There'll be much more about Friedman and Galbraith in Part Three.

Political Economic Experts

In one way or another, political parties can be placed somewhere between two opposite beliefs. Republicans equate the moral principle of "the greatest good for the greatest number" with communism, of all things. Therefore, they believe that an economic system should produce a few winners, some also-rans, and large numbers of losers. They see the economic system as a game, and the object is to get all you can.

This is the survival-of-the-fittest sort of mentality. It also suggests that the most powerful winners—those who have accumulated the most money, and their descendants—should control the economic system in every way they can.

Democrats, on the other hand, use the moral principle of "the greatest good for the greatest number," *not* as a disguised form of communism, but as a standard for judging *any* kind of government. This principle is fundamental to democracy and is the primary goal of democratic capitalism.

It holds that an educated, *informed* citizen is the best judge of various economic policies, and that government should not allow powerful economic predators to control our free markets. It supports the belief that every citizen, from birth, should have reasonable opportunities to prepare for, and eventually have, a decent job that is fairly rewarded.

Of course, the ultimate disagreement between the two philosophies is about taxes. Republicans always favor tax breaks for rich nonworkers—capital gains benefits, reduced property taxes, lower inheritance taxes, lower income taxes for the wealthy, etc.

Democrats also want lower taxes, but primarily for low and middle income workers—lower social security taxes, lower sales taxes, lower income taxes for workers, and so on.

THE 1980s PROPAGANDA EXPERTS

If you want to know who supported the predatory survivalists who brought you the 1980s and the tremendous injustices between the incomes of workers and rich nonworkers, all you need to do is study the publications that support America's conservatives and their economic goals. Note that the following references match Rush Limbaugh's positions perfectly, and they have undoubtedly supplemented his childhood indoctrination.

The Financial Press

As far as the financial press is concerned, it's as though none of the world's great philosophers ever existed. It's like Socrates said "Greed is good," instead of "The unexamined life is not worth living."

It's like the one who said " 'Greed without guilt' is our banner and byword" was Immanuel Kant, instead of Daniel Seligman.

Seligman, for benefit of the unwary, is one of the Limbaugh-style

117

philosophers at *Fortune* magazine, and he made the statement in his column of March 2, 1987. Always one to defend the high ideals of greed and excessive profits, Daniel warned:

> Our own view is that what people are calling greed tends to be operationally equivalent to good old profit-maximization . . . Meanwhile, nobody out there seems to be defending greed. Badly needed in the current situation, one intuits, is some business-side counterpart of Dr. Ruth Westheimer, the famous TV sexologist, to make people feel good or at least not excessively guilty about their acquisitive instincts.[3]

The late Malcolm Forbes, when editor-in-chief of *Forbes*, put it much more succinctly in one of his famous, and amazingly frank, two line editorials:[4]

<div align="center">

IF THIS IS IT
make the most.

</div>

By the way, Malcolm understood the difference between how you treat the workers *versus* nonworkers. He spent over $2 million for his birthday celebration in Morocco for his wealthy friends.

Later, after his annual *Forbes* magazine staff Christmas party, an employee said, "We were handed a box of popcorn and that was it. Then we were forced to sit and watch home movies of his trips to Morocco and Spain. We had to stay for two hours, and people who didn't want to go to the party were made to feel awful."[5]

Given the number of our rich, respectable American citizens who have been caught with their hands in the till, Seligman's concern for the survival of greed seems a bit overdrawn. And Forbes' recommendation to get all you possibly can in this life hardly seems necessary.

The '80s Version of Fair Pay

According to America's financial press, business executives' pay should be in line with their stratospheric greed. In other words, they should be paid a *lot*. Unfortunately, *workers*, having low expectations, no bargaining power, and no political influence, shouldn't be paid much at all.

Forbes' Steve Kichen noted that the chief executives of the fifty largest corporations made only $114 million in 1989, and opined that "Relatively speaking, that's not much." His reasoning:

> The group's aggregate remuneration works out to a mere hundredth of a percent of the companies' $1.3 trillion in revenues, and less than two-tenths of a percent of their $73 billion in profits.[6]

Damn, Steve. We can appreciate how these poor fellas might feel slighted when they see all that money lying around, but do you realize what that means about the typical hourly worker's pay?

According to your figures, the average CEO here is making $2,280,000. To make it easy, although overgenerous, let's assume that the average hourly worker in his company is raking in $22,800. This means that the average worker is getting a mere *ten thousandth* of a percent of revenues and less than *two-thousandths* of a percent of the profits. It's hard to envision anything that small.

Also, do you mean that if one of these egomaniacs takes over another egomaniac's company in a hostile takeover he should then make $4,560,000, based on total profit? Just because he can mismanage two companies in the same amount of time he can mismanage one—does that mean his income should double?

In addition, can't one person survive on, say, only a million a year? With good investment advice, which CEOs get free from their corporations, shouldn't they and their families be able to survive for eternity on just one year's income?

The average working couple can't even make it through November if the refrigerator conks out. Many of them, if they have a major illness, may be ruined for life.

Real Prestige: The Harvard Business Review

Of course, one would expect *Forbes* to lead the pack in supporting blatant greed. But Harvard professors are not to be outdone by someone outside academia. Harvard's Michael Jensen and Kevin Murphy (of Rochester) made even more extensive, and ridiculous, justifications for sheer avarice.

In the *Harvard Business Review*, they looked at increases in CEO pay, related to the increasing prices of their companies' stocks:

> For the median CEO in the 250 largest companies, a $1,000 change in corporate value corresponds to a change of just 6.7 cents in salary and bonus over two years. Accounting for all monetary sources of CEO incentives—salary and bonus, stock options, shares owned, and the changing likelihood of dismissal—a $1,000 change in corporate value corresponds to a change in CEO compensation of just $2.59.[7]

As a tribute to the high regard they have for social justice, Mike and Kevin concluded:

> Are we arguing that CEOs are underpaid? If by this we mean "Would average levels of CEO pay be higher if the relationship between pay and performance were stronger?" the answer is yes.[8]

C'mon Mike and Kevin. In the U.S., the average hourly employee didn't even keep up with inflation for the past fifteen years, let alone participate in the increase in value of his company's stock.

Adjusted for inflation, the average worker got *less* as his company's stock went up. In fact, as everyone knows, one of the main reasons stocks went up in the '80s is that workers made less. When workers make less, companies make more profits, the stock goes up, and the execs get bigger bonuses. That's managerial ability for you.

Mike and Kevin also made the same tedious analysis we find everywhere: they compared CEOs' income with the groups that have some of the highest paid thieves in the world—investment bankers and lawyers. For example, they noted that the *average* partner in Drexel Burnham Lambert, and there were *twenty* of them, made $18,000,000 in 1988.

Business professors always do this. When they want to justify the greed of their best clients, they always pick someone greedier. Giving credit to Mike and Kevin, at least they didn't make the usual compar-

isons by picking rock stars and Hollywood actors. But, after all, they have their standards, and their article was in the *Harvard Business Review*.

When business publications and Harvard professors look at the pay of executives, they always compare up. When they consider the pay of laborers, they always compare down.

For example, suppose a Harvard professor consults with a company that wants to pay its workers as little as possible. He first tries to compare wages the client company pays with the wages other conspiring employers in the area are paying.

If that doesn't work, he points out that the guy who cleans up the elephant dung at the zoo in Bujumbura, Burundi only makes *75 cents a day*. There are many like him and they would all love to work in a plant imported from the U.S. That usually stops any worker discussions about unionizing, the Harvard prof collects his fee, and the CEO is written up in *The Wall Street Journal*, *Fortune*, and *Forbes* as a tough, "bottom-line," competitive manager, fully deserving his huge bonus.

Of course, the wage disparities cited here occur throughout our entire society and include all levels, not just CEOs and lower level workers in corporations. The fundamental determinant of income, regardless of a person's title is: to what degree is the person a worker, or a nonworker?

How you evaluate these income disparities, in terms of ethics and morality, depends upon your philosophy. Are you a survivalist, still mired in the primitive stage of human evolution? Or do you believe that we are capable of rising above our primitive animal instincts to become stewards of our world?

And, incidentally, which of these philosophies best typifies family values, and the tenets of every major religion in the world?

15.

Right-wing conservatives: the anti-capitalists of the '80s

Limbaugh has noted that the rich paid more taxes after their rates were lowered in 1982 than they did when rates were much higher. He cites this as proof that lower taxes on the rich means more tax revenue for the government. Since the rates went down from 70 percent to around 33 percent in 1982, one superficially would think he had a good case.

Of course, what Rush is leaving out is that, although tax rates on our richest citizens went down by half, their incomes went up *twenty-one* times, straight into the stratosphere. According to the Internal Revenue Service, from 1980 to 1990, incomes for those making over $1 million/year increased by 2,184 percent. Incomes for those making $200,000 to $1 million increased by 697 percent. No wonder these people paid more taxes, even at lower rates. I'm sure those who earned $20,000–$50,000 a year would gladly switch places; their incomes went up only 44 percent, and didn't even keep up with inflation.[1]

It is even more important to understand *why* the rich made so much money in the '80s. You see, our "super-capitalists" spent the 1980s cashing-in, buying-up, and selling-out the past forty years of American productivity. They became, in reality, a new breed of *anti*-capitalists.

Capitalism is designed to reward individual incentive and risk-taking. People invest money in land, manufacturing plants, equipment, research, technology, and so on, hoping to make a profit. Taking money out of those same productive uses, with no exchange of value, is *anti*-capitalism, and the middle-income worker's worst enemy.

And that's what the '80s were about. As the decade progressed, our wealthier citizens sensed that the cycle of materialism was coming to its explosive end. Getting rich fast was never so readily possible in our country, but time was getting short.

They had the eerie feeling that our society was spinning out of control. Apparently unsolvable problems were becoming more so, and the cost of future attempted solutions may make it harder to accumulate wealth.

These feelings led to one of our most wanton periods of the rich cashing-in, buying-up, and selling-out. They:

- *Cashed-in* workers' pension funds, company health plans, safety programs, corporate research programs, functioning manufacturing plants, office buildings, and anything of value for money on the barrelhead.
- *Bought-up* yachts, furs, second-third-and-fourth homes, airplanes, neighborhoods, treasury bills and bonds—anything associated with luxury, or profit without effort or risk.
- *Sold-out* middle- and lower-income American citizens, especially those in the manufacturing industries. They destroyed the power of labor unions, shipped jobs to Mexico, imported low-wage immigrant workers, and so on—in exchange for huge profits and bonuses for themselves.

THE SUPER RICH

The super rich are selling-out American workers in just about every way they can. The inheritors of wealth are cashing in their chips, and they don't give a damn where the chips fall.

Sidney Carroll, an economist at the University of Tennessee, studied the statistics of private wealth and investment between 1983 and

1989. He concluded that recipients of massive inheritances have little incentive to engage in the creative entrepreneurship that built their family fortune. In fact, "the evidence suggests that people receiving windfalls through inheritances tend to reduce their labor force participation."[2]

In other words, they take their money and run.

The Fourth Generation

The rich of today are not like the rich of yesteryear, who at least pretended that they wanted to spend their money prudently. First-generation robber barons seemed to care somewhat for the business they were in, or, at least, they usually knew something about it.

Their descendants, certainly by the fourth generation, couldn't care less about the business, its employees, or its customers. All that counts is the money. There is no way that socially responsible decisions can be made when money is the *only* issue.

Fortune magazine described the fourth generation of Rockefellers, known as the "cousins," who sold Rockefeller Center to the Japanese:

> After a century of unparalleled good works, the legendary family's sense of mission has faded, and fecundity is splintering its fortune. Not even a few billion goes all that far when split among 83 heirs, many of whom hanker for more cash—now. . . . This family is down to the Cash-Out Generation.[3]

According to *Newsweek*, Mitsubishi, which bought Rockefeller Center, has been reinvesting its profits in real estate. The Rockefellers, on the other hand, had been selling off property for more than four years. This was after heirs complained that the bulk of their trusts was tied up in commercial buildings, and some of them weren't getting enough money from them.[4]

The Millikens

The Rockefellers are pikers, however, compared to the Millikens.

The *Charlotte Observer* reported the Milliken family's investment values this way:

In his 42 years in the business, billionaire Roger Milliken has guarded the Milliken & Co. empire against all outsiders.

He was the Carolinas' richest man, yet he lived modestly in a downtown neighborhood and drove an aging car. He refused interviews and shunned publicity. . . .

Fed up with their uncle, Milliken's nieces and nephews sold stock in September to two competitors, Erwin Maddrey and Bettis Rainsford, who run a prosperous five-year-old Greenville, S.C., textile firm. "They felt we would be willing to entertain taking on Milliken by aggressive means," Rainsford said. "We are. . . ." At stake is a $3 billion textile firm. . . .

"They all respect [Roger Milliken]. They love him. But they'd like more money for their stock. . . . "

[Roger's comment to one of his nieces]: "Agnes, don't you have enough money as it is?"[5]

How's that for family loyalty? And conservatives can't understand why workers aren't satisfied with their wages. They even have the gall to blame increases in worker's incomes for many of our economic ills, such as inflation and our nation's loss of manufacturing jobs.

The Gettys

For sheer spectacle, however, look at the Gettys. They have so incredibly much to fight over. It could almost be called entertainment for the public, if it weren't so pathetic. *Fortune* magazine described how concerned this super-rich family is about creating jobs for American workers:

A raging and bizarre family fight is buffeting the Sarah C. Getty Trust, the chief beneficiary of last year's sale of Getty Oil to Texaco. At stake is control of about $4 billion in assets. . . .

The trust is so immense that last year, when it tried to move the Texaco proceeds into Treasury bills with dispatch, it was slowed to a crawl by a Treasury rule prohibiting any one buyer from taking more than 35 percent of the bills sold at each weekly auction. . . .

The battle was escalated to all-out war by three sisters. . . . [T]he trust (previously) provided each sister income of about $8.8 million annually. But when Texaco bought Getty for more than $10 billion . . . the trust's income leaped and so did each sister's share—to more than $35 million in 1984. . . . [6]

If all this seems like harmless family squabbling that doesn't affect you, remember: when these people and their descendants get their cash, they're going to buy, among *many* other things, twenty acres of prime oceanfront.

The same place you *used* to go fishing. They'll put a fence around it, build a single mansion on it—that they'll use three weeks out of the year—and hire a security staff with guard dogs to keep out the working riffraff on their days-off. Hope you enjoy watching TV all day.

Their most important concern is keeping their power to exchange money for true wealth (products and services). Investing in manufacturing plants in the U.S., in product research, in employee training, in advertising, etc.—in other words, *capitalism* —is irrelevant to them.

THE LEVERAGED BUY-OUT (LBO) SELLOUT

Every rich American "investor," with the assistance of any available investment banker, is combining forces with whatever lawyer he can find to steal everything he can from all possible corporations in the United States. Some of the more popular techniques are known as greenmail, the hostile takeover, and the leveraged buy-out (or LBO for short).

When it comes to destroying the middle-income American worker, the LBO is a more important factor than are heirs to fortunes. For sheer greed masquerading as business acumen, nothing can beat it.

According to the LBO mentality, the worker's welfare is totally irrelevant to ethical management decision making. Of course, this attitude affects all kinds of management actions, but it's devastating when done on a large scale, as most LBOs are.

There are undoubtedly many causes of the loss of a "sense of community" throughout the United States. But the LBO mentality, and its

devastating effects on the majority of employees, has to be one of the most important causes.

There have been many notable LBO failures that resulted in bankruptcies, reorganizations, and massive junk bond defaults—all of which hurt workers immeasurably. But even the successful ones have ended up hurting workers. There are many variations, but a "successful" LBO works like this:

Step 1. A group of wealthy investors with excellent credit ratings sells bonds with huge interest rates to other wealthy investors.

Step 2. With the money from the bond sales, and little or *none* of their own, they buy a corporation.

Step 3. A sidestep: they pay off a black—er, "greenmailer," to keep him from doing the same thing.

Step 4. They "streamline" the company. This means that, in one way or another, they get rid of 63,000 managers and workers. And they close down or sell the corporate units they don't understand. The workers who survive the massacre see their wages cut from $12.00 an hour to $6.50 an hour.

Step 5. They tell workers that they must now work much harder if the corporation is to survive. Because of the corporation's new heavy debt load (the high-interest bonds, remember) and the reduced workforce, each person must reach much higher levels of performance. If they don't reach their new back-breaking objectives, they'll be punished severely, or possibly lose their jobs.

Step 6. They remind workers that if they don't like the way they are being treated, there are plenty of jobless out there who would like to replace them.

Step 7. When the suicides set in and people die of heart attacks, marriages break up, and some workers turn to crime, the rich investors and the financial press start the propaganda campaign. They explain why it was all necessary: the workforce was lazy and needed to be shaken up by rich saviors with superior family values.

Step 8. The greenmailers, whose only role was intimidation, deposit $59 million profit in their bank accounts. The investor group gets $60 million in fees, and their stock in the company increases by $625 million. The directors and top executives of the corporation deposit $28 million in their own bank accounts.

Step 9. Wall Street proclaims another exemplary success for capitalism.

In case you're wondering, the investors who raped the employees of Safeway followed these very same nine steps. And guess what—the Safeway leveraged buy-out was cited as one of the *good* ones. That was before an in-depth investigative report was published in the *Wall Street Journal*.[7]

Even after the *Journal* article came out, *Forbes* still considered the Safeway buyout a good one. According to *Forbes* Managing Editor Lawrence Minard, "That Safeway has been able to . . . improve upon its pre-LBO performance is a real tribute to its chairman, Peter Magowan."[8]

No one could make a statement like that unless profit for the wealthy were the sole criterion—not social responsibility, not justice, not honor.

George Roberts, one of the principal partners of the investment group involved in the Safeway robbery, was quoted in the *Journal* this way:

Employees "are now being held accountable," Mr. Roberts says. "They have to produce up to plan, if they are going to be competitive with the rest of the world. It's high time we did that."[9]

There are no better examples of the gray-flannel anticapitalist barbarians of the '80s and their hypocrisy. *Low level employees* are the villains in all this! Roberts and Minard have demonstrated America's growing prejudice against middle- and low-income workers as well as it can be done.

WHERE THE MONEY IS GOING

What are they doing with their money after they've sold out? It's not going, in any *serious* way, into education (except for their own children), manufacturing (unless it's in Mexico or Taiwan), technological development (unless they themselves have a rare disease; they *will* fund research for that), or other productive applications.

The bulk of it is going to themselves—personally, and for their own creature comforts. After they, their children and their grandchildren are *completely secure*, they then may consider contributing to charitable organizations. Naturally, to help the people whose jobs they eliminated.

If you want to look at what rich people are doing with their money these days, and you don't know any of them personally, just spend a few days reading the news periodicals (the figures below represent pre-1992 prices and will have undoubtedly increased by the time you read this):

- The *rights* to buy ten season tickets to the Charlotte Hornets sold at auction for $97,500. (Note that the rights holders *still* have to buy the tickets.)
- You can rent a yacht for twelve guests in six staterooms for $88,000 per week in Ft. Lauderdale.
- The green fee at Pebble Beach is $200—per person.
- A "bungalow" in Palm Beach is $350,000. It's $3 million to $20 million for ocean front.
- Residences at Fisher Island, Florida, with "unparalleled security," range from $500,000 to $7 million.
- The list never ends.

TO SOME, ANTICAPITALISM IS ONLY A GAME

Richard Munro, CEO of Time, Inc., commented on the roughly $12 million he stood to make over a ten-year period because of his company's acquisition of Warner Communications:

"That sounds like a lot of money unless you live in New York and live in the world I live in. In New York City, it's like Monopoly money."[10]

Everyone's already heard Donald Trump's view: "I don't do it for the money. I've got enough, much more than I'll ever need." Aristotle Onassis offered a combination of Munro's and Trump's philosophy: "After a certain point money is meaningless. It's the game that counts."

With almost tedious repetition, so-called investors claim that money itself means nothing. This is, of course, a patently transparent attempt to remove the stigma of greed and immorality from their actions. "It is just a way of keeping score about who's winning."

Too bad. Money is very important to the American workers who are hurt by the callousness of the game. For them, genuine capitalism, the investment of money into *productive* enterprises *in the United States,* is crucial to their survival.

So, despite lower tax rates, did the rich pay more taxes than ever before, as Limbaugh claims? Of course they did, and no wonder:

During the '80s, the ultra-rich got outrageously high *after-tax incomes* for themselves by cashing-in, buying up, and selling-out the wealth that genuine capitalism had created over the previous forty years. In exchange, low- and middle-income citizens must now deal with the social problems that poverty and community disruption cause—and a bigger share of future tax bills.

16.

Reagan and the '80s:
the best of times?

According to Limbaugh, "liberals are trying to rewrite history." They are trying to make the '80s look worse than they were, and they are ignoring all the good things in the United States. Limbaugh is doing his best to "prove" that the conservative economics of the Reagan/ Bush administrations paid off. Therefore, he has to convince the public that the '80s were good for America.

He cites examples such as: the wealthy paid more taxes in the '80s in absolute terms than ever before, the total number of jobs increased, people who invested in property and the stock market saw their wealth increase, and, in general, many people now consider themselves better off than ever before.

Schizophrenic America

To be sure, there are many good things about the '80s in America. Unfortunately, the United States has two distinctly different personalities, and the bad one far outweighs the good one. You read about its dual personality, and the resulting problems, every day.

For example, if you were a subscriber to *Forbes* and the *Wall Street Journal* on October 13, 1989, you got two quite different impressions

of the United States in that day's mail. One was enticing and upbeat; the other was depressing and foreboding.

The upbeat publication was *Forbes'* first edition of *Personal Affairs*. It came out in October, 1989, and was a perfect symbol for the success of our most blatant decade of greed. The lead editorial explained the purpose of the new magazine this way:

> Knowing what, when, where, and how to enjoy the things that the pelf and power of success make acquirable or doable are what *Forbes Personal Affairs* is all about. . . .
>
> It's pretty dumb to spend full time in the countinghouse when you have more to count than you need for life/family essentials.
>
> So you can find the ways and means to have the fullness of life that success makes possible, Kip and Tim Forbes, along with *Personal Affairs* Editor Bill Flanagan, have created this new magazine.[1]

Inside the magazine, articles described how to lead a fuller and more satisfying life:

- Where to get a fine blazer (that's a coat-type blazer—the kind you wear) "at a pretty good price" of $2,200.
- Where to get made-to-order cuff links that "can add a dash of distinction to your business and formal attire." Up to $3,100 for 18-karat gold enameled links.
- Recommended three-star restaurants in Paris—"never mind the $150 per head."
- Getting a center-court seat at Wimbledon for $2,136.16.
- Buying multi-million dollar estates at cut rates in Texas. (One: "Though the asking price is $12.5 million, the house may . . . not bring much more than half that price. . . .")
- Four-in-hand horse racing—"the entrance fee is somewhere around $250,000, and the annual upkeep runs to six figures."
- Skiing in British Columbia, using helicopters and snowcats (which cost half as much) to get to the slopes.

- Where to find consultants who can help you design the boss's office, at $200-$500 per square foot. "Shame on you if your office is dull. All it takes to do up the place is time, money, imagination—and a bit of ego."
- Some of the others: SCUBA diving in Grenada; hunting deer and grouse in Scotland; stocking your wine cellar.

Whereas *Personal Affairs* was uplifting on that day in October, 1989, the lead article in the *Wall Street Journal* was a classic example of poor taste. The headline: "Along the Rich Banks of the Mississippi Live Poorest of U.S. Poor—They Endure a Lack of Jobs and a Plantation Mentality, While Landowners Thrive—Where Dreams of Blacks Die."

> For here is a region that epitomizes the extremes of American wealth and poverty. It is almost unbelievably fertile, with topsoil 25 feet thick or more. It has mansions and big cars and a wealthy gentry that for decades has gathered round the fountain in the ornate lobby of Memphis's grand old Peabody Hotel. . . .
>
> But, especially along the Mississippi, it has county poverty rates that range from 20 percent to 50 percent-plus. . . . It has white as well as black poverty, and good ol' boys gather over coffee to talk of dove hunting and running deer with dog packs.[2]

Forbes Personal Affairs was designed for those who are making more money than they can think of ways to spend. That's the side of America that Limbaugh is proud of. The *Journal* article is typical of the flood of news items that describe the side that is going to ruin our country for rich and poor alike, if we can't find better ways to solve the problems that the greed of the '80s has exacerbated.

The Political Causes of Decline

Kevin Phillips, in his *Politics of Rich and Poor*, presented the most thorough and definitive analysis of the health of the United States dur-

ing the '80s. He did so through the perspective of economic indicators and the political forces that affect them.

From every imaginable angle, Phillips presented a mind-numbing array of statistics that leaves no possible doubt: during the decade of the '80s, there was a massive shift of wealth from the poor to the rich.

Quoting figures based on the nonpartisan Congressional Budget Office:

> . . . since 1977, the average after-tax family income of the lowest 10 percent, in current dollars, fell from $3,528 to $3,157 (in 1987). That's a 10.5 percent drop. During the same period, average family income of the top 10 percent increased from $70,459 to $89,783—up 24.4 percent. The incomes of the top 1 percent, which were "only" $174,498 in 1977, are up to $303,900—a whopping 74.2 increase over the decade.[3]

According to Phillips, a new generation of wealth-oriented Republicans, with little or no opposition from Democrats, brought this about by changes in taxes, budget priorities, deregulation, and the roles of money and debt. As a result, our government has duplicated the same conditions that led to the depressions of "The Gilded Age" (panic of 1893) and "The Roaring Twenties" (crash of 1929).

At this point of our economic cycle, the beginning of the '90s, Phillips sees us at the last stage of ascent, just prior to "speculative implosion," with significant international dangers we've never had to face before. Most persons can easily understand Phillips's descriptions of historic political and economic cycles, from build-up to speculative implosion.

This time, however, there is an added wrinkle that was missing in previous economic and political cycles: the huge transfer of wealth to the foreign wealthy. Phillips made an ominous observation:

> Within the United States, the rich got richer, but at the cost of a major decline in comparative U.S. world assets and purchasing power and a squandering of the nation's future. . . . Unlike prior heydays when the country as a whole was getting

richer, many of the new fortunes of the 1980s reflected a nation consuming, rearranging and borrowing more than it built.[4]

Phillips's credentials give powerful support to the "decline of the '80s" case. Let me remind you that he was chief political analyst for the 1968 *Republican* presidential campaign and his opinions are regularly sought by leading news organizations.

When a respected card-carrying Republican criticizes Republicans, and the criticisms make eminent sense, we had better take notice.

Certainly the Republicans did, judging from their panic reactions to his book.

THE DAILY NEWS

If you doubt Phillips's opinions, or mine, or anyone else's for that matter, just read your daily newspaper. There is no way conservatives can cover up the injustices of the '80s.

Newspapers everywhere reported the results of the 1990 census, which, incidentally, updated and confirmed the statistics that Phillips presented. According to the U.S. Census Bureau, the middle class is losing ground, with 42 percent of households living on less than $25,000 a year in 1989. A decade earlier that number was 31 percent. Nearly two-thirds of Americans were living on middle incomes in 1989, compared with nearly three-fourths a decade earlier.

In 1989, 31.7 million people lived below the poverty level, compared with 27.4 million in 1979. Those with high incomes grew from 11 percent in 1979 to 15 percent in 1989, and 1.4 million households had incomes of more than $150,000 a year.[5]

In other words, our own Census Bureau says that, during the '80s, the vast middle class and the poor got poorer. The rich got incredibly much richer. No matter how hard Limbaugh and the other right-wing crazies try to put a favorable spin on these statistics, they can't deny the deteriorating economic conditions that you can see for yourself.

It's not even debatable, unless you *choose* to remain blind to what is happening. Times are bad and getting worse for American workers.

Even those lucky enough to have a job, whether skilled or unskilled, haven't been keeping up with inflation. In most marriages, both husband and wife need to work if they are to have an adequate income. Not only must most families struggle with inadequate incomes, they also must live in deteriorating communities, as indicated by crime rates, school conditions, environmental problems, and so on.

What is not generally understood is that *these problems are all related to each other*. They're caused by national and local laws, economic policies, and traditions that unfairly favor the educated and the affluent, at the expense of the poorly educated and the non-affluent. These forces all got worse in the '80s.

And Part Three explains how right-wing conservatives made it all happen.

Part Three

For the Serious
Limbaugh Debater:

A Case Study for the
Decade of the '80s

Right-wing conservatives of the world have united, and are in the process of casting American workers back into the dark ages of history. But, at least for now, democratic capitalism is still alive in the United States, and workers can fight back.

A first step in the right direction is to understand the duplicity—and the danger—of Rush Limbaugh, his current associates and his historical comrades. They are all soulmates in the same right wing political movement. They have finally created an investment market that is worldwide and totally free for the established wealthy and labor markets that are always local and ruthlessly controlled by conservatives.

Part Three, therefore, is based on a case study of Spartanburg, South Carolina, the south in general, and their impact on the rest of the country. Spartanburg is a Limbaugh dream come true. It is one of conservative America's premier economic success stories, and it's a perfect model of what's happening in our country.

In other words, the rich have gotten richer in Spartanburg, and the quality of life has deteriorated for the poor and many members of the working class. But, what is worse, Spartanburg has had disastrous effects on less successful—but more principled—communities that have been competing with it.

17.

Spartanburg, South Carolina: Milton Friedman's model for conservative economics

If Rush Limbaugh wanted to pick one city as an example of the successes of the 1980s, he couldn't do better than Spartanburg, South Carolina. If not *the* most successful city of the '80s, it had to be *one* of the most successful. Milton Friedman, an economist with ideas similar to Limbaugh's, selected it in 1979 as one of his models to introduce America to the conservative policies that would dominate the next decade.

Friedman probably contributed more to the deregulation of American business and industry in the 1980s than any other economist. He was said to have been Ronald Reagan's favorite economist, and he served on a panel that advised the president on economic policy.[1]

FREE TO CHOOSE

In 1979 Friedman produced an influential series of videotape programs under the general heading of "Free to Choose."[2] The programs were financed by a host of large corporations, and were widely distributed to television stations, private industry and educational institutions. They were extensively quoted in publications and seminars. You also

can be sure that they were used to support many arguments for deregulation in the early '80s.

The central themes of the "Free To Choose" videotapes were that:

1. The "invisible hand" of the free market corrects most economic and social problems.
2. Government regulations just slow the free market process and make it less effective.
3. Private enterprise always benefits society—despite the greedy inclinations of some of its leading participants.

According to Friedman, whenever government gets in the act, it merely introduces a different class of greedy people who don't produce a useful product or service.

Who Protects the Worker

"Who Protects the Worker," was one of the final programs in the series. Friedman obviously intended it to provide the *coup de grace* to all those who stubbornly cling to the belief that the totally free market may have some weaknesses. He tried to demonstrate that the free market and free enterprise—not unions, not government—were the *workers'* best assurance of a good life and a high standard of living.

Employees, not just owners and managers, were better off when they had to individually negotiate with employers for their wages. Somehow, they would be able to obtain better deals for themselves than if they were members of a union.

To conclude the session, "Who Protects the Worker," Friedman presented Spartanburg, South Carolina, as the model of capitalism at its best. Spartanburg had achieved some commendable economic successes and had received national recognition for rejuvenating its depressed business climate.

In order to increase capital investment in the area, the city and county governments had offered attractive tax benefits and low utility rates to new companies, and to existing companies that expanded their operations. In addition, South Carolina was a right-to-work state,

known to be hostile to unions, and to have employees with a strong work ethic.

For ten years prior to the videotape, Spartanburg had been very successful in attracting new businesses from all over the world, and was thriving economically. Unemployment was down, the city and county were saving money in welfare and food payments, and wages went up—at least a little.

The Pure "Free Market" Theory

In his videotaped introduction of Spartanburg, Friedman presented an excellent summary of the classic reasons for an economy with few governmental regulations, few or no taxes, and almost no unions:

> Fifteen years ago, the economy of Spartanburg, South Carolina was stagnant. It depended on peaches and cotton. Wages were lower than the national average and unemployment was higher than the average. Then, dramatically, the picture changed. The people in Spartanburg decided to make their town the center of free trade.
>
> They did this by using a new right-to-work law, eliminating many restrictions on labor. The city council cut taxes to the bone. They advertised the fact that Spartanburg is a place worth investing in.
>
> By any standards, let alone Spartanburg's, the result was revolutionary. Industrialists came from Germany, Switzerland, all over the world, to build factories, to set up plants. The workers in Spartanburg clearly benefited from the new industries. . . .
>
> Suddenly, in a free market, workers who once could not find jobs, were now at a premium. Everyone benefited, workers and employers alike, and the town thrived. When unions get higher wages for their members by restricting entry into an occupation, those higher wages are at the expense of other workers who find their opportunities reduced.
>
> When government pays its employees higher wages, those higher wages are at the expense of the taxpayers. But when workers get higher wages, and more civilized working condi-

tions, through the free market, when they get them by firms competing with one another for the best workers, by workers competing with one another for the best jobs, those higher wages are at nobody's expense. . . .

In a televised panel discussion that followed Spartanburg's story, the moderator asked Friedman:

Would you, in effect, like to see the whole of the United States become, as it were, Spartanburg writ large?

[Friedman] Oh, absolutely.

[Moderator] What would that mean?

[Friedman] It would mean the widening of the opportunities for everybody. It would mean opportunities for employers all over to compete with one another for workers. It would mean an opportunity for workers to find jobs, to make the greatest use of their own skills and their own capacities, it would mean that consumers would be able to get better products at lower prices. . . .[2]

The Success Side of Spartanburg

The decade after Friedman produced his videotapes was kind, economically, to Spartanburg. Its success continued to be remarkable, and it is still a prime example of the benefits of conservative economic and social policies. It also is a model for what is happening to many of the most successful cities in the United States.

The U.S. has provided more material benefits for selected people and specific communities, in the shortest time, than at any other place or period in history. The same thing could be said about Spartanburg *within* the U.S.: it is one of our most prosperous communities in terms of improved material benefits for more people.

Material and Community Benefits

After the decade of the '80s, when you drove through the streets of Spartanburg, you could literally feel its vitality. New buildings of all kinds: manufacturing, office, school, entertainment, cultural arts, and

so on. Most people seemed to drive about five to ten miles over the speed limit. Everybody had to get somewhere in a hurry.

There were new country clubs and neighborhoods where there hadn't been any before. When you asked a waitress how well she liked living in Spartanburg, she said "It's God's country, wouldn't live anywhere else. Of course, I live in the country, ten miles from here." People everywhere greeted the stranger cheerfully and were eager to talk of Spartanburg's successes.

More than sixty firms from thirteen foreign countries had located in Spartanburg in the previous twenty years. The International Festival had become an annual event in Spartanburg. Public spirited members of the international companies provided authentic foreign foods, drinks, and souvenirs. They clearly had a broadening and educational effect on the entire area.

The employees who came from the northern United States with their companies, as well as employees who came on their own, also brought in new perspectives that enriched the area.

Other annual events included Oktoberfest, a Fall Arts Festival, the Piedmont Interstate Fair, and the Spring Fling/Jazz In The Park. Excellent restaurants of all kinds abounded—steak house, international, seafood, fish camp, pizza, you name it.

Spartanburg was justly proud of its new Regional Medical Center on Wood Street. It is still one of the largest teaching and research hospitals in South Carolina. People come from all over the state, as well as from other states, to take advantage of its Heart Center. It is a modern, full service hospital, with cancer and psychiatric services, as well as emergency and trauma services.

The University of South Carolina at Spartanburg had become the largest satellite campus of the University of South Carolina. Wofford College was selected as one of "America's Best Colleges" by *U.S. News & World Report*, and was chosen for Peterson's *Competitive Colleges* and Fiske's *Best Buys in College Education*.

The Greenville-Spartanburg Airport, located west of the city, doubled the size of its facility with a $40 million expansion. The Spartanburg Downtown Memorial Airport provided additional facilities for private business travel.

What used to be a small southern community became a city with a ballet guild, an exotic animal park, science center, arts council, and little theatre. Its "Showplace of the South" memorial auditorium "features major broadway productions, concerts by top recording artists, sporting and community events."

If you wore a business suit, you could walk into the foyer of the new Chamber of Commerce building at 105 North Pine Street and ask the lady at the desk if she had any public relations information for companies interested in coming to the area. She would be ready for you with an impressive package of brochures of all kinds. They described the healthy economic climate, the tax breaks given to industry, the variety of restaurants, cultural opportunities, availability and quality of schools, hospitals and so on.

Economic Growth

By 1990, Spartanburg was located in the thirty-sixth largest market area in the United States. Its statistics were impressive.[3] Capital investment in new businesses for 1988 was $116,050,000, with a creation of 1,530 new jobs. Even more impressive, during the same year there were $296,891,000 in expansions of existing business, for a creation of 1,197 new jobs.

Retail sales in 1989 were $3,160,716,110, compared to $859,677,-670 in 1979. Unemployment in 1988 was 3.3 percent of the labor force, and was in the 3–6 percent range for the five years prior to 1990.

Between January, 1988 and July, 1989, the labor force grew from 107,510 to 120,020. This was an increase of 12,510 persons, or about 9.6 percent, in just 18 months. It was a great way to close out the decade.

The benefits to workers from all this are obvious. Under these conditions job opportunities are plentiful for those who have the necessary skills. Relatively inexpensive fast food franchises are everywhere. Discount stores, outlet stores and competing merchants provide products and services that are as inexpensive as anywhere else in the U.S.

As Friedman predicted, during the '80s Spartanburg continued to reap the benefits of a pro-business environment, supported by tax and

anti-union legislation. There was explosive growth, and the dramatic increase in the community's material wealth was evident.

Based on Spartanburg's obvious successes, I still wouldn't hesitate to recommend it to most skilled workers seeking employment in the South. Compared to other communities, it has a lot to offer. If the story ended here, we could indeed claim that we had found the answers to our economic and social problems.

Unfortunately, there's more. There is a dark side to conservative economics. However, that part comes in the future, and Limbaugh and his cohorts have chosen to ignore it for now.

You see, there are two factors that conservative economists such as Milton Friedman never want to consider or even think about: first, the huge income disparity that results when wealthy conservatives have almost total control over workers' welfare; and second, the incredibly high costs of community disruption.

Those are the main subjects for the rest of Part Three, along with the issues that accompany them.

18.

The dark side of
conservative economics

There's a dark side to Spartanburg's success. It's identical to the dark side of the economy of the United States. It's the side that Limbaugh tries to convince you doesn't exist, and that conservatives try to hide from public view. Despite Spartanburg's impressive record of attracting new businesses to the area, and the corresponding economic benefits, those on the bottom half of the pay scale haven't shared proportionately.

The rising economic tide didn't lift all boats to the same degree. In fact, some seem to have sunk.

THE DOWNSIDE OF PROGRESS

According to the Bureau of Labor Statistics, in 1979, the year of Friedman's videotapes, the hourly wage for manufacturing workers in Greenville-Spartanburg Metro area was $5.35. This was one cent more than the South Carolina average, and $1.48 below the average for the United States.

Over the next ten years, a decade of so-called unprecedented prosperity, the average Spartanburg hourly wage increased to only $8.34.

TABLE 1
WAGE RATES FOR MANUFACTURING WORKERS[1]

	Average Hourly Wages		Average Weekly Wages	
	1979	*1989*	*1979*	*1989*
United States	6.83	10.33	279.02	421.99
South Carolina	5.34	8.51	222.14	351.46
Spartanburg	5.35	8.34	220.96	342.77

This means that at the end of 1989, the Spartanburg worker made 17 cents *less* per hour than the South Carolina average and almost $2.00 less per hour than the U.S. average (see Table 1).

Spartanburg continues to be cited in the financial press as a model of community success. But the financial conditions for its workers, compared with workers in other states, and in South Carolina itself, actually *deteriorated* in the roaring decade of the eighties. (Comparisons of the weekly wage rates in Table 1 yield identical conclusions.)

In the eighties, the hourly manufacturing wage rate in Spartanburg went up only 56 percent, compared to an increase in inflation of 71 percent. During the same period, the income of corporate executives increased by 149 percent.[2]

So—during the roaring eighties, the wages of manufacturing workers didn't even keep pace with inflation in one of the most financially successful communities in the United States. Spartanburg's outstanding success came at a price to an important segment of its citizens, its workers.

Of course, corporate executives and shareholders made out like bandits during this same time period. Including stock and other compensation, the number of Carolinas executives earning at least $1 million increased from four in 1989 to sixteen in 1990.[3] This doesn't include the ones who received millions in golden parachutes.

An Upscale Housing Market

While the economy is booming for executives, the picture continues to get bleaker for America's lowest paid workers.

U.S. News and World Report listed the Greenville-Spartanburg metro area as the third best housing market in the United States for 1990, behind West Palm Beach and Akron. By "best" they are referring to skyrocketing prices for houses.

Once a major textile region, the Greenville-Spartanburg metro area has grown tremendously as foreign firms, including Hitachi, Michelin Tire, and Adidas, have moved in to take advantage of the area's proximity to Southeastern markets and its large pool of nonunion labor.[4]

Prices of existing houses in the area went up 20.7 percent from the first quarter of 1989 to the first quarter of 1990. In October 1990, TW Services (Denny's Inc. and Canteen Corp.) announced plans to move their corporate offices to Spartanburg from Irvine, California. The top twenty officers who moved to the area bought houses that cost $300,000 and more.[5] That was a low price compared to Irvine, California, but to a working-class native in the Spartanburg area, it represented high inflation.

The rise in housing costs is great news to present home owners, housing speculators, developers, lawyers, and business persons of all kinds. Those who benefit from a rising housing market would also include corporate executives who are looking for additional ways to invest their excess cash. In fact, affluent persons looking for investments with tax advantages are an important cause of housing inflation.

But for the newly married husband-wife couple working on an assembly line, the great housing market is bad news. They're rapidly falling behind. Houses are steadily going out of sight. It's the old story. Workers either can't make the down payment, or, if they do, the monthly payments are beyond their reach. And rent keeps going up.

A secretary working in downtown Spartanburg said that her son and his wife were both college graduates and were both working. Because of housing prices, they had just purchased a trailer. Like many other working couples, they see trailer-park living as their only viable option.

In fact, South Carolina is number one in the country for mobile home purchases *per capita*, and accounts for over 40 percent of new home purchases. North Carolina leads the nation in *total* mobile home purchases, accounting for nearly 10 percent of all homes in the country.[6] Naturally, territorial conflicts between owners of traditional homes and encroaching owners of mobile homes are increasing throughout both states.

The Bottom of the Labor Pool

But that's not the worst part of this story. Conditions for those at the bottom of the labor pool—and there are of a lot of them—are grim indeed.

Although the unemployment rate has supposedly varied from 3 to 6 percent in Spartanburg, everyone knows that the actual rate is about three times that. For every person who is officially seeking work, there are two who have given up and resigned themselves to living off of welfare programs, or however they can.

Twenty percent of the residents of Spartanburg lived in public housing in 1989[7] and that's an understatement. Public officials know that there are more families living in public housing than are on the rolls, even though it is illegal. Residents are making room for those who have nowhere else to go.

The public housing population consists of people working for minimum wage, or wages that are much lower than manufacturing wages. Or, they are not even working. The waiting list for people who want to enter public housing is longer that can ever be filled, at least with currently projected funding.

The public officials who deal with Spartanburg's poor are apparently doing an outstanding job. They have received more money than other areas of the state by applying for funds that other communities didn't use. The ones I met appeared to be an alert, talented group of persons who are doing a job that would be expected of a first rate community.

However, they will tell you (with lowered voices) that they've given up on those at the very bottom. They're just trying to help those who have at least some income, some education, or who exhibit some sign

of rehabilitation. They go on to add that *no one, anywhere,* knows what to do about the people that society has left behind.

This kind of American citizen is growing in number. New employers who consider coming to Spartanburg want more than people who are willing to work for low wages. Increasingly, they want *disciplined, educated* people who are willing to work *hard* for those low wages.

Many of these new workers are better educated than the original resident laborers, and have replaced them in some of the more desirable jobs. The new workers come not only from other states, but from other countries. As with many other parts of the U.S., Spartanburg has its share of immigrants, a few of whom have already cycled into public housing.

Spartanburg is truly a model of what has happened in the United States during the '80s. It demonstrates why private enterprise and a labor market controlled by politicians and business groups are deficient, *in themselves,* as a complete model for a successful society.

THE STEEL FIST IN THE VELVET GLOVE

If you want to find out how the "free market" works when dominated and controlled by business and industry, get into your business suit again and go back to Spartanburg. Go back to the Chamber of Commerce building on North Pine Street. Ask the same lady if she has any information about hourly wage rates, trends in wages over the past ten years, and union activities in the area.

The Spartanburg Development Association

Without a moment's hesitation, she will smile and tell you that everything you need to know can be provided by the Spartanburg Development Association (SDA) at 292 South Pine, just down the street from the Chamber building.

When you arrive at the SDA office, a charming receptionist will greet you. You explain that the Chamber of Commerce said that SDA may have some information on area wages, trends in wages, and union activities. She's obviously heard the request before.

She presses a buzzer, and a gracious gentleman immediately comes out of a back office, greets you, and takes you to a conference room. When he asks you who you represent, just say that that's confidential, which it is. He will nod, "Oh yes, I understand. It isn't unusual."

In the following conversation, he appears to have two goals: first, to assure you that Spartanburg is a fine community "with fewer than 1 percent unionization," and second, to give you a sales pitch about how SDA helps companies remain nonunion.

Now it's time for you to express some skepticism, not about the threat of unions—they are almost nonexistent—but about the level of hourly wages. You note that Spartanburg's success has been widely publicized for the past ten years, and, with the "influx of new industry, haven't wages gone out of sight, regardless of being union-free?" After all, economic theory stipulates that competition for a product or service, such as labor, raises its price.

The answer almost makes the rest of this chapter unnecessary. He responds, "I wouldn't say this to just anybody, but wages haven't gone up like you would expect. This is traditionally a cotton and textile area and the wages have always been low. The workers are used to it."

He points out that the SDA is a nonprofit employers' association and has over 200 member companies, the biggest ones in the area.

Along with offering many kinds of training courses in management, SDA does an annual wage and benefits survey of local businesses.

As a result, member companies know the hourly wage for every conceivable job classification, along with any kind of data that can affect local labor expense: absenteeism rates, employee benefits, vacation practices, holiday practices—you name it.

SDA also publishes periodic bulletins to inform members about union activities, labor law issues, pending environmental legislation, and any other items of interest to business and industry. It periodically sponsors a seminar on "Union Avoidance Strategies."

So, hourly workers in Spartanburg are not unionized. The *employers* are. Of course, it's unofficial and they would vociferously deny it. But they are as protective of their members as is any union or professional association.

Just as Friedman had predicted, hourly workers must compete for

jobs. But, contrary to Friedman's predictions, employers do not compete for workers, they *collaborate* to avoid competition.

They know to the penny how much they have to pay in wages and benefits without causing unnecessary inflation in the local wage market. The statistics for the decade of the '80s clearly indicate that corporate executives have been very successful in holding a tight lid on wages, while realizing huge salary and bonus gains for themselves.

All this is done under the euphemism of enlightened management and "making third party intervention [unions] unnecessary." SDA's official statement of purpose is revealing:

> SDA's primary mission is to aid area businesses in the development and preservation of a healthy industrial climate through the promotion of sound management practices and enlightened employer/employee relations programs. These vital factors, done properly, produce an atmosphere which makes third party intervention unnecessary.[8]

Anti-Worker Tradition of the Southeast

Of course, the activities of the SDA is the *nice* side of company collaboration. There are darker sides. A few years ago, a former associate of mine attended a meeting of personnel managers in a community not more than twenty miles from Spartanburg. The subject was "how to prevent unions." During the discussion, one of the personnel managers wondered what all the fuss was about:

> I never have any problems with unions. If someone starts talking union, I take him out into the parking lot and explain that I know every personnel manager in this county. If he keeps talking union, I'll fire his ass and make sure that neither he, nor any member of his family, ever works in this county again.

In 1929 Sinclair Lewis wrote about the *Cheap and Contented Labor* of the South, and concluded his introduction with this press release:

> Greenville, S.C., Nov. 21 (A.P.) Public whipping posts as a means of proper punishment for "Northern reformers who think they are called upon to reform conditions in textile mill

villages here" were advocated today by the Rev. D.B. Hahn, pastor of the Pendleton Street Baptist Church. . . .

He said Northern newspapers were conducting campaigns of propaganda against Southern textile mills "lest the textile power of the North be transferred to the South. . . ."

Touching upon two mob floggings of textile union organizers during strikes the past summer, he said there was no doubt "they got what was coming to them," but added he favored public whipping posts as a "better means of administering such punishment."[9]

That was in 1929. In 1934, not all that long ago, police and deputized nonunion workers in Honea Path, South Carolina, killed seven people participating in a national textile strike. Joe Hallinan of Newhouse News Service noted that "The labor movement never recovered. To this day, South Carolina remains one of the least unionized states in the nation."[10]

Killings, mob floggings and public whipping posts are no longer allowed, or needed, today. Conservative politicians and employers effectively keep wages low by using modern management and propaganda tools. In addition, they artfully use the pressures of both the national and the international labor markets to keep employees docile.

Enlightened Management

If employees start thinking about a union or demand higher wages, company executives make a veiled threat that they may close shop and leave the area, just as they did when they abandoned the North.

They point out that workers are already making good wages, *compared to other employees in the community*. A strike can ruin a worker's savings, and any increase in wages won't make up for a lengthy strike. That usually stops any union discussion, even if conditions are intolerable.

Employees have seen companies abandon whole plants with little concern, and they've read about American jobs being exported to

other countries. On television they've seen the depressed conditions of the industrial North.

They know the major reason they now have jobs is that companies deliberately sought out areas of chronic low wages. Still and all, poor wages are better than no wages, and union activity could ruin all that.

The free market, combined with "gentlemen's agreements," affects wages this way: as the demand for more workers increases, the level of new business investment will go down, or new workers from other depressed locations will enter the local work force. Either way, wages don't improve, at least not nearly as much as they should. After all, keeping wages low is the key to economic growth.

What makes matters worse for the worker is South Carolina's *official* economic development policy. The state will not recruit industries with labor union contracts. In fact, the union status of a company is one of the first questions posed by the State Development Board to prospects.[11]

The anti-worker strategy goes even further than that. You don't have to ask around very long before you discover that devious tactics are used to keep wages low. If an outside employer, on his own, wants to locate in the Spartanburg area, he gets a cold reception from the power establishment if:

- he has a "union shop," or if
- he intends to pay wages that the business establishment considers excessively high for the industry.

Because of the inflationary effect this kind of new employer would have on wages, business and government officials simply don't give the inquiring visitors any help in finding a location or in getting established.

After a local company, Mack Trucks, Inc., lost an election to the United Auto Workers union in 1989, the city's anti-worker newspaper, the *Spartanburg Herald-Journal*, ran a front-page feature story. The feature had not one favorable comment about unions. From the governor to a roster of local businessmen and civic leaders, all comments stressed the advantages of not having unions:

Gov. Carroll Campbell and many business leaders throughout the state expressed confidence yesterday that the workers of South Carolina would continue to keep their distance from union representation. . . .

[Emil Spieth, plant manager for Hoechst Celanese]: "I don't think we need a third party to come between us and our employees. I think we enjoy the kind of relationship between us and our employees that makes a union unnecessary. . . ."

B.B. Cole of the Kershaw County Economic Development Commission originally helped recruit Mack to the Midlands. "Oh, God," Cole said when informed of the UAW win. "You can put that in. Oh, gosh. Well, I'm disappointed."[12]

Mr. Cole's loss of composure is understandable. He must have had serious problems with his friends at the commission for allowing that kind of mistake to enter the state. Charles Ferillo, Jr., deputy lieutenant governor when Mack was recruited, said, "The lessons are we need to have a much more extensive and in-depth understanding of industry before we try to recruit them to this state."[13]

Spartanburg's record for the '80s demonstrated three things. First, corporate executives will *not* risk a cut in profits, or management wages and bonuses, in order to pay hourly employees more. Employee wages are *always* an expense to be minimized.

Second, companies will not pay more than local wage rates absolutely require, regardless of employee financial needs, and no matter how high the companies' profits.

Third, employers and local politicians have almost total control of the labor market when there are no effective organizations to represent workers' interests.

Of course, some companies in Spartanburg pay more than others. There is a hierarchy of desirable employers, just as in any other area of the country, and in that sense there is competition. But the overall range is much lower than the rest of the country, just as it is designed to be.

Who protects the worker? In Spartanburg, nobody. And the deck is stacked against him. The worker is on his own, competing with thousands of others, with no negotiating leverage whatsoever.

155

Is there a "free labor market" in Spartanburg? Definitely not. Labor is controlled as tightly as any commodity in which a relatively few collective buyers confront thousands of sellers. And right-wing conservatives want to keep it that way.

Spartanburg is truly the model of the '80s.

19.

John Kenneth Galbraith's Spartanburg: the long-term social costs of modern conservatism

Rush Limbaugh is preoccupied with sex—mostly other people's sex. He blames much of our social degeneration on the breakdown of family values, which he equates with homosexuality, the antics of Ted Kennedy, unwed pregnancies of those on welfare, and promiscuity in general. (Contrary to the Bible, he evidently feels that divorce, and legal sex with more than one partner, is just fine.)

When he's not talking about sex, he cites other symptoms of dysfunctional family values, such as the rising crime rate, cheaters on welfare, the homeless who don't want to work, the drug culture, and anti-gun advocates.

It's pointless to argue with him about the importance of family values. Everyone agrees that family values are crucial to our "sense of community" and our ability to function as an effective, harmonious society. However, Limbaugh leaves out the two most important requirements for *developing* sound family values: first, an adequate education; and second, a reasonable level of economic security. If one or both of these are missing, it is very difficult to develop the values that are so important.

Prior to the breakdown of family values, and the resulting loss of a sense of community, is our political failure to provide many of Ameri-

157

ca's citizens with a decent education, and a reasonably secure work environment. Our workers, especially our lowest paid and least educated ones, don't make enough money to responsibly take care of a family, and most simply don't have the ability to adjust to their radically changing communities.

Spartanburg's successes and failures provide important clues to what our problems are, and point the way to some solutions. Although the city is complex enough to warrant several Ph.D. dissertations in economics and the social sciences, the following facts are indisputable:

1. Spartanburg has one of the cheapest labor markets in the United States and is very attractive to new industry. It is truly an economic success.
2. Spartanburg is experiencing rapid growth, in both population and new jobs.
3. Overall measures of Spartanburg's economic health are steadily improving.

But here's the nagging fact that just won't go away:

4. Its measures of *social* conditions are steadily getting worse.

In the past, some have argued about the cause-and-effect relationships between economics and social conditions. The Spartanburg experience clearly demonstrates that some of these causes have now become self-evident. Consider John Kenneth Galbraith's view of how affluence affects society.

GALBRAITH'S "AFFLUENT SOCIETY"

As far as I know, Galbraith never heard of Spartanburg, South Carolina. However, he *did* predict Spartanburg's problems, and its future, in his book of over thirty years ago, *The Affluent Society*.[1] He described how the affluence of the free enterprise system eventually outpaces public services. The production of goods and services for

profit takes precedence over spending money to improve schools, roads, and social services of all kinds.

The affluent and powerful people of society blame fraud and inefficiency when they refuse to support the funding of government services. (Of course, fraud and inefficiencies in business, they say, are just part of the price we all have to pay for a dynamic free market system.)

According to Galbraith:

> In a community where public services have failed to keep abreast of private consumption . . . in an atmosphere of private opulence and public squalor, the private goods have full sway. Schools do not compete with television and the movies. . . .
>
> Violence replaces the more sedentary recreation for which there are inadequate facilities or provision. Comic books, alcohol, narcotics and switchblade knives are, as noted, part of the increased flow of goods, and there is nothing to dispute their enjoyment. There is an ample supply of private wealth to be appropriated and not much to be feared from the police.[2]

Although the problems of the affluent society are to be found in communities across our prosperous nation, from New York to San Francisco, they are least painful in the Spartanburgs of America. Still, judge the accuracy of a few of Galbraith's predictions yourself, as they apply to affluent Spartanburg.

The Failures of Affluence

Spartanburg's successes mostly relate to the economic affluence of the wealthier half of its citizens. Its list of failures relate to the quality of individual lives, especially among the nonaffluent. (But its failures eventually will include the affluent as well, because what happens to part of society ultimately affects all of society.)

In 1989, the Spartanburg County Foundation published an analysis of the "Critical Indicators" of Spartanburg county health, and compared it to twelve other counties in "Upstate" South Carolina. The twelve Upstate counties had the same general demographic characteristics as Spartanburg. Of thirty-eight indicators, Spartanburg was better than Upstate on thirteen, worse on twenty-one, and tied on four.[3]

159

By now it should come as no surprise. Affluent Spartanburg was doing better than its less prosperous South Carolina neighbors on most *economic* measures. But it was doing worse on most indicators of *social* health.

- It led Upstate for "capital investment" by a whopping 160 percent. It also led in rapes by 76 percent, and its "adult education enrollment" was worse by 50 percent.
- Its unemployment figures were better by 22 percent, but its motor vehicle thefts were ahead by 34 percent and infant mortality was worse by 22 percent.
- Paradoxically, it led Upstate in "spending per student" and teacher salaries, but it also had more high school dropouts.
- It had higher per capita income, yet more divorces and admissions to mental hospitals.
- It was better on "business openings," but worse on "breaking and entering" and "aggravated assault."

Spartanburg is a mirror image of the U.S. The affluent citizen is doing great materially, while workers, especially at the lowest levels, are losing out, and society is falling apart.

A review of the *Spartanburg Herald-Journal*, the city's major newspaper, for 1989—just ten years after Friedman did his videotapes—shows the same problems that plague most of the rest of the U.S.: citizen complaints about taxes, increased crime and violence in public schools, increased drug use, lack of social services, and so on. All this, despite being a boom-town. Or, should we say, *because* of being a boom-town, *and not raising enough taxes to pay for the problems that come with rapid growth and community disruption.*

The lists of Spartanburg's successes and failures fit Galbraith's predictions precisely, including the unwillingness of its affluent and educated citizens to finance necessary public services with taxes. What is most disturbing, however, is that this is occurring in one of America's premiere economic success stories of the decade of the '80s.

Galbraith's analysis of affluence and public spending is right on target. Unfortunately, the critics of government spending are also correct: nothing quite matches the bureaucracy for wasting money.

However, government, with all its strengths and weaknesses, is our last refuge. Once problems harden to the point where people have lost the ability or motivation to solve them, only the government has the money or motivation to help. The free market is only interested in people with money—not people with almost unsolvable problems.

A Self-Evident Proposition

Large-scale educational and financial injustices are impossible to rectify, and very difficult to make up for, even partially.

Once an injustice is done, the conditions will never again be the same. Conservatives don't understand the irreversibility of their actions. It's impossible to go back and pay workers the wages they should have had forty years ago, or to give their impoverished descendants the quality of life they *should* have had. We can't retroactively give grown adults the education they should have had in the first grade—or give them the benefits of educated parents they *should* have had.

In other words, there is no way to magically give impoverished children a feeling of economic and personal security they should have had since birth, or to enlighten children who have had no educational role models in their families for generations.

Conservatives always refuse to consider the long term social consequences of political and business decisions. Instead of trying to prevent problems at the front end, they want to delay taxes as long as possible and deal with them at the back end. They would rather spend money for police and prisons than for libraries, public schools or public parks.

Their mottoes are, "progress now and clean up the mess later," and "the free market cures all ills." All that counts is personal success and making a profit. We'll face the future when it gets here. Nonsense.

If we don't address our problems as they occur, they will only get worse and more expensive to solve later. Therefore, we must begin to place greater emphasis on *preventing* social problems. We've never really done this before.

Unfair Education

Education in Spartanburg is typical of education throughout the Carolinas. In other words, public schools have always been inadequately funded for children of working class parents. The Carolinas have distinguished themselves by developing notoriously bad educational systems.

From the time when it was illegal to teach blacks to read or write, through the period of incredibly bad segregated schools, to the poor public schools of today, the Carolinas have been at the bottom of the U.S. academic pile. Of course, their private schools are among the best in the nation.

And if you're one who believes that "you can't improve schools by throwing money at them," consider this: the average cost of sending a child to a private high school in Charlotte, North Carolina, is around $8,000, and that doesn't include perpetual building-fund drives and special fees. For public schools it is around $4,000, and that includes the school lunch programs.

In the 1989–90 school year, South Carolina public high school seniors scored worst in the nation on the Scholastic Aptitude Test, and North Carolina was the next worst. From year to year, the Carolinas alternate with each other in monopolizing the dead last position in the United States.

Once a society seriously short-changes its working citizens with an inferior education, it automatically handicaps their descendants for generations to come. All over the country, statistics prove that children of better educated parents do better in school than children of uneducated parents.

Children of educated parents do well even in *poor* schools. Their parents compensate for school deficiencies with their own tutoring. They value discipline and they understand the rewards that come to those who improve their skills and abilities. Their children catch on early in life about how to learn on their own.

Children of educated parents have a competitive edge in all aspects of life. If the parents are also affluent, and don't think the public schools are good enough, they send their kids to good private schools. When it's time for college, the affluent parents can make up for their

children's deficiencies by sending them to top-ranked universities. The nonaffluent, educated parents find a way to send their kids to the best public colleges and universities they can afford.

On the other hand, children of poorly educated parents do terribly in poor schools. If they don't get an appreciation for education from motivated teachers, with adequate resources, they just don't get it. When they go home, their stressed-out parents are unable, unmotivated, or simply don't have the time, energy, or background—in values and family tradition—to help them.

Unfair Wages

Although the quality of education is important to family values, there is a still more fundamental issue that is a prerequisite for a good education. It's the issue that affluent citizens never want to face: When employers refuse to pay employees a decent wage, even when they can afford to, they create a dependent class of citizens who cannot withstand even minor financial setbacks. Although the individual employer benefits from low wages, and the consumer may realize some short-term price advantages, *society* ultimately loses.

The employer has, in effect, secured for himself and his descendants a surplus of security and all that that implies. He and his heirs now have freedom from financial stress, access to the best schools, and ready-made influential contacts with the power establishment, among all the other things that go along with surplus wealth.

The United States is a quite different country for the underpaid, poorly educated worker. He lives from paycheck to uncertain paycheck, often without pension or medical benefits. Besides being under severe emotional stress, he has to deal with the problems found in degenerating neighborhoods and schools, along with their deteriorating social values.

He has no family tradition of success to draw strength from. With hard work, he can be successful. If he's lucky, he may even become affluent. But it's tough, and the odds are against him, as the monotonous litany of today's statistics indicate.

So—if you're a worker without a formal education, you have to have good role models in your family, or be lucky, to make it. If you're

rich, or have a good education, you have to be unlucky to fail, and even then, failure is by no means assured.

THE CHRONIC ANTI-WORKER
BIAS OF THE CAROLINAS

Spartanburg, the Carolinas, and the Southeast in general, compared to the rest of the United States, have historically provided a terrible environment for their workers. The tradition continues.

When the Atlanta-based Southern Labor Institute studied working conditions throughout the U.S. in 1990, it used thirty-five indicators of quality of life, including factors such as income, working conditions, and social conditions. Ken Johnson, director of the Institute, reported that South Carolina came in dead last.[4]

Predictably, Curt Cottle, a spokesman for South Carolina's State Development Board, said the report's low rating has a positive side. According to Cottle, South Carolina continues to attract new jobs because of its cheap land, low taxes, low wages and low level of unionization.

In other words, Carolinas politicians, in cooperation with special interest business groups, have opted to continue their short-term solutions for overcoming their horrendous past by maintaining their traditional biases against workers. They see bad working conditions for workers as a plus for the economy. And, as Galbraith predicted, they don't plan to increase taxes on wealthy nonworkers in order to correct community problems.

They not only aren't ashamed of their workers' low wages, they openly brag about them. South Carolina placed an ad in the June 11, 1990 issue of *Forbes*, citing reasons why companies should relocate in the state. The ad featured a statement from its conservative Republican governor at that time, Carroll Campbell:

> South Carolina has earned the confidence of business leaders through a vigorously pro-business climate. Companies from around the world continue to prove their confidence in the strength of our economy by investing their capital resources in record numbers.[5]

Evidently, the governor believed that working voters don't read *Forbes*. Everyone except an orthodox hypocrite admits that "pro-business" is a code word for anti-worker, low wages, and low taxes. In effect, it says: "Come here, the business community is solidly united to keep profits high, for people like us—and wages low, for workers. It's always been that way here, and it still is."

They've been effective. Carolinas industry hunters landed $1.3 billion in European plants and industries in 1989, using low wages and the anti-union environment as a clincher. When union leaders charged them with doing this, Alvah Ward, director of business/industrial development and head of North Carolina's European recruitment said:

> I've been here twenty-one years, through four governors, and this staff has never sold the cheap labor aspect. You simply make known what is the statistical base of your work force.[6]

Well, you wouldn't conclude that when you listen to George Dean Johnson, Jr., past president of the South Carolina Chamber of Commerce and a Spartanburg lawyer. According to the *Spartanburg Herald-Journal*, Johnson "asserted that 90 percent of those industries which have located and/or expanded in South Carolina over the past thirty-five years have done so as a result of the state's low union activity."[7]

By the way, the statistics that Ward was referring to: fewer than 5 percent of the Carolinas' workers were members of unions, and the average wage of $8.51 was among the nation's lowest. Virtually every businessman in the country knows that he can abandon his present community and come to the Carolinas, a non-union, low-wage area.

For an honest opinion about how the Carolinas attract industry, listen to Guenter Venneman, vice president of Getrag, a producer of timing gears and transmissions for Detroit's Big Three auto makers. In a remarkably candid interview, he described why his company decided to come to North Carolina:

> We wanted to be in a right-to-work state. . . . We wanted a non-union environment. . . . It's always been our theory that we want to be, as far as wages and benefits and so forth, not an A

but a B or a B-minus, as compared with Detroit and UAW country.[8]

How about maybe a C-minus or D? Parts makers in the Carolinas pay a *lot* less than in Detroit: North Carolina auto-parts workers averaged about $437 a week in 1988. Although that's about 20 percent above the state's average manufacturing wage, the average Michigan parts worker earned $762 a week.

In summary, to attract new industry, the Carolinas politicians rely on "right-to-work" laws which make it next to impossible for poorly educated workers to form unions to protect themselves. Then they collaborate to keep wages as low as possible, and offer tax breaks to industry that other parts of the country are unwilling to match.

They have revived their economies the traditional southern way: by selling natural resources and poorly educated workers to the lowest bidders. Affluent, educated nonworkers have benefited for now, but the longer range prospects for their own quality of life are not good.

The welfare of our lower-paid, poorly educated Americans *directly* affects the long term quality of life for *everyone*. Think about it: Even if you are rich and well educated, the areas of your own community in which you can safely travel are constantly getting smaller. You could be sitting in a shopping mall and get shot in someone's killing spree.

The death penalty, more prisons, and stiffer sentences may be short term answers. But there are too many people without decent jobs who just don't care if they live or die any more. If we don't start paying the price to prevent the *causes* of the deterioration in family values—poor education and huge income disparities between rich and poor—conditions can only get worse.

20.

The conservative cycle:
what goes around, comes around

Limbaugh does everything he can to justify greed, and to create a new class of American royalty. The business and political leaders who agree with his vision for the future therefore compete with each other for new industry by:

- Keeping wage rates for their own workers as low as possible, and profits to owners and stockholders as high as possible,
- Agreeing to keep tax rates on business and the wealthy at levels inadequate to maintain necessary services and to solve community problems, and
- Keeping a blind eye to business's violations of the free market, the environment, and basic employee rights.

And when they do, there is no way communities—and family values—can avoid disintegrating. What's more, *this kind of competition hurts both the communities that lose and the communities that "win."* In the United States, community stability and a healthy society can never be achieved as long as some communities choose to reduce competition for new industry to the lowest moral standards.

The same is true for the world market. No nation can achieve a healthy society if it chooses to compete with other nations on the basis

of which countries have been willing to treat their workers the most inhumanely.

The Controlled Labor Markets of the '80s

What we normally think of as a free market is really a market controlled by employers. Employers have always controlled wage rates, but it's even more true today because:

1. Employers increasingly have a global market, but the vast majority of workers are local.
2. Political biases in impoverished or undeveloped areas, like the Carolinas and third world countries, are always pro-business and anti-worker. They always need fresh infusions of money (new industry) to compensate for their past social and economic injustices.
3. Within a community, the advantages in wage negotiations are all on the employers' side. There are usually a relatively few employers, but thousands of workers.

Put these three things together, and you have massive community disruption. Let's see how they apply to Spartanburg, as it interacts with the national and world labor markets.

The Local Work Force

We already know that a company can close down a plant anywhere in the world and open a new one wherever the wages are lowest. It's become commonplace. The labor market for *employers* is worldwide and totally fluid. There are no loyalties to workers, only to economic profit—and employers will abandon a community at the drop of a dime.

For the average *worker* in Spartanburg, however, the labor market is almost completely local. Some day Milton Friedman should meet a

typical Spartanburg worker, and go with him when he drives home. As he's driving down the rural road, the worker will point to a nearby house. That's where his parents live. Across the road is an uncle. Down the way a bit is a cousin. The trailer at the back of the lot is where the cousin's sister and her husband live. You get the idea.

If he is living in a city neighborhood among strangers, they are people just like himself. He likely will be within 200 miles from home. He's spent most of his life in God's country and has no inclination to leave. He'd rather have a poor job here than a higher paying job someplace else.

Practically speaking, the world labor market is closed to him. If economic necessity forces him to leave, he'll be facing serious stresses. He doesn't have the education to adapt well to radically different circumstances.

It isn't the same with educated nonworkers, who see the world as their community. An individual may have gone to, say, the University of South Carolina, and met people from all over the world. She's visited her classmates' homes and gone skiing in Vermont. With friends, she took spring break in Florida. Just about anywhere she goes in the U.S., she knows someone nearby she can contact. If that's not the case, it doesn't make all that much difference, because she's used to meeting all kinds of different people.

For educated nonworkers, the labor market is global and they can go where the wages are highest. For the majority of workers, it is local and they must take what is offered. Although this assures a steady supply of cheap labor to employers, and lower prices for products, it has devastating effects on communities throughout the world. Low wages or no wages disrupt lives, both for the community that gets the additional jobs and the community that loses them.

THE STRESS CONNECTION

When it comes to propaganda, Limbaugh and the conservative think tanks have the moral standards of the American Tobacco Institute. Just as the Tobacco Institute still refuses to admit that tobacco causes

human illnesses, conservative politicians refuse to admit that unfair economic policies cause poverty.

Instead, conservatives make much ado about how divorce and poor family values cause poverty. They say that the cause of poverty is not lack of jobs, not community disruption, not poor education, not economic insecurity, not income disparity between rich and poor—it is divorce, illegitimate births, and poor family values. Of course, they are partially right, but mostly wrong.

Conservatives have been bombasting the public so much about this that you're probably getting fed up hearing about how workers are under severe stresses today. But, in case you're an affluent nonworker, and you don't want to admit that there is a connection between stressful lives and our society's degenerating problems, just consider the examples below.

Statistical Studies

The Census Bureau tracked families for two years in the 1980s, and found that one out of seven married couples below the poverty line splits up, compared with one out of thirteen couples with higher incomes. Clifford Johnson, family support director for the Children's Defense Fund stated, "We've known intuitively for a long time that poverty and other economic problems create a lot of stress for parents."[1]

The results of a nationwide study were reported in the *Journal of the American Medical Association*. The researchers found that children who move often are 35 percent more likely to fail a grade and 77 percent more likely to have behavioral problems than children whose families move rarely. The authors, led by Dr. David Wood of Cedars-Sinai Medical Center, concluded, "A family move disrupts the routines, relationships and attachments that define a child's world. Almost everything outside the family that is familiar is lost and changes."[2]

Remember, the first study just demonstrates how low income increases divorce rates, and the second study is just about families that *move*. That doesn't come close to the stresses that people feel when they not only have to move, but, in addition, are without a job that pays a decent wage.

The Valdez *Incident*

If you're a right-wing crazy and still want to blame community degeneration and poor economic conditions on divorce and poor family values, rather than the other way around, consider the *Valdez* incident.

Alaska's experience after the *Valdez* oil spill is especially instructive. Here we had a tough, competent, hard-working populace, living where they wanted to live, but who suddenly had to deal with community disruption and financial insecurity. In other words, they didn't fit the descriptions of conservative scapegoats: laid-off, middle-income, manufacturing workers, unemployed people in ghettos, and liberals.

George Laycock interviewed an Alaskan social worker for an article in *Audubon*:

> The disruption of lives, community relations, and work plans led to new stress levels. A social worker at the South Peninsula Women's Services in Homer told me, "We're seeing many more cases of domestic violence than we did before the spill, and people aren't getting over it. It comes from disrupted life-styles and uncertainty over sources of income. Alcoholism and drug abuse have increased. I think these people may feel the effects for twenty years."[3]

Stresses of the Nearly-Rich

If you still can't sympathize with problems caused by financial insecurity, consider a study about the fears of *affluent* people, done by Ernst & Young and Yankelovich, Clancy, Shulman:

> Unlike most studies of the affluent market, this survey excluded the super-rich. Average household income for the sample was $194,000, and average net assets were reported as $775,000.
>
> The goal was to learn about one of today's fastest-growing income groups, the upper-middle class. Although they represent only 2 percent of the population, they control nearly one-third of discretionary income. . . .

Despite their considerable incomes and assets, 40 percent of the respondents in the study don't feel financially secure, and one-fourth don't feel that they have made it. Twenty percent don't even feel they are financially well off.[4]

If *these* people don't feel financially secure, or that they "have it made," what does that suggest for the workers in the bottom 20 percent? They made less than $7,700 in 1988, had no assets to speak of, and saw their income drop 8 percent in the previous eleven years. Or how about the bottom *50 percent*? They made less than $22,000, and their income dropped by 6.3 percent in eleven years.

Insecurity of the Super-Rich

It's hard to take this next example seriously, but you may find it entertaining. Henry Kravis is one of the richest men in the U.S., and was one of the main players in the RJR buy-out. After that incredible spectacle of competitive greed, Henry told a *Fortune* reporter that money meant *only security to him*: "Greed really turns me off."[5] Damn, if *Henry* is still searching for security, maybe we'd better stock the pantry with survival foods.

The Economic Cycle Continues

Just as the Carolinas attracted industry with their low wages, they are now losing industry to third world countries whose leaders take advantage of their workers even more.

In 1990, one in ten workers in the Carolinas was in the textile industry, and it's steadily closing down. The U.S. Department of Labor says that the two states lost 7,100 workers in the twelve months ended June 30, 1990, due to plant shutdowns and increased automation. At least seventy-five Carolinas textile and apparel factories had closed or laid off workers as of that time.[6]

Duke Kimbrell, chairman of Parkdale Mills, said that if imports continue to grow at current rates, there won't be a U.S. textile industry in eight years.[7] Naturally, all Carolinas politicians are now fighting for import restrictions to save the industry.

By the way, have you ever noticed how much of your clothing was made in Taiwan? It's one of the countries that took so much of our textile industry from us. Guess what, those who got rich in Taiwan are now abandoning their own workers to invest billions in other Asian countries with even lower wages. According to *Business Week*:

> The Taiwanese are jumping ship. Taiwan's richest families made their millions in less than two generations—some in less than a decade. . . . [M]ost are jumping into foreign markets for instant gratification. To escape rising wage costs and tightening environmental regulations, more and more manufacturers are simply moving production elsewhere in Southeast Asia to keep doing exactly what they have been doing back home.
>
> By this year, the capital exodus was so huge that it aggravated a stock market collapse. . . . That capital flight means less money for domestic growth. . . . [8]

It never ends. As soon as workers begin to participate in the prosperity of a region, wealthy nonworkers abandon it. Their exodus is especially rapid when the social disintegration—*which they caused*—begins to accelerate. Naturally, Taiwan's environmental problems are horrendous, and housing prices have gone out of sight for most of its workers.

It's ironic. The very same tactics that South Carolina used against the industrial North are now being used against them. It is now experiencing the same kind of community damage that it caused in the rest of the country. Northern communities that once had adequate tax bases, effective schools, and decent measures of social health saw companies abandon them to move south, purely in the name of competition and excess profits.

Internal Regional Disruption

The same kind of "free market" economics is occurring *within* South Carolina. The "rich versus poor disparity" between its own counties is getting worse. Communities like Spartanburg that have been doing an outstanding job of recruiting new industry are attracting citizens from other communities in the region that aren't growing as fast.

Dan Mackey, executive director of the state Advisory Commission on Intergovernmental Relations, noted in December, 1989:

> Here we are just a few weeks away from the last decade of the century . . . and we are fast becoming a state that has one set of counties which are "haves" and one set of counties which are "have-nots."[9]

Right Wing Economics Gone Berserk

Certainly some community growth is healthy, even at the expense and disruption of other communities. Without constant readjustments, any economy, or society, would become stagnant. However, there has to be a point where the disruption becomes excessive. It can reach a level where problems become almost irreversible.

School buildings in abandoned communities stand empty, while those in growing communities can't keep up with the sudden inflow of students. Instead of building academically desirable small schools, they build huge monstrosities because of the economies of scale.

Whereas the streets in abandoned towns are empty, growing cities can't handle the traffic jams. Empty store fronts stand useless, or burned out, in the abandoned communities. Lack of space and decreasing supplies cause building costs to skyrocket in the more dynamic, congested communities.

Declining communities are losing their citizens, along with their industries—as well as their tax base—and, ultimately, their quality of life. At the same time, growing communities are exceeding their tax base, and also losing their quality of life. And everyone, everywhere, complains about increases in taxes, which seem to be going out of sight, but are still inadequate.

All are losing their "sense of community" and are under stress. It's the classic prescription for the problems associated with community degeneration: crime, drugs, family breakdown, violence, the loss of values and so on. And the prescription applies to both the have and the have-not communities.

This is the point at which the economic benefits of conservative irresponsibility break down. Most of us benefit from the economies of

environmental pollution—up to a point. Most of us benefit when our own auto workers lose their jobs to lower paid Mexican workers—to a point. Most of us benefit from the lower labor costs when a maker of tennis shoes moves from the Northeast to the South, and then to Indonesia—for awhile.

But then we go too far. Suddenly we find that we've gone beyond our known solutions to social problems. That's when the financial costs of social and environmental irresponsibility hit us between the eyes. Not only do these costs become incalculable, their payment may possibly become unachievable.

Of course, those at the bottom of the pay scale suffer first, and most, from community disruption. Undereducated and with no financial cushions, they are least able to withstand the costs of conservative economics. They dominate the statistics of social degeneration, and they will lead the way to a quality of life that none of us wants.

PERSPECTIVES

Note that the Spartanburg statistics are taken from public records and they are as accurate as their own official documents. The comments by members of the Spartanburg Chamber of Commerce and the Spartanburg Development Association occurred as presented, and they are as accurate as my note-taking abilities.

However, judge for yourself. I'm sure there is a dynamic, "successful" Spartanburg near you. Read its newspapers. Even the ones with an anti-worker bias can't keep the bad news off the front page. Watch the documentaries on TV, listen to the radio, look at the *total* picture—and envision the kind of future the Limbaugh conservatives are trying to con you into.

Spartanburg's future successes and problems are predictable. We already know how communities can attract new industry, and what causes the social degeneration of communities. We simply cannot continue making the same mistakes that we made throughout Limbaugh's glorious decade of the '80s.

21.

First, the American Indian; now, the American worker

Limbaugh eagerly joined the hullabaloo about celebrating, and protesting, the Columbus holiday of 1992. It gave him a perfect opportunity to further galvanize his right-wing conservative supporters. They had an absolutely delightful time offending the ethical sensibilities of any reasonable person.

He couldn't understand why the Indians were less than enthusiastic about losing their continent to the white faces, or why Caucasians should feel any twinges of guilt. His reasons for feeling good about what his ancestors did to the Native Americans:

- The Native Americans themselves committed savage atrocities against the defenseless settlers who were taking their land. So, in a sense, they got what they deserved when the settlers killed them.
- There is no way we can ever undo history, and no way to try to compensate Native Americans for what was done over a hundred years ago. We can't be held responsible for what our ancestors did.
- The Native Americans weren't really doing anything of consequence with their continent anyway, and

- Look what great things Caucasians have done since they set-
 tled here. The U.S. has given more culture and material
 progress to the world than any other country in history.

So, according to Limbaugh, there is no reason to feel guilty about
the past or present plight of Native Americans, and, if you do, it is the
result of a liberal plot to make everyone communists.

If you are a worker without a college degree or special training,
watch out. The Limbaughs of the world are setting you up for the
same fate as the Native Americans. They are saying the same things
about you as they said about them, but sanitized, of course:

- During the previous fifty years, unions made excessive wage
 demands on defenseless businesses, and caused artificially
 decent living conditions for workers. Therefore, workers are
 now getting what they deserve when they lose their jobs to
 Mexicans who are making one tenth as much.
- Our conservative ancestors decided *long ago* that American
 workers should compete with the most impoverished work-
 ers of the world. There is no way we can turn the clock back
 to earlier times when we paid workers decent wages for man-
 ufacturing products for our own consumption.
- Since work now can easily be farmed out to other impover-
 ished countries, uneducated American workers can't really
 contribute anything of value to society.
- Look at what great things conservative politicians have done
 for our country by selling out our workers: low inflation
 rates, low interest loans for housing, cheaper products for
 everyone, and a rising standard of living for the top half of
 American citizens. We now can take pride in being the most
 ostentatious country ever.

So, instead of feeling guilty at what we've done to workers, we
should just put them out of mind (as we have done with Native
Americans) and continue on our way. And if workers complain, we'll
just tell them they have the same opportunities as anybody else (as we
have told Native Americans).

The Conservative War Against Workers

If you think Limbaugh's ideas are new or unique, you haven't been reading much lately. Conservatives everywhere are writing off the American worker. In their book, *Megatrends 2000*, John Naisbitt and Patricia Aburdene expressed contempt for the "doomsayers in our midst." With characteristic understatement, they predicted:

> Before us is the most important decade in the history of civilization, a period of stunning technological innovation, unprecedented economic opportunity, surprising political reform, and great cultural rebirth. It will be a decade like none that has come before because it will culminate in the millennium, the year 2000.[1]

Their good feelings about the United States aren't extended to our lower-skilled workers, however. They asked, and answered, a revealing question:

> Did the unskilled, uneducated white male have it made in the industrial America? You bet. Those days are gone forever.[2]

The sad question now is: why? And why can't the uneducated, unskilled worker, of whatever color or sex, be able to work hard and make a decent income today? Not a fabulous income, or even a good income. Merely an income sufficient for a family of four to survive without being on welfare.

You can feel the answer in the ill-disguised glee of Naisbitt's and Aburdeen's own words. Affluent nonworkers have finally won the battle-of-the-buck against their less educated brothers and sisters. It's now official: people who merely work hard don't deserve a decent living, as they did during the most prosperous years for the majority of Americans.

The political power of labor unions has been severely crippled. Business cooperatives are effectively keeping a lid on the wages of

unskilled workers. Our country's protection of workers against unprincipled national and international predators has been withdrawn.

U.S. businesses can now take full advantage, not only of the cheapest labor available in the U.S., but also the cheapest labor available anywhere in world. The resulting business profits and increased income for affluent nonworkers are phenomenal. What great news!

What the *Megatrends* optimists don't see is that the cities of our country are falling apart at the same time. Except, of course, for many rural communities and the guarded communities in selected locations.

Those who criticize the Reagan and Bush administrations of the '80s and early '90s for not having a domestic policy just don't understand. *Not having a policy was the policy.* It's the conservative philosophy that the business of government is to get out of governing. In effect, it was a policy of "let the financial predators loose." And communities all across the United States suffered.

The War Within Our Borders

If you want to understand what is happening today in the United States, you need to understand what conservatives have been doing throughout our current century. *The seeds of Spartanburg's present economic success, and our country's economic disasters, were sown decades ago.* The depression of the '30s is a good place to begin our discussion of conservative class warfare, because it has been well documented.

History professor Carl Abrams reviewed a massive amount of data for his book about the southern conservative anti-worker bias of the 1930s. In *Conservative Constraints: North Carolina And The New Deal,*[3] he described how conservative landowners, businessmen, and politicians sabotaged the New Deal in the south in order to keep worker wages low in agriculture and manufacturing.

Conservatives kept the state legislature from adequately matching New Deal relief funds, which would have created new jobs for the people who needed them most. They made sure that agriculture pro-

grams benefited the wealthiest farmers, instead of the poorer ones who actually needed help.

Abrams also demonstrated that the "attack politics" of modern conservatives were alive and well, even back in the '30s. Wherever New Deal programs were implemented, conservatives threw up road-blocks in their paths and forced them to be inefficient and costly.

In addition, they did everything they could to ensure that most of the benefits went to those who were already affluent. Then they widely and loudly publicized the fact that the programs they had sabotaged were not working. And, of course, the public became disgusted with "government bureaucrats."

This is no different from the way modern conservatives sabotaged "Superfund," our government's attempt to clean up toxic wastes. In *Who Will Tell The People*, William Greider documented how special interest groups did everything they could to make Superfund as ineffi-cient and costly as possible, and to save money for some of America's biggest corporations. This was a deliberate effort to help conservative politicians create a negative voter backlash against Superfund, and to persuade Congress to back off its original legislation.[4]

The Taft-Hartley Law

Following the depression of the '30s, the North led the country, with the South tagging along, to the highest standard of living for workers anywhere in the world—in wages, working conditions and education. Progress continued well into the '70s, but the seeds of disas-ter were planted in 1947. That's when Congress passed the Taft-Hartley law, Section 14(b). Among other things, it allowed individual states to forbid the "union shop."

In a union shop, all employees who benefit from a union's activities must pay dues. It is an indispensable advantage for workers to have a union shop, because, without it, many workers have no incentive to join. They get all the benefits of a union, but don't have to pay any of the expenses. In addition, when some employees pay dues and others don't, yet all benefit, many of the ones who originally paid will stop. In other words, a union shop is vital to unions.

Some states saw the Taft-Hartley law as a golden opportunity to

attract industry from other states. They made the union shop illegal by passing so-called "right-to-work" laws. As a result, right-to-work states have been, and still are, attracting industry from non-right-to-work states in the country.

Incidentally, despite its name, the concept of "right-to-work" was not invented by, or for, workers. The National Association of Manufacturers thought it up in 1903 as a propaganda ploy. It was an emotional appeal to convince voters that workers shouldn't have the right to have a union shop—and, eventually, the ploy worked for them.

It took Republicans and conservative Democrats forty-four years of political double-talk (the term itself, "right-to-work," is proof of the deceit of its sponsors), before they could push Taft-Hartley through President Harry Truman's veto. That bit of anti-worker legislation eventually led to an unintended but predictable consequence: our present wanton disregard for worker welfare and community stability as criteria for business decisions.

North versus *South*

The problems of cities—crime, violence, school dropouts, joblessness, etc.—are fundamentally the same throughout the U.S., both North and South. The *causes* of the problems were the same—loss of a sense of community, economic hardships, lack of family stability and family values. To quite an extent, these, in turn, were caused by severe community disruption—also in both North and South. But the primary causes of *community disruption itself* are, in some important ways, different between the North and South.

The South's problems have always been, and still are, rooted in a history of terrible educational systems and anti-worker laws and traditions. The North, on the other hand, traditionally had good-to-excellent schools and a balanced management/worker environment.

A primary cause of the North's escalating economic and social problems is the flight of its industries to the South, with its lower wages and poorer conditions for workers. Even more damaging, however, has been the double-barreled influence of the South on the North:

- Because of the lower wages and poorer working conditions in the South, workers throughout the North have had to become more "competitive." Meaning: they must work harder for less money, simply because companies *threaten* to leave their communities and move South.
- Rather than the North influencing the South's values, the South influenced the North. Nationwide, greed and an anti-worker mentality won out over morality. Profit and personal material welfare became more important than fair wages and working conditions for workers. Using Limbaugh's cliché, "social engineering never works," business leaders made community welfare irrelevant to business decisions.

Just as industry moved from the North to the South, in search for low wages and terrible working conditions, industry is now moving to other countries. In both cases, the cause is the same: a conservative philosophy of survivalism. All spoils go to the winners, with no regard for those left behind.

INTERNATIONAL CLASS WARFARE

Free world trade is an excellent concept, as long as every country adheres to the same standards of competition, including wage rates, environmental controls, and fair exchanges of products and services. So far, other countries are not even close to meeting those conditions.

Of course, industries in the South now want protection from the unfair trade practices of other countries. *These are the same practices they used when they attracted industry from the North.*

The words of Paul Bahrami are priceless. He is president of the company that owns Fashion Printing in Concord, North Carolina. Bahrami is against the North American Free Trade Agreement, because:

By forcing companies that produce domestically to compete with companies that produce in Mexico, you also force them to

cut wages and benefits to American employees or face the threat of closing down. . . . Do we really want to see future generations of Americans living at the standards at which the Mexicans are now forced to live?[5]

Of course Bahrami is right, but his argument is *almost* humorous. It is exactly what liberal Democrats argued when conservatives got the Taft-Hartley bill passed. Substitute "northern employees" for Americans—and "southern employees" for Mexicans, and you have the identical situation. There is a principle here:

A region with a history of brutal anti-worker practices will take business and industry from a region with more moral practices every time. It is true within the United States, and it is true internationally.

It is always that way. Conservatives want profits now, regardless of cost, and to hell with the most basic of family values: education, economic security, stable communities, and truly free markets that are protected from unethical competition.

Japan

Japan is a good example of our high-tech competition. No one pretends that the Japanese are coming close to meeting us halfway in allowing the free exchange of goods and services. From food to industrial products, the Japanese government's official policy is to conspire with its industries to keep foreign competition out of their country.

Yotaro Iida, chairman of Mitsubishi Heavy Industries, Ltd., did us a favor by explaining another reason we're losing the trade wars:

When I first visited the U.S. in 1953 and 1954, Americans were producing very good goods. But recently, America has stopped making things. And as America stops making things, Japan steps in.[6]

We need not dwell on the fact that we should be producing more of

our own manufactured products, or that Japan is taking monstrous advantage of us. That is obvious to everyone. What is not so obvious, at least to conservatives, is: what is fair for the American worker in the total scheme of free trade?

Sure, Japanese workers put in between twelve- and fourteen-hour days, six or sometimes seven days a week. Most can't afford a vacation. If they don't "volunteer" to work overtime, they can be fired and blacklisted. They work hard, but it's due as much to fear as to loyalty and a work ethic. They are sacrificing their quality of life to compete on the world markets.

Half of the Japanese households aren't connected to a municipal sewage system. They have only 58 percent as much paved road as Americans or Western Europeans. Their suicide rate is increasing, even among youngsters, because the stress is taking its toll.

Does all this mean that we must force American workers to go back to the work standards of the nineteenth century, simply because other countries in the world are still there? Just because the powerful elite in Japan treat their workers like chattel, does that mean that we must do the same?

Mexico

Mexico is a good example of our financially strapped, low-tech competition. Because of recent and proposed trade agreements, Mexico may cause the loss of American jobs to accelerate even more.

Consider an event that didn't make the national news, because it has become so common: Hamilton Beach/Proctor-Silex laid off about 600 workers at its manufacturing plant in Southern Pines, North Carolina and shifted the jobs to Mexico. Officials said that labor costs are cheaper in Mexico, where the company has operated a plant for ten years.[7]

Richard Slack, the human resources director said, "We have been here as a good employer for nearly thirty years. And we certainly like the area. It's purely an economic decision." Let's see. The company liked the area. Workers made a good quality product. The company, however, was losing money because it simply cannot compete with Mexican manufacturers who pay their workers one-tenth as much in wages.

The *only* option left is to go out of business or move the jobs to Mexico. Or maybe the American workers could survive on only $2,000 per year.

"Ah," say the conservatives, "the American workers will find something else to do. Plus, the workers in Mexico will benefit tremendously and become customers for American products."

Wrong on both counts, if statistics and history are indicators.

In an open letter to President Bush and Mexican President Salinas de Gortari, The Eureka Committee, one of Mexico's oldest human rights groups, had this to say:

> It has become indispensable for Washington's interests that Mexico appears to be an example of democracy and respect for human rights. But everyday reality is just the opposite. The will of citizens is not respected in the ballot boxes, nor are the most elemental social and human rights.[8]

Mexican workers who now have manufacturing jobs *still* have terrible living conditions, and make barely enough to survive, let alone buy many of our products.

On the other hand, Morgan Guaranty Trust estimated that, as of 1988, wealthy Mexicans had taken some $84 billion out of Mexico. The money ended up in California condos, art, and just about anything other than better living conditions for Mexican workers.

Now get this: the per-capita income in Mexico is only $2,300. If the rich in Mexico are skimming billions off the top, and squandering it, the average Mexican consumer must have considerably less to spend than the $2,300 per-capita "average" would indicate.

"FREE TRADE" AND THE
VANISHING AMERICAN WORKER

Will our displaced workers be able to find good jobs, and maintain their standard of living? History says definitely not. Even the optimists, Naisbitt and Aburdene, say, "There is no doubt about it: wages are

down for unskilled, uneducated male workers."[9] When they lose their manufacturing jobs, for most of them, the next step in income is significantly down. Bob Hall, research director of the Institute for Southern Studies, says that:

> Taken together, service and trade jobs now employ nearly half of all Southerners. That's up from about a third in 1969. But those new jobs just can't compete with the wages and benefits offered by the region's old industrial base.
>
> The Squeeze is on, and people are having to work harder for less pay.[10]

Of the new jobs added in the South during the decade of the '80s, only 68,500 were in manufacturing, while 5 *million* were in services. Since 1969, the percent of non-agricultural workers in the South employed in manufacturing dropped from 27.5 percent to 18 percent in 1989.[11]

Perspectives

Now you know, if you didn't already, what's happening because conservatives have sacrificed workers on the altar of free trade. Of course, it's nothing new, and has been going on for years. It's just that the Republican '80s made it respectable.

Are the lower prices that we pay for small appliances worth destroying a small community in North Carolina? Is the loss of downtown Detroit, much of Flint, and the deterioration of the many automobile communities in the U.S. really worth getting cheaper, even better, Japanese cars? Add to those cities the textile communities in the South and the electronic communities all over the country, to mention some of the more noteworthy.

As our manufacturing jobs leave the country, there goes the neighborhood. And here come the drugs, alcoholism, crime and all the things we complain about today.

The wealthy and the educated, of course, benefit immediately and directly from *unmanaged* world free trade. Prices in general are lower

for most people. But workers pay dearly for it, and it eventually destroys communities. Most other countries have neither working democracies nor true capitalism. Among our international competitors, both rich countries and poor countries, workers don't come close to sharing the prosperity with the wealthy elite.

We need to announce to the world that we'll no longer participate in the age-old practice of cheating workers out of their fair share of the fruits of their own labors. This will require that we revive some ancient, "discredited" ideas, such as *managed* free trade, that are rapidly regaining respectability.

The international playing field needs to be leveled, and to the extent necessary, our nation's economy fenced off from the immoral abyss around it. It's hypocritical and morally dishonest to expect the American worker to give up his share of the prosperity of the United States—that he is largely responsible for—just because of the deplorable ways other countries treat their workers.

You can bet your life's savings on one thing. If citizens of other countries spoke perfect English, were familiar with our culture and business practices—and could do the jobs of our corporate executives, congressmen, doctors, lawyers, investment bankers, management consultants, small business owners, and so on—our right-wing conservatives would shut down so-called free trade in a heartbeat.

Our wealthy American nonworkers would clearly see the threat of outsiders who would be willing to work seventy hours a week for one-tenth of what they're making. They would see their own struggles, efforts, and pains of their younger years, in effect, going down the tubes for the sake of a fictional and immoral "free market." Suddenly, the inevitable and disastrous decline in their overall quality of life would become *personally* apparent to them. And they would *know* the unfairness of it.

Naturally, the only jobs we can export today are the ones that our least educated and hardest working citizens can do, so our business and political leaders don't have a thing to worry about. They can go to bed at night with clear consciences and secure feelings. They can remain warm in the comfort of knowing that they and other wealthy families, and their descendants, are well off and becoming even more

affluent—benefiting from the *constantly degenerating* cut-throat competition that they have willingly brought upon our workers.

So, if you are truly a worker—remember what happened to the Native American. Limbaugh and his ilk are gunning for you, and you are rapidly becoming irrelevant to the politically powerful.

Unfortunately, too many people have been conned. They think their real friends are their enemies, and that their real enemies are their friends. The first step to correct this situation is to expose the Rush Limbaughs of our country for the class warmongers they are.

CONCLUSION:

Morality and America's new world role

Limbaugh and his right-wing conservatives have a real problem. As the '80s progressed, the number of millionaires tripled, and fewer and fewer people owned more and more of everything in the United States. At the same time, the incomes of the bottom half of Americans didn't keep pace with inflation. More people fell out of the middle class, and still more dropped below the poverty line. Yet, somehow, Limbaugh must convince voters they should vote for conservative politicians who wish to continue favoring the rich.

How to do it? Easy. Just twist everything around, and reverse all our traditional values. Equate capitalism with greed, discredit our free press, deny that democracy was a fundamental cause of our economic successes, de-educate the public, and remove "fairness" (morality) from the equation entirely.

How American Capitalism Defeated Soviet Communism

We've all heard the good news: communism is dead and we've declared capitalism the victor. The bad news is, we don't understand that capitalism, in our country, is only one-fifth of our success story.

189

First, of course, *capitalism is superior to communism* because it relies on individual initiative and it rewards success. But the greed that Limbaugh glorifies isn't its essence. Its essence is that *ethical* individuals can become wealthy by providing useful products or services, in a truly free and open market. That is the *only* way capitalism can continue to work.

Second, *democracy beat dictatorship*. Limbaugh doesn't really trust democracy; he wants a plutocracy in which the conservative elite rules the country from behind the scenes. He took extreme delight at the fact that the Republicans lied to Congress during the star-wars fiasco. He also thought that Ollie North's private war, with Republican direction and blessing, and against the wishes of the elected representatives of Congress, was a good idea. Those are the kinds of things dictators do. A true democracy is based on a balance of powers, with decisions being made in an open, truthful environment.

Third, *our free press defeated a government controlled press*. Our free press is one of the most important reasons capitalism has been uniquely equipped, especially compared with communism, to withstand an astonishing amount of unethical behavior. It exposes wrongdoings in government, academia, corporations, churches, and even in the press itself. You name it; if it is a wrongdoing, almost any journalist would love to expose it.

An effective and free press allows our county to discover and correct its problems. The communists had no such advantages; their institutions continually got more corrupt. The attitudes of Limbaugh and the right-wing crazies toward our free press, and their attempts to discredit it, are well known and need no elaboration here. (See Chapter 5.)

Fourth, our *educated and informed citizens defeated uneducated and misinformed citizens*. Regardless of right wing propaganda of the past, the American public has been fairly well informed about public affairs. Limbaugh, however, seems to have discovered new ways to distort reality, and make misinformation appealing to those whose primitive and divisive biases are still intact. It is well past time to counteract this latest threat to an educated public.

Fifth, and most importantly, *a fundamentally moral society defeated an immoral society*. Benjamin Franklin prescribed the key

ingredient for our eventual success: "Only a virtuous people are capable of freedom." John Adams was a little more specific: "Our constitution was made only for a moral and religious people. It is wholly inadequate for the government of any other."

MORALITY:
THE FOUNDATION OF DEMOCRATIC CAPITALISM

Only a culture with sound moral values can effectively solve its problems, whether social or economic. Citizens must be willing to sacrifice their own self-interest at crucial times when courage is called for. Immoral cultures always degenerate because greed, considered a vice prior to the conservative '80s, overcomes all attempts at objective problem solving.

That could be good news to the extreme right wingers who cherish the notion that the former Soviet Union is still America's biggest threat. Russia's first steps to embrace capitalism were to send some of their students to the Harvard Business School, and to have Harvard professors go over there.

Think of it! The Soviet Union adopted communism, and *now* Russia wants to incorporate the worst values of capitalism: markets ruthlessly controlled by individual business persons, unlimited profits for the greedy, and no moral base to build on. Just imagine what will happen to them after *they* staff thousands of their own savings and loans, or whatever, with executives trained by the Harvard Business School.

Not only did our right-wing economists insist that Russia convert to *unmanaged* capitalism, they insisted that they do it immediately and completely. Not in ten years, not five years or one year—but immediately. Not sequentially, not by degrees, not by sector, not in increments—but everywhere and without reservation.

In other words, right-wing economists, by habit and instinct, prefer anarchy to *any* system of government. Their confidence in the virtues of greed, the rapid growth of wealth by the already rich (and its "trickle down"), and their blind distaste of any governmental protec-

191

tions from financial predators has led to economic chaos. Our well-intentioned right-wing advisors may well have created a fascist Russia, unless the Russians, and we, are very lucky.

With much the same approach, America's right wingers want us in the United States to forget that their most hated virtue, "fairness," (Limbaugh always says the word with a sneer) is what sane people also call morality, and is the foundation of democratic capitalism. They want us to depart from our own blueprints for success, and to abandon the behaviors that got us, admittedly rather shakily, to the 1980s.

The players in a free market and a free society *must* define and respect moral values. To the extent they don't, and the financial and social predators begin to take over, some sort of democratic control of behaviors becomes necessary. Without sensible controls, we lose the freedoms we originally designed into the system.

It's a catch-22. If the players become *too* corrupt, and we continue to add still more protective controls, we eventually destroy the original purpose of the free market. It becomes a straitjacket of regulations.

Conservative "Realism" and the Loss of Morality

As soon as two of us get together and decide to be "realistic" about what's actually going on in the market, both reality and ethical behaviors degenerate. That is, as soon as we agree that:

- self-interest is, in itself, a healthy mental attitude,
- you can't expect people to be saints,
- everybody manipulates the market and the system,
- we all discriminate in favor of our friends, relatives, and close associates,
- there always have been and there always will be poor people, no matter what we do,
- and on and on

these things become truer today than they were yesterday.

In other words: *The practical expediencies of today become the moral standards of tomorrow.* As new players enter the game and

competition gets more intense, the above axioms become even more true. And suddenly we wake up one day and can't recognize the society we once were proud of.

The Business and Political Leaders of the '80s

There is a saying among management consultants: walk through any office, through any manufacturing plant—whatever you see going on, management is causing. The same is true of our society. Our leaders' values are reflected in our laws, our financial priorities, and our public and private institutions. These, in turn, determine the public's values and, hence, their behaviors.

If moral values in the United States are degenerating, or getting better, our leaders—political, religious, business, legal, academic—are the cause.

The country clubs, the ghettos, the elegant hospitals, and the crime rate are all caused by society's leaders. So are magnificent universities, teen-age pregnancies, heroic deeds, great libraries, illiteracy, charitable endeavors, and drug addiction.

Examples of success and failure are found in every society. However, the *quality of leadership* is what distinguishes between those societies that nurture positive forces and discourage negative forces, and those in which the opposite is true.

In the '80s, America's business and political leaders sold us out. Their "bottom-line" realism drove out all ethical considerations that related to our most numerous and most defenseless citizens: workers, especially the unskilled ones.

Instead of striving for a better society for *all* Americans, those in power pursued benefits only for the educated and affluent. The system that was designed for all was replaced by a system for the elite. In practical effect, they replaced democratic capitalism with plutocratic capitalism.

They violated two ethical principles that are especially significant, and are at the heart of our present problems:

1. "Utility" (the greatest good for the greatest number) is probably the least appreciated ethical standard, and our violation of it is

the major cause of the income disparity between rich nonwork-
ers and everyone else.

2. The public's right to be fully and honestly informed about
national issues has been violated by some of the most cynical
and accomplished political propagandists our country has ever
had.

If we are to rescue our society from the wretched excesses of the
'80s, we need to arm ourselves against these ethical violations through
understanding and political action.

UTILITY:
THE FORGOTTEN MORAL STANDARD

Before you can understand *utility*, you have to understand two other
principles of moral behavior: *rights* and *justice*.

Rights relate to the *individual*: the right to have the opportunity to
make a decent living, for example. Or to be fully and honestly
informed about important social problems.

Justice goes further and relates to relationships *between* individu-
als, such as fair wages to every person in a work group. Or, in a nega-
tive sense, equal punishment for equivalent crimes against society.

Utility goes still further, and is concerned with the greatest good for
the *greatest number*. Just because it's legal, one person shouldn't buy a
corporation's pension fund, sell it at a huge profit to a fly-by-night
investment house, and use the money to buy a yacht and a mansion—
while thousands of elderly pensioners, on reduced incomes, see the
fund go bankrupt later.

Actually, the principles of rights, justice and utility are all interre-
lated and never exist in isolation. They simply give different perspec-
tives from which to view moral considerations in decision making.
Given these qualifications, "utility" is the ethical Achilles heel of capi-
talism, or of any other economic system that is supposed to benefit the
greatest number of people.

Our system of democratic capitalism does a reasonable job with

194

rights and justice issues, especially when compared with other countries. We're a sentimental people and we readily resent obvious injustices to, or between, *identifiable* individuals.

No country, including the United States, however, has ever been much concerned with *utility*. Utility relates to the amorphous public—people who don't live in *our* neighborhood, are not members of *our* political party, don't have *our* level of education, are not members of *our* management clique, and so on.

Unethical utility decisions affect our economy—and our workers—far more than do unethical rights or justice decisions. Rights and justice, although not completely satisfactory in actual practice, are accepted by U.S. citizens as necessary moral "givens."

On the other hand, we totally disregard utility considerations. Capital has become "only money," and to manipulate money is a legitimate part of the American Monopoly game of power politics, power management, or power whatever. It's based on the principle that the spoils go to the victor, not on what is best for the total society.

We've reached the point in the U.S. where the misuse or squandering of money is not only *not* subject to moral censure, it has become a perverted, even glorified, *right*.

Utility Values of America's '80s

The prevailing utility values of the eighties are best exemplified by the late Malcolm Forbes' famous seventieth birthday party. The *New York Times* described it this way:

> Morocco's delight at the publicity surrounding the party helped Mr. (Malcolm S.) Forbes justify the expenditure of an estimated $2 million on celebrating his seventieth birthday. . . .
>
> Mr. Forbes offered an explanation that seemed closer to the heart of a man who likes to be called a prophet of capitalism. "Most people, if they had the money and were in the same position as I am, would do what I do," he said. "It's stupid not to go through life enjoying it when you have good luck and good fortune. . . . "
>
> He has acquired an island near Fiji, a château in France, a

ranch in Wyoming, a mansion in London, a 150-foot yacht and a Boeing 727 as well as his palace here. . . .

It was therefore not out of character for Mr. Forbes to charter a Concorde, a Boeing 747 and a DC-8 to bring over his guests from the United States for the weekend here. A score or so preferred to come in their executive jets and private yachts.[1]

As might be expected, many editorialists were critical of Malcolm's extravagance. Not everyone, however. Fellow millionaire-at-birth William F. Buckley completely sympathized with Malcolm's brand of moral values:

> Oh my goodness, what moral onanism is going on in connection with Malcolm Forbes' birthday party. . . .
>
> We have—all of us—the right to be our potty little selves, and if Richard Burton wants to buy the Hope diamond for Liz, there it is; and if a million people want to make pilgrimages to the grave of Elvis Presley, why, let a million people do what they want to do; and if Michael Jackson can make more money in one evening than Wolfgang Amadeus Mozart made in his lifetime, well, whoever said economic democracy and sound aesthetic judgments go hand-in-hand?[2]

That about sums it up. To wealthy nonworkers of the eighties, how you spend two million dollars is merely a question of *aesthetics*. Ethical utility considerations are irrelevant.

Utility Values of the World

Mention anyplace in the world—China, Japan, Russia, Latin America, the Caribbean, the Arab states, the Philippines, what have you—great wealth proliferates alongside abject poverty. Utility is totally disregarded as a moral issue.

As soon as laborers begin to participate in the prosperity of a region, the wealthy either beat them down, or abandon them and take their money to new sanctuaries. Their exodus is especially rapid when the social disintegration—*that they caused*—begins to accelerate.

The wealthy of Argentina have taken their money to Miami and Switzerland to avoid their country's hyper-inflation. The businessmen in Brazil and El Salvador (that is, the ones who decided not to leave their countries) formed alliances with the military and the police to protect their interests from the growing number of poverty stricken teen-agers in the streets (by killing them.)

Georgie Anne Geyer of Universal Press described the virtual collapse of law and order in St. Croix in 1989. Gangs of native St. Croixans armed with shotguns and hunting knives had looted and plundered the island. Geyer reported how disintegration, or "deculturalization" is taking place across the Caribbean. And she noted the opinions of the press and the scholars in Jamaica:

> They talked about rich Jamaica becoming "Haitianized," or brought down to the total impoverishment of Haiti. With the top and highly productive third of its population in the United States, the Jamaica of so much promise had become a country of young men waiting on street corners. . . .
>
> Projections are that the Caribbean Basin faces a tripling of its labor force from 53 million in 1980 to 150 million by the year 2025, half under eighteen years of age. Job creation is virtually nil, infrastructures break down daily, and sentiment against tourists who are their only hope is raging. . . . [3]

It goes on and on, all over the world. There is no way we as a nation can force, bargain, or buy ethical treatment for workers in other countries, especially *when we don't treat our own workers ethically.*

The best we can do is to announce to the world that we'll no longer lower our moral standards to the lowest levels just to be competitive in markets that are controlled by the predators of other nations. Then we must *actually adhere* to our own ethical standards of rights, justice, and, especially, utility.

We need to demonstrate world leadership by example. We won't continue to participate in today's willfully vicious race to take advantage of, and then abandon, the world's least educated and least skilled people. Our commitment to moral treatment of workers would be not

only on behalf of our own working U.S. citizens and our own long term survival as a humane society, but also on behalf of the working people of the world.

OPEN AND HONEST COMMUNICATION

The second major ethical violation that has hurt the middle class American is the deliberate distortion of information in political communications. It made the good guys look like they were disloyal Americans who wanted to "tax and spend"—and the bad guys look like dynamic individualists, fighting for the common man.

Class Warfare and the Divisiveness of Race

The Republican "southern strategy" is probably the most egregious example of deliberate distortion in political communication in recent history.

Because of the civil rights legislation of the '60s, minorities made significant progress in coming into the mainstream of American life. The increased competition for jobs and promotions has undoubtedly made it tougher on some whites, leading to well-publicized charges of "reverse discrimination."

Compared to other economic factors, however, the number of whites who didn't get jobs because some blacks got them, has been minuscule. Instances of reverse discrimination are almost incidental, compared to the *millions* of workers who have lost their jobs, or been forced into poorer-paying jobs, because Republicans and conservative Democrats deregulated business and *totally disregarded the rights of workers—black or white.*

Republicans have been remarkably effective in diverting attention from their own sorry record with regard to working class Americans. Since the 1960s, they have deliberately injected race into both local and national political campaigns. In the '80s, their television ads heightened racial animosity in order to increase their political advantages. The Bush campaign did it with the Willie Horton ads, Jesse Helms with the quota ads.

Republicans have played ancient racial prejudices against economic common sense. They've tapped the suppressed resentments of white workers against black workers. All this, in order to stop workers from trying to understand the complexities of the national and world economies and the Republicans' unwillingness to support policies that are fair to middle- and low-income Americans.

Conservative Smokescreen: Black versus White

For white voters, conservatives have deftly switched what should be a wealthy-nonworker *versus* worker issue to a white *vs.* black issue. And in the process, they have won large numbers of white voters to their side.

In a speech to the Senate, Senator Bill Bradley confronted the Republicans on their cynical willingness to aggravate race relations for political gain. He noted that George Bush opposed the Civil Rights Act of 1964, and said that the Act "violates the constitutional rights of all people." This was at a time when blacks had to use separate restrooms and restaurants, and were turned away from hotels and movies.

Bradley asked the question of Bush: "Did you ever change your mind and regret your opposition?" Bush never answered the question, because he couldn't. He was caught red-handed.

Bradley summarized the real issues for the middle-class American worker precisely:

> The average middle-income family earned $31,000 in 1977 and $31,000 in 1990. No improvement. During that same time period, the richest 1 percent of American families went from earning $280,000 in 1977 to $549,000 in 1990. . . .
>
> Just as middle-class America began to see their economic interests clearly, and come home to the Democratic Party, Republicans interjected race into campaigns, to play on new fears and old prejudices, to drive a wedge through the middle class, to pry off a large enough portion to win.[4]

Of course, the race-baiting issue is important for reasons other than the fact that it is bad for all workers and it unfairly affects political

elections. There is no need to document the terrible living conditions for many blacks in our country. It is another of the worsening problems that we have to address as a nation.

Putting it off until another day will only make our future options more expensive or distasteful. Eventually, our grandchildren will face alternatives that no moral society ever wants to face: what do you do with large numbers of almost unsalvageable human beings? Pay tremendous amounts of money to rehabilitate them from cradle to high school—or kill them, pen them up, isolate them in ghettos, or what?

If we're a moral society, we *have* to address the problem. Do we want ethical politicians to do it today, or leave it to our children's children?

PERSPECTIVES

The *only* organization that is interested in *objectively* solving *nationwide* problems is the federal government. Despite its well known inefficiencies and corruption (as occur in *all* large human organizations), *no other segment of our society* has its balance of powers, its democratically elected officials, or its charter to uphold the interests of the total society.

Our task, then, is to educate the public to vote for political leaders who actually want to address national problems. We need leaders who recognize that the survival of any society depends on its ability to correct the imbalances that always are developing within its systems.

Rights, Justice, and Utility Within Our Own Borders

Every problem has a scope, a dimension, and a sphere of impact. And, as much as they hate to admit it, political leaders always have a limited jurisdiction of power, especially when it comes to conditions in other countries.

Therefore, they simply cannot control the injustices to working class citizens in other countries, or force other countries to reduce the fundamental cause of their own domestic problems: the huge disparity between their incredibly wealthy citizens and their impoverished citizens.

Our leaders *do*, however, have the power to refuse to allow our own workers to suffer from the same inhumane work conditions that are prevalent in other countries, by appropriately managing international trade. Our leaders also can control the injustices that result from destructive economic imbalances that occur between states *within* the United States. Therefore, our *first-priority* concerns should be with what is occurring within our own national borders.

Our own nation is the largest domain we *can* manage, and it is the smallest domain that we *must* manage.

Certainly there are international solutions for many of our economy's problems, and we must enter agreements with other nations in order to realize them. There also are local solutions to problems that individual states can implement. But, for the 1990s, the solutions to our most important problems must be *national* in scope.

The Pinnacle (?) of Right-Wing Attack Politics: Rush Limbaugh

Rush Limbaugh once complained to an interviewer that "I am not a bigot, I am not a racist, a homophobe, male chauvinist pig, or any of that."[5]

Maybe not. But he obviously designs his comments to *appeal* to bigots, racists, homophobes and so on, and to the shreds of those characteristics that exist in all of us. And in the process, he adds to the power of those who have always fought for special privileges for the wealthy, and against advancements in worker and civil rights of all kinds.

You know it and I know it. Most Limbaugh supporters have to know it. George Bush and Dan Quayle have to know it. Bill Bennett, Jack Kemp, and Pat Buchanan have to know it. Roger Ailes has to know it (he is a master of attack politics and media consultant to Nixon, Reagan, and Bush, and the one who got Limbaugh into television).

Yet, despite this knowledge, or possibly because of it, Republicans made Limbaugh their unofficial star at the 1992 Republican National Convention. Paul Colford describes the event this way:

"Rush, Rush, Rush!" went the chant inside the Astrodome when he took his place in Quayle's private box of blue chairs

201

reserved for family and friends. There was Falwell seated behind Marilyn Quayle, Robertson on her left side, and Limbaugh on the right, at one point arm-in-arm with her as she glowed.

"Rush, Rush, Rush!"

These were his people and he was their hero.[6]

Ronald Reagan wrote an especially revealing letter to Limbaugh: "Thanks for all you're doing to promote Republican and conservative principles. Now that I've retired from active politics, I don't mind that you've become the number one voice for conservatism in our country."[7]

Let us hope that Rush Limbaugh represents the pinnacle of attack politics, and that we are now on the downhill slope toward a more reasoned debate about our national problems. Unfortunately, during difficult economic times, intolerance and divisiveness have tremendous appeal.

Mein Kampf, after all, was a best seller. By capitalizing on public anger, Hitler became extremely popular with the German people and eventually prevailed. And it isn't yet clear that we are still capable of resisting the same kinds of destructive appeals in the United States.

H.G. Wells wrote, "Human history becomes more and more a race between education and catastrophe." Today's race is between catastrophe and our understanding of the relationship between mankind's darker side and the necessity for an effective government.

Now comes the really bad part. Genuine problem-solving works well only as a prevention of, not as a solution for, hopeless situations. The longer we delay preventing problems, the harder and more costly it will be to solve them. Societal degeneration can reach a point beyond which there are no morally satisfactory remedies, or at least we haven't found them.

We must resist the temptation to glorify demagogues. And we shouldn't vote for leaders who publicly *espouse* the values we cherish, but who we know will actually represent our own short-term, narrowly defined selfish interests. People everywhere are rebelling against injustice, and are becoming harder to forcibly control. More and more of our citizens no longer care if they live or die.

We must vote for leaders who will address the legitimate grievances of *all* those under their stewardship. The only other alternative is to constantly evolve in directions we all abhor, with totalitarian leaders we never should have wanted in the first place.

ADDENDUM:

The cycle continues

BusinessWeek's cover story of September 27, 1993,[1] reported that the southern Interstate 85 corridor, from Alabama to Virginia, is experiencing an economic boom. Wages in the area are going up and getting closer to the wages in other parts of the country. Unemployment is down, and the material quality of life seems to be improving for many of its citizens.

The star performer of the I-85 corridor, Spartanburg, South Carolina, now claims the highest per-capita foreign investment in the U.S. Yet Tim Kuether, the city's director of planning and community development, said that the city itself "is becoming a haven for the minorities, the poor, the less educated and the like."

There are no movie theaters downtown, no big hotels, nor major department stores. The last department store left the downtown area some ten years ago.[2] All the prosperity is moving to the suburbs.

The only reason the I-85 corridor's wages are closing the gap with other workers nationally is that wages in other areas have *decreased* over the past twelve years relative to inflation. Workers who come to this "boom" area from other parts of the country are dismayed at its low wages.[3]

The I-85 region continues to use its low wages, huge tax breaks,

204

and, according to *Business Week*,[4] its reputation for "rabid anti-union-ism" to persuade companies to move to the area.

For example, to get BMW in 1992, South Carolina agreed to make its taxpayers pay financial incentives of $130 million over thirty years, with most of the expense already occurring in the first year. As part of the package, the state bought 1,000 acres with middle-class housing—that BMW will lease for $1 a year.

More recently, in the fall of 1993 various states bid against each other in order to attract a new Mercedes plant. The major contenders were thought to be North Carolina and South Carolina. Frank Hefner, a research economist with the University of South Carolina's College of Business Administration, saw it as "the new war between the states."[5] Watts Carr, North Carolina's Commerce Department's top industrial re-cruiter noted, "The pendulum seems to be swinging toward even more aggressive incentives. At some point, it goes beyond the sanity line."[6]

Well, it did. To most persons' surprise, Alabama won the bidding war at an estimated cost to its taxpayers of up to $360 million. In effect, the state agreed to pay Mercedes more than the plant itself will cost. Mercedes will pay *no* taxes for twenty-five years, and the state will withhold 5 percent of workers' salaries, to help the company pay its planned construction debt.

The Wall Street Journal reported the event this way: "Alabama declared war on North and South Carolina last spring. No blood was shed, but a lot of money was. . . . And big companies—foreign and domestic—are finding ingenious ways to cash in."[7]

The *Journal* noted that Alabama is under court order to spend more than $500 million a year upgrading its schools, and that "Mercedes's corporate income taxes could have been used to help pay those bills, but Mercedes will be exempt from such taxes for years."

Also, according to the *Journal*, economists say that "The giveaways rarely determine whether the company will make an investment in the first place; they just influence which state the factory goes in. . . . And the aid rarely creates jobs; it shifts them from state to state."[8]

The shifts are continuing, still seeking low wages. On January 10, 1994, Gibraltar Packaging Group announced that it would close its North Carolina factory and relocate to Alabama. "It is just a less

expensive part of the world in which to operate," said Jay Kilkenny, chief financial officer for the Charlotte based packaging maker. "Wage costs are appreciably lower."[9] Imagine! Companies are now leaving *North Carolina* to get lower wages in the United States!

Another event gave further evidence of the South's traditional bias against middle- and low-income workers. In 1991, a group of 500 Greensboro, North Carolina, businesses joined forces to *discourage* United Airlines from locating a $500 million maintenance facility there. Why? Because United would have brought 6,000 *unionized* jobs at *$40,000 a year*.[10] You just can't have bad examples like that around. So, United picked Indianapolis.

Of course, conservatives are pointing with pride to the fact that manufacturing seems to be making a comeback in the North. What they *don't* advertise, however, is that workers are making much less. A *Wall Street Journal* story summed it up perfectly:

> The heartland's manufacturing renaissance comes at a price. The typical wage of $8.60 an hour at the reopened Cummins plant is half that at the company's main heavy-duty engine plant in downtown Columbus. Most workers at the reopened plant can't afford to buy the Dodge pickups that run on the engines they assemble. . . .
>
> Brooke Tuttle, president of the Columbus Economic Development Board, figures that the area has lost 5,700 jobs at the major employers that paid $12 to $15 an hour. At the same time, it has gained 6,000 new jobs, partly by promoting the wages of $6 to $8 an hour to business prospects. "You don't have to be a rocket scientist to know we're still losing our standard of living," Mr. Tuttle concedes.[11]

Here's another thing you can bet your life savings on: the top corporate executives in these new manufacturing facilities are *not* taking comparable pay decreases. In fact, they are probably making more than ever before, because they have been able to cut workers' wages.

In other words, the cycle described in Chapter 20 continues. Right now, the southern states that win in the battle for new industrial

investment are those that are most willing to sell out their workers and their taxpayers. Their tradition of ignoring their growing social problems is paying off. Those left behind are of no concern to the wealthy, the educated, and the powerful elite (America's new plutocrats) in their mad rush to live the lifestyles of the rich and famous.

As you might expect, the economic disparity between the I-85 corridor and its neighboring communities is still getting worse. "When you get away from this corridor, the jobs aren't out there," according to Robert B. Jordan, head of the North Carolina Economic Development Board.[11]

It's noteworthy that most of the news sources cited here were essentially positive about the economic affluence of the I-85 corridor and the South's success in attracting industry. *Business Week*, the Newhouse News Service, and the *Charlotte Observer* articles all emphasized the economic advantages of winning the battle for new industry. The main point of the *Wall Street Journal* article about the Mercedes plant, however, was that "Alabama won the business, but some wonder if it also gave away the farm."

The news reports mentioned the downsides of progress, but almost as an afterthought. It's as though community disruption, especially in *other* communities, is not an important issue in a region's quest for economic success.

If history is any guide, we know that the problems of crime, underfunded schools and social services, drug abuse, and everything else associated with community degeneration will increase everywhere, *including the I-85 corridor.*

Taxes will have to go up, and voters will threaten to revolt, as they already are, in both the "winning" and the losing communities. In both cases, affluent and educated voters will never allow taxes to increase enough to keep pace with the rapid acceleration of community change. They already have it made, and, if worse comes to worse, they can always move to whatever safe refuges are left in the U.S.

And, as usual, Rush Limbaugh will be only too happy to point out that liberals want to spend still more tax money in their attempts to solve almost unsolvable social problems. The same problems that conservatives have caused, ignored, and abandoned.

NOTES

Introduction: The great Limbaugh con

1. David H. Bennett, *Demagogues in the Depression*, (New Brunswick, NJ: Rutgers University Press, 1969); Alfred McClung Lee & Elizabeth Briant Lee, *Fine Art of Propaganda* (New York: Institute of Propaganda Analysis, 1939).
2. Robert Lewis, "More of the same . . . in 1994," *AARP Bulletin*, January, 1994, 8.
3. David Rogers, "At Empower America, Refuge for Conservatives, First Year Has Been a Tale of Money and Ego," *Wall Street Journal*, January 6, 1994, A14.
4. "Limbaugh On Parade," *Flush Rush Quarterly*, Summer 1993, 12.

1. Symbolism over substance

1. "Observations," compiled by Jane McAlister Pope, "Coming eye to eye with truth," *Charlotte Observer*, April 7, 1991, 1B.
2. "Lee Atwater's Eulogists Betrayed Him," *Charlotte Observer*, April 25, 1991, 8A.

2. Environmentalist wackos

1. Paul Craig Roberts, "What Hasn't Changed In the East Bloc?" *BusinessWeek*, March 12, 1990, 24.

2. Susan Peters and Annie Stine, "Reagan's Rogues," *Sierra*, November/ December 1988, 20-22. Reprinted with permission of *Sierra*.

3. Name just one country

1. "Personal Income Tax Rate for Top Bracket," *Knight-Ridder Tribune News*, February 14, 1991, published in the *Charlotte Observer*, February 18, 1991, 3D. Reprinted by permission: Knight-Ridder Tribune Graphics.
2. Alexander Cockburn, "Debt and Destruction in the Wake of the Free-Market Gale," *Wall Street Journal*, November 8, 1990, A25.

4. Government regulation equals communism

1. Judy Woodruff, "Other People's Money," "Frontline," WGBH Educational Foundation, May 1, 1990.
2. "Get Out the Padlocks," *Wall Street Journal*, June 21, 1989, A16.

6. Wealth trickles down

1. Bruce L. Fisher, "Bush Agenda Would Help Business By Raising Taxes On Workers," *Charlotte Observer*, October 3, 1989, 9A.

7. Wealth is not a zero-sum game

1. "Did You Know?" *Charlotte Observer*, December 16, 1989, 1D.
2. "Affording Housing Isn't Getting Any Easier," *Charlotte Observer*, August 14, 1990, 1B.
3. David Gates, "Chic Comes to Crested Butte," *Newsweek*, December 27, 1993, 45.
4. Bruce Dunford, "Natives Die Waiting for Land," *Charlotte Observer*, April 19, 1992, 13A.
5. "Scholar: Americans a Threat to Planet," *Charlotte Observer*, April 6, 1990, 11A.
6. Edward Giltenan, "Waterborne Whiplash?" *Forbes*, September 5, 1988, 104.
7. Gretchen Morgenson, "'Profits are for Rape and Pillage,'" *Forbes*, March 5, 1990, 97-8.
8. Susan Lee, "Too Early for a Party," *Forbes*, July 23, 1990, 39.
9. "Donald Trump, Move Over," *Newsweek*, February 5, 1990, 42.
10. Elizabeth Leland, "Money—Plenty Of It—Needed To Get ACC Ticket," *Charlotte Observer*, March 2, 1990, 1C.

11. "S.C. Hunters Demand Land At Any Cost," *Charlotte Observer*, May 13, 1990, 8B.
12. Ronald Bailey, "Should I Be Allowed to Buy Your Kidney?" *Forbes*, May 28, 1990, 365.

8. Tax coal miners at 100 percent; investors, 50 percent

1. Kenneth L. Fisher, "Backwater Bargains," *Forbes*, March 19, 1990, 200.
2. Jane Bryant Quinn, "Inherit the Rind," *Newsweek*, August 10, 1992, 55. Reprinted by permission; all rights reserved.
3. Ibid., 55.
4. "Greenspan on Capital Gains," *Wall Street Journal*, January 25, 1991, A12.
5. Paul Recer, Associated Press, "Doctor Charges $5 Per Visit But Makes Forbes' Rich List," *Charlotte Observer*, April 15, 1991, 2A.
6. "Unsubtle," *Newsweek*, September 17, 1990, 6.
7. Gene Koretz, "Cutting Capital-Gains Taxes: History Says It's A Mistake," *Business Week*, August 24, 1992, 16.

9. So many middle-income people; so few wealthy

1. Malcolm S. Forbes, "Fact and Comment," *Forbes*, October 23, 1989, 21.
2. Kevin Phillips, "Capital-Gains Cut," *Wall Street Journal*, February 7, 1991, A15.
3. Gene Koretz, "Would the Economy Gain From Spreading Inherited Wealth?" *Business Week*, May 18, 1992, 22.
4. Lars-Erik Nelson, "Oh, To Be A Rich Texan Dining At Bush's Tax Trough . . . ," *Charlotte Observer*, September 20, 1990, 17A.
5. "Rich Would Gain Under GOP Plan," *Charlotte Observer*, September 14, 1990, 3A.
6. Laura Saunders, "Personalized Taxes," *Forbes*, June 1, 1987, 84.
7. Ibid., 87.
8. Ibid., 86.

10. Class warfare: liberals *are doing it?*

1. Michael Novak, "A Hanging Judge," *Forbes*, August 6, 1990, 73.
2. Alix Freedman, "Attention Yups: Give Away Your Wealth," *Wall Street Journal*, August 11, 1989, A11.

3. Robert Johnson, "Country Clubs May Be Old-Line, but They're In a Nouveau Revival," *Wall Street Journal*, April 12, 1990, 1A.
4. Thomas E. Ricks, "How 4 Pals Who Mixed Golf and Stock Tips Landed in the Rough," *Wall Street Journal*, July 21, 1989, A1.
5. Hilary Stout, "Deep Problems at IRS," *Wall Street Journal*, January 2, 1990, A1.
6. Jackie Calmes, "White House Urged IRS to Focus Audits On Lower-Income Payers, Agency Says," *Wall Street Journal*, March 21, 1991, A2.
7. R.A. Zaldivar, "Tax System Polarizing Rich, Poor," *Charlotte Observer*, February 18, 1990, 20A.
8. Ibid., 20A.
9. "Notable and Quotable," *Wall Street Journal*, November 23, 1990, A8.

11. Class warfare: world perspective

1. "Class Struggle Will Not End With Communism," *Wall Street Journal*, May 13, 1990, A13.

12. What work is

1. Udayan Gupta and Brent Bowers, "When It Comes to Pay, Heads of Little Firms Can Outdo Top CEOs," *Wall Street Journal*, July 20, 1993, A1.

13. Conservatives' Hidden Agenda

1. Ron Winslow, "Rising Supply of Doctors May Be Bad Medicine for Health Costs," *Wall Street Journal*, May 8, 1991, B1.
2. John Hechinger, "Presbyterian's Nurses to Go to Hourly Pay," *Charlotte Observer*, August 20, 1993, 1D.
3. Randall Smith, "In Failed Bid for UAL, Lawyers and Bankers Didn't Fail to Get Fees," *Wall Street Journal*, November 30, 1989, A1.
4. Ron Suskind, "Threat of Cheap Labor Abroad Complicates Decisions to Unionize," *Wall Street Journal*, July 28, 1992, A1.

14. Two philosophies

1. Gene Koretz, "Look Who's Being Tightfisted About Charity Giving," *Business Week*, November 5, 1990, 29.
2. Rush Limbaugh's family relationships are described in Paul D. Col-

ford, *The Rush Limbaugh Story*, New York: St. Martin's Press, 1993, 2-7.

3. Daniel Seligman, *Fortune*, March 2, 1987, 119.
4. Malcolm S. Forbes, "Fact and Comment," *Forbes*, October 2, 1989, 19.
5. "Overheard," *Newsweek*, January 1, 1990, 11.
6. Steve Kichen, "Pay Preview," *Forbes*, May 14, 1990, 91.
7. "CEO Incentives—It's Not How Much You Pay, But How," *Harvard Business Review*, May-June, 1990, 139.
8. Ibid. 139.

15. Right-wing conservatives: the anti-capitalists of the '80s

1. Donald Barlett and James Steele, *Philadelphia Enquirer*, in "Rules Shaping the Economy Stacked Against Middle Class," *Charlotte Observer*, November 24, 1991, 1A.
2. Gene Koretz, "Would the Economy Gain From Spreading Inherited Wealth?" *Business Week*, May 18, 1992, 22.
3. Carol J. Loomis, "The Rockefellers, End of a Dynasty?" *Fortune*, August 4, 1986, 26.
4. Carolyn Friday and Joshua Hammer, "'Now They're Just Rich,'" *Newsweek*, November 13, 1989, 63.
5. Elizabeth Leland, "Textile Empire's Breach Rivets City," *Charlotte Observer*, November 11, 1989, 1A.
6. Carol J. Loomis, "The War Between The Gettys," *Fortune*, January 21, 1985, 20.
7. Susan C. Faludi, "Safeway LBO Yields Vast Profits but Exacts A Heavy Human Toll," *Wall Street Journal*, May 16, 1990, A1.
8. —, "A Leveraged Buyout That Worked," *Forbes*, Nov. 12, 1990, 8.
9. —, "Safeway LBO Yields," A9.
10. —, "Overheard," *Forbes*, November 1989, 27.

16. Reagan and the '80s: the best of times?

1. "Fact and Comment," *Forbes Personal Affairs*, October 23, 1989, 9.
2. Dennis Farney, "Along the Rich Banks of the Mississippi Live Poorest of U.S. Poor," *Wall Street Journal*, October 13, 1989, A1.
3. Kevin Phillips, *Politics of Rich and Poor*, New York: Random House, 1990, 14.
4. Ibid., 153.

5. Lawrence L. Knutson, "Census Statistics Prove It: Poor, Middle Class Lose Ground," *Charlotte Observer*, May 31, 1992, 12A.

17. Spartanburg, South Carolina

1. Elton Rayack, *Not So Free To Choose*, New York: Praeger, 1987, 1.
2. Milton Friedman, *Free to Choose*, "Who Protects the Worker?" Vol. 8, 1980, Free to Choose Enterprises, series 11787.
3. Spartanburg Chamber of Commerce informational package, 1990.

18. The dark side of conservative economics

1. Data are from *Employment and Earnings*, U.S. Department of Labor, Bureau of Labor Statistics, Washington, D.C., March 1980, 115-119, and March 1990, 146-150.
2. Carol Hazard, "As Company Profits Go, So May Go Executive Pay," *Charlotte Observer*, August 27, 1990, 7D.
3. Carol Smith and Clifford Glickman, "10 Highest Paid Carolinas Executives Of Public Companies," *Charlotte Observer*" August 27, 1990, 1D.
4. Compiled by Gary Cohen and Margaret Mannix, "The 25 Top Housing Markets," *U.S. News and World Report*, April 9, 1990, 84.
5. Associated Press, "Spartanburg Gets Company Headquarters, 500 Jobs," *Charlotte Observer*, October, 1990, 8F.
6. Allen Norwood, "Mobile Home Battles Erupt in Suburbs," *Charlotte Observer*, November 11, 1993, 1A.
7. *A Study of the Spartanburg Housing Authority*, League of Women Voters of Spartanburg County, May 18, 1989, 2.
8. *THIS IS SDA*, Spartanburg Development Association, undated single-page pamphlet, Spartanburg, S.C.
9. Associated Press release was in Sinclair Lewis, *Cheap and Contented Labor*, reprinted by the Marion Tragedy Memorial Fund, Asheville, NC, 1980, 4.
10. Joe Hallinan, "Spartanburg Moves From a Textile Past to a Varied, Thriving Economic Mix," *Charlotte Observer*, March 14, 1993, 7B.
11. Thom Fladung, "Dream Sours, Leaving Mack Trucks Inc. Bought, S.C. Burned," *Charlotte Observer*, October 22, 1990, 2D.
12. "Businesses, Governor See No Rush to Labor Unions," *Spartanburg Herald-Journal*, April 28, 1989, A1.
13. Thom Fladung, "Dream Sours," 2D.

19. John Kenneth Galbraith's Spartanburg

1. John Kenneth Galbraith, *The Affluent Society*, Boston: Houghton Mifflin Company, 197).
2. Ibid., 195.
3. "Critical Indicators," *Spartanburg County Foundation*, 805 Montgomery Building, Spartanburg, SC, 1989, 2.
4. Associated Press, "Study: S.C. Workers Worse Off," *Charlotte Observer*, Monday, November 5, 1990, 4D.
5. "South Carolina," *Forbes*, June 11, 1990, 142.
6. Ed Martin, "Luring Europeans With Low Wages, Few Unions," *Charlotte Observer*, September 2, 1990, 7C.
7. "Lack Of Unions Attracts Industries to State," *Spartanburg Herald-Journal*, February 10, 1986, 1A.
8. David Perkins, "State Of The Parts," *Business/North Carolina*, May 1990, 55, 58.

20. The conservative cycle

1. "Poor Parents More at Risk For Breakups," *Charlotte Observer*, January 1, 1993, 9A.
2. Brenda C. Coleman, Associated Press, "Frequent Uprooting Hurts Kids, Study Says," *Charlotte Observer*, September 15, 1993, 1A.
3. George Laycock, "The Disaster That Won't Go Away," *Audubon*, September 1990, 108.
4. "Careers Count Most For the Well-to-do," *Wall Street Journal*, October 16, 1989, B1.
5. "RJR: A Lesson in Greed, 1988," *Wall Street Journal*, December 26, 1989, B1.
6. "Jobs Hang On Thin Thread," *Charlotte Observer*, September 10, 1990, 5A.
7. *Charlotte Observer*, "Textile Workers Rally To Save Jobs," September 13, 1990, 7A, and "Textile Bill OKd, But Isn't Veto-Proof," September 19, 1990, 1A.
8. Dinah Lee and Dirk Bennett, "Taiwan's Billions Are Hitting The Road," *Business Week*, September 17, 1990, 124-5.
9. David Proffitt, "Taxes," *Spartanburg Herald-Journal*, December 28, 1989, 1A.

21. First, the American Indian; now, the American worker

1. John Naisbitt & Patricia Aburdene, *Megatrends 2000*. New York: William Morrow, 1990, 11.
2. Ibid., 47.
3. Carl Abrams, *Conservative Constraints: North Carolina And The New Deal*. Jackson, Miss.: University Press of Mississippi, 1992.
4. William Greider, *Who Will Tell the People*, New York: Simon & Schuster, 1992, 42-45, 418.
5. "NAFTA Deadly to Small Businesses," *Charlotte Observer*, August 25, 1993, 11A.
6. Alan Murray and Urban C. Lehner, "What U.S. Scientists Discover, the Japanese Convert—Into Profit," *Wall Street Journal*, June 25, 1990, A1.
7. John Hechinger, "Moore Countians Who Face Loss of Their Factory Jobs Organizing, Asking For Help," *Charlotte Observer*, April 4, 1991, 1D.
8. "Today's Quote," *Charlotte Observer*, November 29, 1990, 21A.
9. Naisbitt and Aburdene, 47.
10. Associated Press, "Southerners Working Harder For Less Pay," *Charlotte Observer*, October 24, 1990, 12C.
11. Ibid., 12C.

Conclusion: Morality and America's new world role

1. Alan Riding, "As in Old Days, the Jet Set Comes In for a Landing," *New York Times*, August 21, 1989, A4.
2. William F. Buckley, "Happy Birthday, Malcolm," *Charlotte Observer*, August 28, 1990, 11A.
3. Georgie Anne Geyer, "Rioting After Hugo Reveals Breakdown Of Society In Caribbean," *Charlotte Observer*, September 27, 1989, 23A.
4. Richard Reeves, "Straight Talk on Race," *Charlotte Observer*, July 21, 1991, 3D.
5. Paul D. Colford, *The Rush Limbaugh Story*, New York: St. Martin's Press, 1993, xii.
6. Ibid., 177-178.
7. Ibid., 214-215.

Addendum: The cycle continues

1. Dean Foust and Maria Malory, "The Boom Belt," *Business Week*, September 27, 1993, 98-104.
2. Joe Hallinan, "Spartanburg Moves From a Textile Past to a Varied, Thriving Economic Mix," *Charlotte Observer*, March 14, 1993, 10B.
3. Foust and Malory, op. cit., 101.
4. Ibid., 100
5. Dan Chapman, "Mercedes: Are We Using Enough Bait?" *Charlotte Observer*, August 30, 1993, 1D.
6. Ibid., 14D.
7. E.S. Browning and Helene Cooper, "States' Bidding War Over Mercedes Plant Made for Costly Chase," *Wall Street Journal*, November 24, 1993, A1.
8. Ibid., A6.
9. "Firm Picks Alabama for Production Work," *Charlotte Observer*, January 11, 1944, 1D.
10. Foust and Malory, op. cit., 101.
11. Robert L. Rose, "Once the 'Rust Belt,' Midwest Now Boasts Revitalized Factories," *Wall Street Journal*, January 3, 1993, A1, A38.
12. Foust and Malory, op. cit., 104.